AWESOME 3D GAME DEVELOPMENT

NO PROGRAMMING REQUIRED

Awesome 3D Game Development

No Programming Required

Clayton E. Crooks II

CHARLES RIVER MEDIA, INC.

Hingham, Massachusetts

CHARLES RIVER MEDIA, INC.
10 Downer Avenue
Hingham, Massachusetts 02043
781-740-0400
781-740-8816 (FAX)
info@charlesriver.com
www.charlesriver.com

This book is printed on acid-free paper.

Clayton E. Crooks II. *Awesome 3D Game Development: No Programming Required*.
ISBN: 1-58450-325-4

Library of Congress Cataloging-in-Publication Data
Crooks, Clayton E.
 Awesome 3D game development: no programming required / Clayton E. Crooks II.
 p. cm.
 ISBN 1-58450-325-4 (pbk. with CD-ROM : alk. paper)
 1. Computer games—Programming. 2. Three-dimensional display systems. I. Title.
 QA76.76.C672C77 2004
 794.8'1526—dc22
 2004010659

Printed in the United States of America
04 7 6 5 4 3 2 First Edition

CONTENTS

ACKNOWLEDGMENTS

There are many people who have been involved with the development of this book, and because of their hard work and dedication, you are now holding it. First, I'd like to thank everyone at Charles River Media, and especially Dave Pallai, for the opportunity to write another book. It continues to be a great pleasure to work with you. Thank you all for your help and advice throughout the process.

Lastly, thanks to my family, my wife Amy and son Clayton, for giving up so much of their time to allow me the opportunity to do these types of projects.

PREFACE

Developing 3D games is undoubtedly one of the most rewarding and challenging aspects of computer science. And like most areas of computing, it is constantly evolving. Although creating a game is a very attractive concept to an aspiring developer, it is often very difficult to learn the intricacies of C/C++ or the advanced techniques required specifically for game development and overcome the difficulties associated with putting all these items into a complete 3D project. In addition to the programming, 3D games have many other areas that need to be addressed, including 2D graphics, 3D modeling, music, and sound effects.

With all these requirements, a would-be game developer is often overwhelmed, and that's where this book comes in. By introducing a series of tools that were designed to be used with absolutely no programming, the developer can then focus his attention on putting a game together instead of the programming. This turns the normally technical concept of game development into a more artistic process and, in doing so, makes game development available to anyone.

GAME PROGRAMMING
OVERVIEW

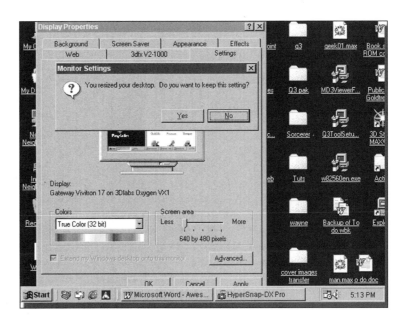

The development of a computer game is a truly unique production, combining a wide range of elements into what is hopefully an enjoyable experience for the end user. A typical game project involves programmers, artists, musicians, designers, and countless other positions that are necessary components for a successful venture. The first chapter of this book will guide you through the various positions, helping you understand why each of these is an integral part of the development process.

Once we finish this first chapter, we'll move on to the second chapter, where we'll discuss the creation of a design document. Subsequent chapters will begin the process of creating a first person shooter (FPS) and the various elements that are required for its construction. Every chapter will focus on a specific topic, and we'll create the key components that will ultimately make up our final project.

THE KEY POSITIONS IN A DEVELOPMENT TEAM

As was previously mentioned, a development project is made up several key positions, and without any of these, it would not be successful. That being said, depending on the size of your team, a single individual may be forced to wear many hats or in the case of the lone developer, all of the hats. That is, although all of the positions are required, a single individual may fill one or all of them.

Because the game industry is still in its infancy, it's sometimes difficult to discuss the positions that make up a team. The type of game being produced definitely also has a profound effect on the required personnel. Every development project is arranged differently, and as the industry matures, more standard types of arrangements will certainly become common. Until that occurs, we are stuck trying to explain most of the potential positions.

Designer

Many development projects have a lead game designer who is responsible for the creation of the game script. The designer could be one of the most misunderstood of any of the key positions and is often left completely off the team. This leaves room for everyone from the producer to a programmer clamoring for the title.

It is the designer who makes many of the decisions related to the creation of important aspects such as puzzles or the levels in an FPS. Like a screenwriter for a movie, he is responsible for the overall feel of the game. Communication is a very important aspect of the job as he works with the other team members throughout the duration of a project.

In the beginning stages of a game, the designer spends most of his time focusing on writing short scripts and working on the beginning storyboard sketches. A typical storyboard displays the action of a game, albeit in a very simple manner. Depending on the basic talents of the designer, the storyboards may even include stick figures and basic shapes to convey their messages. They are a sort of rough draft that will later be transformed into the game itself.

After the decisions have been made on the game concepts, the designers begin working on a blueprint for the game, called a *design document*. The design document is discussed thoroughly in the next chapter as we begin working on our FPS. Simply put, the document details every aspect of a game and will evolve as the game is being developed.

Programmer

Game programmers are software developers who take the ideas, art, and music and combine them into a software project. Programmers obviously write the code for the game, but they may also have several additional responsibilities. For instance, if an artist is designing graphics for the game, the lead programmer could be responsible for the development of a custom set of tools for the creation of the graphics. It is also his job to keep everything running smoothly and to somehow figure out a way to satisfy everyone from the producer to the artists. Unlike the stereotype portrayed on many Web sites, books, or even movies, programmers usually don't stroll into work at noon, work for a few hours, and then leave. The truth is, they often arrive earlier and leave later than anyone on the development team.

The programmer is responsible for taking the vast number of elements and combining them to form the executable program. He decides how fast a player can run and how high the player can jump. He is responsible for accounting for everything inside the virtual world. While doing all of this, programmers often will attempt to create software that can be reusable for other projects and spend a great deal of time optimizing the code to make it as fast as possible.

Sometimes, a given project may have several programmers who specialize in one key area such as graphics, sound, or artificial intelligence (AI). The following list details the various types of programmers and what they are primarily responsible for:

Engine or Graphics Programmers: They create the software that controls how graphics and animations are stored and ultimately displayed on the screen.

AI Programmers: They create a series of rules that determine how enemies or characters will react to game situations and attempt to make them act as realistically as possible.

Sound Programmers: A sound programmer will work with the audio personnel to create a realistically sounding environment.

Tool Programmers: As was previously mentioned, programmers will often write software for artists, designers, and sound designers to use within the development studio.

Audio-Related Positions

High-quality music and sound effects are an integral part in any gaming project and are something that many teams simply cannot afford to throw a great deal of money at. Having superb audio components such as music, sound, and voice can greatly enhance the total experience for the consumer. The opposite is also true, however, and music that is done poorly can be enough to keep people away from your product regardless of its other qualities. There are several individual positions that are usually filled with key audio personnel or perhaps a programmer or other team member, as needed.

Musician

When compared with the stress and long hours of the programmers, musicians are often at the other end of the workload. They have what amounts to the least work of any of the positions on the team. That's not to imply that they don't work hard, it's just that there isn't as much for them to do. They usually are responsible only for the music for a game, and while it's an important job, it does not typically take a great deal of time if it's compared with the other team members' jobs. Because of the relatively short production times, musicians often have secondary work outside the gaming industry.

Sound Effects

Depending on the makeup of a team, a musician could be involved with the creation of the sound effects in a game. This can often make up for the lack of work that they have and help to keep the budgets down. Another route that many teams choose to follow is the purchase of pre-existing sound effects. There are many sound effect companies that distribute their work on CD-ROMs or the Internet, and many teams choose to alter these to their liking.

Artist

The artists are responsible for the creation of the graphics elements that make up a project. They often specialize in one area within a project,

such as 3D graphics or 2D artwork such as textures. The artists usually have a set of specifications that are given to them by the programmer for the creation of the graphics. Unfortunately, artists and programmers often have many disagreements on these specifications. For instance, an artist might want to increase the polygon counts on a 3D model so that his work will look better, while a programmer may want to decrease these same counts to make the program run more smoothly.

Game artists have a variety of technical constraints imposed by the limitations of the hardware they are creating for. Although hardware continues to increase in speed and go down in cost, there is never enough power to satisfy a development project. Therefore, it is often the artists who are given the responsibility to create objects that work within the constraints.

Depending on the development team, there are three basic types of artists: character artists (or animators, as some prefer to be called), 3D modelers, and texture artists.

Character Artists

Character artists have one of the most demanding jobs on the team. They create all of the moveable objects in a game such as the main character, a spaceship, or a vehicle. It is their job to turn the preliminary sketches that are often discussed by the entire team into a believable object on a computer screen.

Using 3D modeling tools such as 3D Studio Max, TrueSpace, Maya, or Lightwave, the character artists use basic shapes and combine them to form the character. If you have never used a 3D-modeling program, you can think of it as a type of digital clay. Once created, the character is then skinned with a 2D graphic image that is made in another program.

The character artists are also responsible for the animation of the objects. They may be required to animate a horse, a human being, or a creature that previously existed only in someone's mind. Character artists often look at real-world examples to get their ideas on how a character should move in certain situations. Depending on the type of game, they may have to create facial expressions or emotion as well.

It's often the responsibility of a character artist to implement cut scenes in a game as well. Many artists enjoy the creation of the cut screens even more than the characters in the game. They have much greater freedom and are not restricted as to the number of polygons a certain object can have or the size of the object.

3D Modeler

The 3D modeler usually works on the settings in which a game takes place, such as a basketball arena or a Wild West wasteland. Background

artists work hand in hand with the designer to create believable environments that work within the constraints of a game. Like character artists, they use a wide range of tools for their jobs, including both 2D and 3D graphics tools, although they usually model only static objects.

Texture Artist

The texture artist might be the best friend of the other artists. It is his job to take the work created by the modeler or character artist and add detail to it. For example, he could create a brick texture that, when added to a 3D box created by the modeler, creates the illusion of a pile of bricks. On the other hand, he could create a texture that looks like cheese, turning this same box into a block of cheese.

Producer

A producer oversees the entire project and attempts to keep everything moving along as smoothly as possible. He often acts as an arbitrator to help patch up any problems between team members. For instance, if an artist wants to increase the color palette and a programmer wants to decrease it, the producer often makes the final decision on these types of key issues.

SECONDARY POSITIONS

There are several secondary positions that can be important to the development cycle as well. Depending on the budget, these positions may or may not exist at all or could be filled by other members of the team.

Beta Tester

Beta testers test the playability of a game and look for bugs that may occur when the game is executed. This is one of the most undervalued of the positions and should never be filled by the person responsible for programming the game. In reality, because of tight budgets and deadlines, this is also a step that is often cut before it is completed, as due dates will unfortunately take precedence over most decisions. If adequate beta testing is performed, a development team can save a tremendous amount of time and resources without having to produce unnecessary patches at a later date.

Play Testers

The play testers are often confused with beta testers, although play testers actually test only the playability of a game and critique areas such as movement or graphic elements. Again, these positions are often filled with individuals who perform other tasks on the team. Unlike beta testers, the play testers do not actually attempt to find or report bugs.

CHAPTER REVIEW

A development team is made up of a variety of individuals who create the necessary components for a successful venture. Contrary to popular perception, game development is not always about fun and games, and because of budget concerns, team members will often spend many hours on the job working in a variety of positions. Often a team will lose a key member, and the others will be required to take up the slack because hiring a new member may not be an option with the time constraints that are a part of the process. Even with the long hours and deadlines, most individuals who find their way into game development would prefer to do nothing else. In the next chapter, we are going to look at what it takes to set up your own development studio.

2

GETTING STARTED WITH GAME DEVELOPMENT

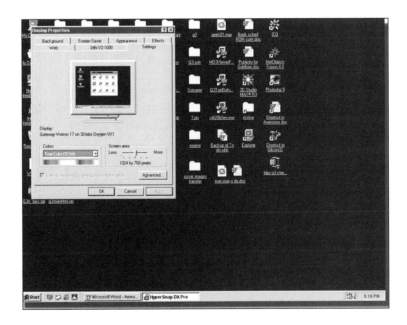

I f you browse most game development magazine and Web sites, you will find most "old timers" grumbling about the death of the one-person development team. In general, with the increase in hardware processing power, the game development industry has gone the way of Hollywood movie studios, with large budgets and large teams making it harder for lone wolf developers to compete. Although the times have changed, thousands of amateur developers, not unlike you, continue to create games.

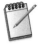 *Some of the materials in this chapter originally appeared in* Awesome Game Creation: No Programming Required, Second Edition, © *2002 by Charles River Media, Inc.*

You might be wondering how you can compete. For starters, part of what makes it difficult to compete also helps amateur developers. With the increase in hardware processing power, software developers have created a wide range of tools that are actually helping small and single-person teams to compete with the larger developers. These tools include graphics applications, 3D modeling programs, and simple 3D engines, to name a few.

The tools are making it easier than ever before to create games by yourself, although it is very important to understand the market you are actually shooting for. While creating the "next big thing" would be very nice, it's probably not realistic. Instead, you should probably turn your attention to smaller niche game markets that the bigger developers are overlooking.

SETTING UP YOUR GAME STUDIO

Before we can make anything, we need to have the proper equipment. And while it may sound expensive, setting up a game development studio doesn't have to be. With Moore's Law (this basically predicts that the processing power of computers will double every 18 months) continuing to hold true, the cost of computers continues to plummet. There are great deals for relatively powerful computers everywhere you look.

To go along with the cheap computers and low-cost hardware, there recently has been a movement toward software that lends itself to a small game developer. In the past couple of years, this trend has continued, offering game development tools that can be used without any programming. When you are setting up your game studio, there are several factors that will contribute to the type of equipment you need to have. Fortunately, you may already have the essentials of a game studio—a computer and this book—however, we will look closer at how to determine if what

you have is enough and the best way to determine what more you may need.

There is a wide range of computers available from which an aspiring game developer can choose. Trying to determine which system you need can be a daunting task. One way to look at this problem is to compare it to the purchase of other items, such as an automobile. For instance, if you were driving six kids to school, driving in a road race, or driving into combat, what vehicle would you choose? Computers are similar to vehicles in this respect. While a minivan, a racecar, and a jeep all have four wheels, they are all designed for very different purposes. So the big question for you is, what will you be doing with your computer? You may not be able to answer this question adequately until you have worked through this book and tried the different types of things you will have to do on your computer as a game developer. Once you have worked a bit in the various applications and learned their specific needs, as well as your needs as a user, you will know what kind of a system you will need to buy.

One thing to consider while working on your currently available system is the system requirements for the applications you will be using or intend to use. These requirements are usually clearly stated on the box, in ads, and on the home pages of the product. Usually the system requirements are broken down into *minimum* and *recommended*.

Usually the minimum system requirements are just that—the bare minimum to run the application. The minimum system will usually not be the most comfortable or even the most useable system to run the application and does not take into account other applications that you may be running at the same time. Let's say that the minimum RAM requirement for your art application is 16 MB, but you plan on running other applications at the same time (and you will as a game developer), such as a level editor, game engine, word processor, and 3D application. Your system will be severely taxed and may run poorly, if at all. And the minimum system does not usually take into account the files you will be working with. If you have experience with image editing applications such as Photoshop or Paint Shop Pro, you know that files can range from a few hundred kilobytes to over 50 megabytes, depending on what you are working on. While you can open and close applications that are not in use, this takes time (especially with slow, RAM-deficient machines) and will severely cut into your productivity and workflow.

Another area you should watch is the recommended hard drive space that the application needs for installation. This does not take into account anything you make with the application, only the application itself, so you need to take this into consideration as well. The processor speed is another variable that you should look at, which again includes only the speed to run the application and does not take into account larger files.

SYSTEM AND EQUIPMENT

The equipment you will need to create a computer game depends on the type and scope of your project. The right setup can range from a very minimal investment to tens of thousands of dollars for the latest and most powerful computer and peripheral setup. To get started, you need to own a basic computer setup with a few important peripherals.

Computer

A computer is obviously a necessary item for game development. As was previously mentioned, there are many great deals that can be had these days for a minimal investment. Unless the needs of your software indicate you need a high-end system, a general-purpose off-the-shelf system usually will do.

When purchasing your system, you should take into account the work and applications you will run. The operating system is important (Windows 98 or above for the tools in this book, although Windows XP would be recommended), and new systems usually ship with the latest version of the biggest OS on the market at the time. The minimal system today usually has a 17-inch monitor, lots of RAM, and a fairly large hard drive. You should have no problem with an off-the-shelf system or a mail-order system from a reputable company.

There are tips related to the purchasing of equipment at the end of this chapter.

Processor

The processor can often be very difficult to upgrade and, with this in mind, you should try to buy as fast a system as you can afford. There are two main manufacturers of processors on the Windows side of things: AMD with Athlons and Intel with Pentiums. We won't get into a big discussion or try to decide which processor you should buy; you can simply assume that they are basically comparable.

One of the reasons you should buy the fastest processor you can is because many of the other components can be more easily upgraded as needed. Getting the fastest chip possible makes sense if you are purchasing a system for general work, but as a game developer, you will be pushing your system harder than most other users and will have a need for the speed. But don't worry if your system is not the latest and greatest; you can still design and develop games with a minimal system, as long as it can run the specific applications you are using.

RAM

Like the processor, you should get as much RAM as possible. RAM stands for random access memory and is measured in megabytes or MB. (A slang term, *megs*, is often used.) RAM is used by the computer as temporary storage for the applications in use. When the system is turned off or the power goes out, the information that is in RAM is lost. Although it is cheap and very easy to upgrade, the prices are at such a low price that it is often a better decision to purchase a system that has a slightly slower processor and buy more RAM, which results in overall better performance at less cost. RAM is definitely the most important thing you can have.

Graphics (Video) Cards and 3D Cards

Video or graphics cards are becoming more important components of systems. They are the device in the computer that allows images to appear on your monitor. A video card usually controls how big the image is on your screen, how much detail it can have, and how many colors are displayed (in the next chapter, we will discuss the specific elements of an image).

Recently, there has been a trend toward faster, 3D hardware-accelerated video cards. Many applications require only the display of simple pictures, but if you are interested in doing 3D-related games, it will make sense to look at buying one of these cards. Most new systems will have a hardware-accelerated card, but the type and memory that it has will affect your performance. There are two manufacturers that are head and shoulders above the rest: Nvidia with its GeForce line of cards and ATI with the Radeon line. Regardless of the type of card you get, a 3D card is specifically designed to take the tasks of 3D rendering from the computer by handling textures, effects, and geometric calculations.

Other Peripherals

Other peripherals that you will need are standard on most computers: a modem, a CD-ROM or DVD-ROM drive, and a sound card. If your system comes with a modem, it will most likely be a 56-k modem, which is the fastest modem available on a standard dial-up connection. A CD-ROM or DVD-ROM drive will probably be present on the system—you can simply choose the type that benefits you the most. The sound card is the device that allows output to be sent to a set of speakers. There are many manufacturers of sound cards and options that you will find. Again, you can choose a sound card that meets your requirements. Lastly, there are

several other peripherals you will want to consider if you have the extra funds.

A scanner works like a copy machine from the user's point of view. A scanner converts your flat document or image into a digital image that can be manipulated in the computer, as we describe in the next chapter. This can be very useful for creating game art, Web sites, logos, and simply getting your picture on a Quake guy's face.

The next item is a digital camera, which works like a camera, but instead of film you get a digital image that is similar to one that you would get from a scanner. The major difference is that a scanner is good for copying flat images that have already been created, while a digital camera is great for real-life image capture. A digital camera can be used to capture an image of your house, whereas a scanner would require the image to be present on paper.

As was previously mentioned, most computers will come with a 56-K modem. This is adequate for many uses, but if you are serious about downloading information or researching on the Web, you should try to get high-speed Internet access. The Internet is such an invaluable resource, especially to game developers, that it is a worthwhile investment. Some of the large downloads you will be making are images, game demos, sound files, development tools, and animation files.

Backup Devices

This item is probably becoming a necessity as the prices of CD burners and media are now very low, and many systems now come with them as a standard item. There are actually two types of drives: a CD-Recordable (CD-R) drive, which can write to a given CD only a single time, and a CD-Rewriteable (CD-RW) drive, which can write, erase, and write to the media again. Once you have started creating content for your games, you will need a way to back them up. A CD-R drive is perfect for this. It is also a perfect way to deliver your materials to potential publishers when you are finished with a project. Instead of putting it on 10 or 15 floppy disks, you can safely distribute it on a CD-R.

Besides CD-R drives, you have several other options for backing up and storing your content. There are drives such as a standard 100-MB ZIP drive and a larger capacity 250-MB ZIP drive. There are also various options for tape backup drives that can hold several gigabytes of data. A standard floppy disk holds 1.44 MB of data, so you can quickly see the advantages of a high-capacity drive.

Another interesting item is a digital art pen and/or digitizer, which is something that an artist will like. These are pen-like devices that allow you to draw more naturally into the computer. This is far from a necessity and very expensive. The less expensive digital pens are good for recording

signatures and basic sketching, but they lack the fine control an artist needs.

Network

A network is another item that is very important. It allows your computers to communicate with each other. While this sounds like an expensive proposition and a complex undertaking, it is a very achievable goal. A good SOHO (Small Office Home Office) network system can be had for under $100 and comes in a kit with everything you need, extending your computing capabilities dramatically. A few of the benefits of a home network are shared peripherals and resources. You can have one scanner, printer, or device on the network that other people on the network can use from their computers. This can be useful because most computers (especially older PCs) have a limited number of devices they can have installed. Also, having many devices installed on a system tends to slow down the system's boot up and response times. You can also back up data on multiple PCs easily. During development of a title, having a network is almost essential because multiple team members are updating code and resources constantly.

Ethernet is the most common home-networking system and the easiest to have friends hook into. A typical system for two computers uses two cards, called Ethernet cards, and a crossover cable, a special cable designed for connecting only two computers. If you have three or more computers, you need what is called a hub, a device you plug all the computers into that routes, or directs, the traffic. The actual software portion of a network can range from simply finding the other computers on the network and accessing the data on their drives to setting up special software that operates peripherals and adds security, chatting, and other advanced functions.

Another type of network is a wireless network, which allows you to share information between computers without physically connecting them. Although there are advantages, wireless networks tend to be more expensive, are susceptible to data corruption, and are limited in distance between computers. Some networks use the phone wires in your house for connections instead of Ethernet or wireless. These are quickly becoming more prevalent for home users but are also susceptible to problems.

The last type of network we'll look at uses the electrical wiring in your home as the network wires and tends to be slower and prone to interference. It also has a security problem because it uses the transformer (the big thing on the telephone pole outside) as the common link for data traveling through your power lines. The transformer may be shared by 20 or more houses on the street, and it is possible for anyone with the same network system to pry into your computers.

One last thing you should buy is a good chair and desk. You will be sitting for long periods of time, and this will prove to be an invaluable investment.

TIPS FOR BUYING EQUIPMENT

Now that you have some ideas about the type of hardware you'll need to purchase, there are a few common sense ideas to keep in mind:

Use a credit card: You should use a credit card or find someone to do this for you, especially when buying online. With a credit card, you have the credit card company and the Fair Credit Billing Act behind you. This rule allows you 60 days in which to report a billing error or vendor dispute.

Don't be cheap: Avoid the so-called "budget" computers unless you really know what you are getting into. In some cases these systems may not include all of the components (larger hard drive, quality monitor, and so on). Expect to pay about $1,500 to $2,500 for a computer with all the fixins. Depending on your experience, it may be a good idea to get an extended warranty, although many new systems have three-year warranties and, after that period of time, the system probably is at a point that it can be replaced.

Protect everything: Buy a CD-ROM burner or ZIP drive. Try to back up data daily to a ZIP (or another computer on your network) and monthly to a CD-ROM. You can never be too safe. Also, buy a battery-supported surge protector or UPS (uninterruptible power source). For about a $100 you can get one that will protect several components, including your modems and phone lines. The UPS will allow you plenty of time to save your work and shut down your computer if the power goes out. Surge protectors are easy to use—you just plug them in, and they protect your computer from power spikes and shutdowns. The surge protector will actually blow a fuse or circuit if it gets hit by a surge of electricity from lightning or bad wiring, in order to protect your computer's innards from being damaged. Of course, the best protection is to turn off your computer and unplug it during thunderstorms.

Research: Above everything, learn about computers for yourself. If possible, try the applications you expect to run on a few systems first. See how those systems handle massive graphic files and huge levels. And remember, most people are very biased about their own systems, so be careful when opinion hunting for computer systems among individuals.

CHAPTER REVIEW

In this chapter, we looked at the basic components you will need to create a development studio. Once you have assembled your game development studio and have it up and running, whether it is an off-the-shelf special or the latest and greatest system money can buy, you will have made a huge step toward becoming a game developer. The next step is to learn the basic building blocks of a game. We'll begin this step in the next chapter by looking at "sights and sounds."

3

BASIC BUILDING BLOCKS OF A GAME

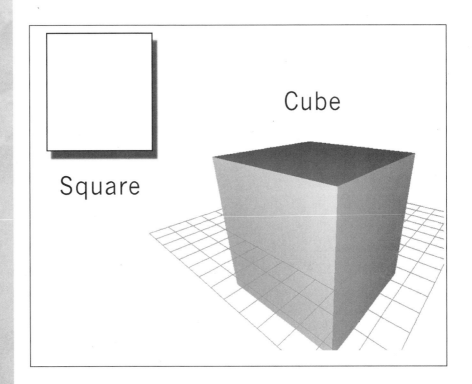

Square

Cube

To create games, you will need to learn, and perhaps even master, the fundamental elements that make up a game—sights, sounds, and interactivity. Although interactivity (or the ability to interact with a computer to play a game) is important, the basics of interactivity are dependent on game type and the application you are using to develop the game. We will learn more about interactivity in the tutorials later in the book as we make several different types of games using various tools. In this chapter, we will concern ourselves with the core building blocks that exist in virtually every game—sights and sounds.

 Some of the materials in this chapter originally appeared in Awesome Game Creation: No Programming Required, Second Edition, © *2002 by Charles River Media, Inc.*

This simple approach is to help you break down and understand a game in your mind at its most fundamental level. This knowledge can be applied to many areas beyond game development as well, since this is the core of graphic design, Web layout, and almost all interactive computing.

SIGHTS

When we talk about sights, we are obviously talking about what you see on the screen during gameplay. In any major production, from a Web site to a game, the layout of the screens and the graphic images that are used to make them are very important. In a large development team, they are usually worked on by a number of people, including a designer, a producer, an art director, and others. In a one- or two-person development effort, you will need to wear several hats and try to perform the actions of all of them. 2D art assets need to look good but also fit in with the audience, technology, and atmosphere for which you are designing. We'll talk about this again later when we look at marketing a game.

The creation of the assets that will be used in the making of the interface elements will require the use of many software tools and techniques. The assets are often sketched on paper or mocked up on the computer before they are created. Some of the tools used are 2D paint programs that work only with flat images, 3D programs that allow you to build and render objects that realistically re-create a 3D environment or object, and even digital photographs and scans. In order to create the images, you will need to have an understanding of the concepts of the images and a grasp on the tools you will be using.

2D art assets include, but are not limited to, the following:

Menu screens: Look at the toolbar in your word processor, browser, or even your favorite game, and you will see art that was created by an artist.

Credit screens: These screens often contain art such as logos, images, and even fonts or special letters from the product, people, and company they represent.

Logos for companies, products, and services: Logos can be simple letters, 2D masterpieces, or fully rendered 3D scenes. Look around on the Net and you will see logos that range from clipart to actual pieces of art.

User interfaces: These are broken down into background images, buttons, cursors, and other art objects a user must click on or interact with.

In-game assets: In the game, the sights are the textures on the walls, the floors, and the characters. Even the 3D models and objects have 2D art applied to them.

The original computers did not display graphics. Instead, they were limited to letters and numbers. Surprisingly, games were still made on these primitive machines. As soon as the original graphics cards (which are used to display graphics on the monitor screen) were made, the games started their move toward the amazing graphics we see today. It can be argued that games have pushed the development of the computer as the gamers demanded (and were willing to pay for) faster chips, better video cards, and better sound. But even as the technology advanced, it was common for the artist on any given project to be primarily a programmer. This was because it was still demanding to get decent art into a computer format, and an understanding of technology was necessary to do so. Today, we can almost ignore the technology we are working with.

Let's look at the core technology a computer artist deals with every day. In computer graphics today, there are two basic types of art: 2D and 3D. 2D, or two-dimensional, art is a flat image with no depth. 3D art, on the other hand, shows depth, as illustrated in Figure 3.1.

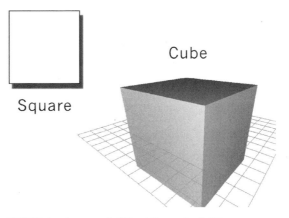

FIGURE 3.1 A square is 2D, while a cube is 3D.

The three dimensions are described in the Cartesian Coordinate System in x, y, and z coordinates. This may be one of the most surprising aspects of game development—you can actually use some of the math-related things you learned in school! In fact, algebra, geometry, and physics all play a role in game making. The Cartesian Coordinate System, at its simplest, is x being a horizontal line (or axis), y being a vertical line, and z being the distance backward and forward (see Figures 3.2, 3.3, and 3.4).

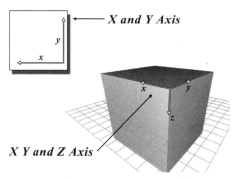

FIGURE 3.2 The Cartesian Coordinate System. The x-axis, y-axis, and z-axis.

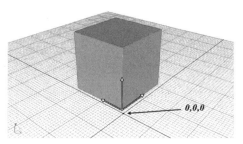

FIGURE 3.3 A cube and the x,y,z value of its location in space.

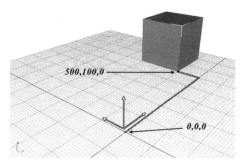

FIGURE 3.4 Another cube in a different x,y,z position.

BASIC ELEMENTS OF AN IMAGE

In order to understand a 2D image properly, you must learn about the basic elements that make it up.

Pixel

To begin with, we will look at the most fundamental of fundamentals—the most basic element of an image—which is the pixel, or a picture element. A pixel is a colored dot on the screen. A computer image is made up of these pixels arranged in rows and columns. See Figure 3.5 for an illustration of a pixel. No matter how big and fancy a computer image is or what has been done to it, it is all just a bunch of pixels.

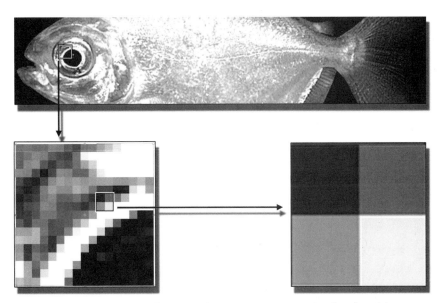

FIGURE 3.5 A pixel is the smallest unit of a computer image—simply colored dots.

Once an image is in a computer, the maximum detail is set and cannot be increased. The image can be enlarged, and the number of pixels can be increased by a mathematical process called interpolation, which is illustrated in Figures 3.6 and 3.7, but this does not increase the detail. It simply adds extra pixels to smooth the transition between the original pixels.

FIGURE 3.6 Here is an area of the fish image before enlarging.

FIGURE 3.7 Here is the same area enlarged with pixels interpolated.

Resolution

Resolution is the number of pixels displayed (width × height) in an image. A typical computer monitor displays 75 to 90 dpi (dots per inch, the number of pixels per inch in an image). A printed image usually needs to be 300 dpi or more if it is to look good in print. Often a computer-based person requesting an image from a person used to working in print is surprised when the one-inch icon he requested is HUGE, but the image attributes still read one inch by one inch. The reason for the enormous size is that the print person saved the file at a higher dpi. Some of the most common screen resolutions are 320 × 200, 640 × 480, 800 × 600, 1,024 × 768, 1,152 × 864, and 1,280 × 1024. For example, an 800 × 600 resolution means that your screen will be 800 pixels wide (horizontal) and 600 pixels high (vertical). (See the examples in Figures 3.8, 3.9, and 3.10.)

Aspect Ratio

Another important component of resolution is aspect ratio, or the ratio of the pixel's width to the pixel's height. Not all images are square. In 640 × 480, 800 × 600, and 1,024 × 768 mode, the aspect ratio is 1:1 or 1, meaning the pixels are perfectly square.

FIGURE 3.8 Here is the Windows Desktop at 640 × 480 dots per inch.

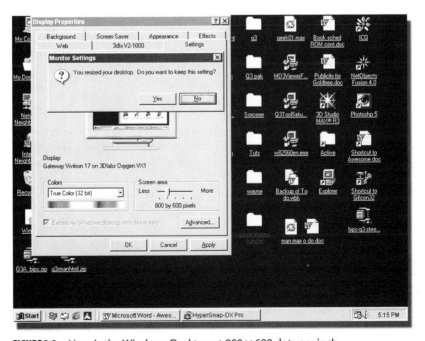

FIGURE 3.9 Here is the Windows Desktop at 800 × 600 dots per inch.

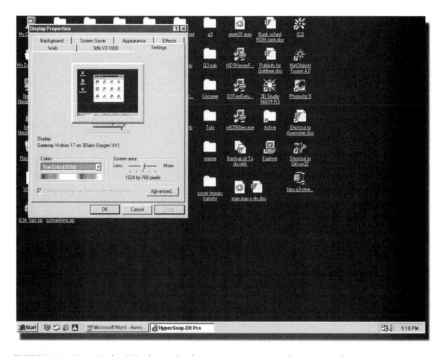

FIGURE 3.10 Here is the Windows Desktop at 1024 × 768 dots per inch.

In 320 × 200 mode, the aspect ratio is 1.21:1 or .82, meaning the pixels are higher than they are wide. If you create an image in 320 × 200 mode and display it in 640 × 480 mode, it will appear slightly squashed, since the pixels are about 20% shorter. See Figures 3.11 and 3.12 and notice the distortion in the image.

Image created by Nick Marks 1999-2000

FIGURE 3.11 Here is an image created at 320 × 200 dots per inch.

Image created by Nick Marks 1999-2000

FIGURE 3.12 Here is the same image displayed in 640 × 480 mode.

Colors

When working with most interactive content, you need to understand how color works in the computer. You will need precise control over your colors in certain situations in order to achieve certain effects and accomplish some jobs. In games and Web sites, you often have to set precise color information to achieve certain effects. Often other computer artists will give you the number of a color to use in an image. An RGB value is the mixture of red, green, and blue to make other colors—like in art class when you mixed red and yellow paint to make orange.

So 255,0,0 means you have all red and no green or blue. Black would be 0,0,0, and white would be 256,256,256. In Figures 3.13 through 3.17, you can see the RGB values of the color, and (even though the images are in 0,0,0 and 256,256,256—excuse me, black and white) you can see the position of the marker in the color palette.

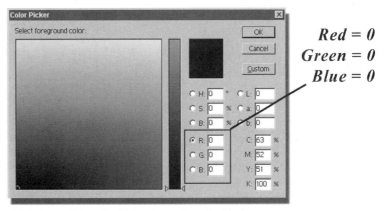

FIGURE 3.13 This is the RGB color palette for black.

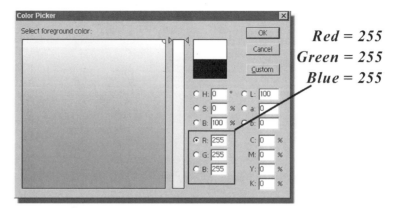

FIGURE 3.14 This is the RGB color palette for white.

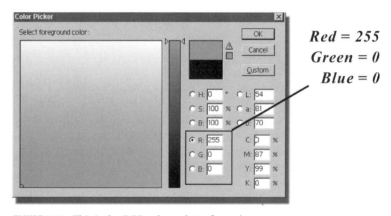

FIGURE 3.15 This is the RGB color palette for red.

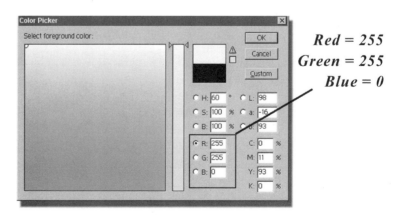

FIGURE 3.16 This is the RGB color palette for yellow.

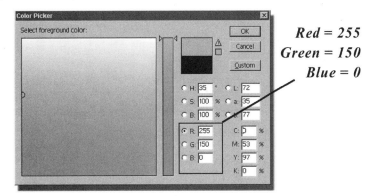

FIGURE 3.17 This is the RGB color palette for orange.

You will also hear color referred to as CMYK. CMYK is a mode used by traditional printing processes and stands for Cyan, Magenta, Yellow, and Black. You will almost certainly never use CMYK color in game and computer content creation and will always deal in RGB or indexed color.

Number of Colors

ON THE CD

A computer video card can display a certain number of colors at a time—16, 256, thousands, or even millions (see Figures 3.18, 3.19, 3.20, and 3.21, and see the Color Gallery in the Figures folder on the CD-ROM for the color versions of the images). The number of colors is called *color depth*, which describes how many colors can be displayed on your screen at once. Color depth is described in terms of bits and refers to the amount of memory used to represent a single pixel. The most common values are 8-bit, 16-bit, 24-bit, and 32-bit color. More bits correspond to a wider range of colors that can be displayed.

True color (24-bit color) is capable of displaying 16.8 million colors for each pixel on the screen at the same time. The human eye cannot

FIGURE 3.18 This is an image in 16 colors.

FIGURE 3.19 This is an image in 256 colors.

FIGURE 3.20 This is an image in thousands of colors.

FIGURE 3.21 This is an image in millions of colors.

distinguish the difference between that many colors. High color displays only 32,000 or 64,000 colors, but it is still a very impressive range of colors, enough colors for most work. The most limited in colors is 256 color. It stores its color information in a palette. Each palette can be set to any of thousands or millions of different color values, but the screen can't show more than 256 different colors at once. Some games still use it because, like resolution, more colors means more data pumped to the screen. So if you can get away with only 256 colors, you can render (or draw) the game pictures to the screen faster. More recently, games are starting to use thousands of colors as the hardware permits.

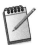 *The word render is used in games, especially real-time 3D games, as the computer and software literally renders or builds an image instantly, based on where you are in the 3D world. Hence the term interactive. In a movie, you watch each frame as it was created by the moviemaker. The frame is unchangeable. In a 3D game, you control how each frame looks by where you choose to go in the world and what you do. Each frame of your gaming experience is made for you on-the-fly, or as your experience is happening.*

256-Color Palettes Explained

Hopefully, you will never need to know this, but here it goes. Each pixel can have a numerical value from 0 to 255 (a total of 256!). The screen knows only where to get the color from, but it does not know the color. Figure 3.22 shows the 256-color palette.

FIGURE 3.22 A 256-color palette. You can see only shades of gray here, but those squares are 256 different colors.

So follow me here. Say you have a picture, and you open the color palette to have a look. If you note that a certain color is assigned to the number 3 place on the color palette and then decide to reassign another color to the number 3 position, your image will now display that new color where the original color used to be.

Even if you have that original color in the palette, it will not be displayed where the number 3 position is being displayed. What this means is that a computer can't distinguish color; it sees numbers. You will have to be aware of this for later tutorials. In Figures 3.23 and 3.24, you can see how the changing of one color affects the image.

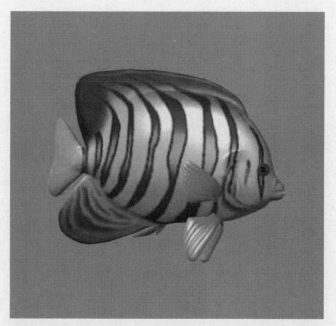

FIGURE 3.23 This is a 256-color image.

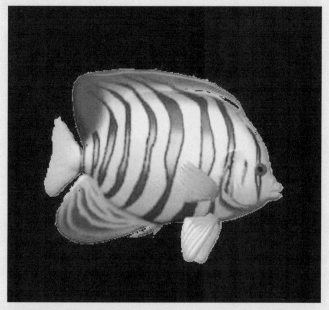

FIGURE 3.24 This is the same image after changing the palette colors. The computer sees the number, not the color.

Now that we understand the basics of images, we can move onto the basics of manipulating images.

MANIPULATING IMAGES

During the development of your project, you will have to manipulate images in order to get them to fit your needs. The basics of image manipulation are similar to the text editing you may have done in your word processor. Commands such as Cut, Copy, and Paste are common. We will also look at Skew, Rotate, Resize, Crop, and Flip.

Cut: If you cut an image, you remove it from the scene. But do not worry—you can paste it back in or undo your action.

Copy: Copy does not alter your image, but it creates a copy in the memory of your computer that you can paste in somewhere else, as shown in Figure 3.25.

Paste

Copy

Cut

FIGURE 3.25 Cutting and copying sections of an image. Note: Copying does not affect the image.

Paste: As mentioned above, after cutting or copying an image, you can paste it in somewhere else, as shown in Figure 3.26.

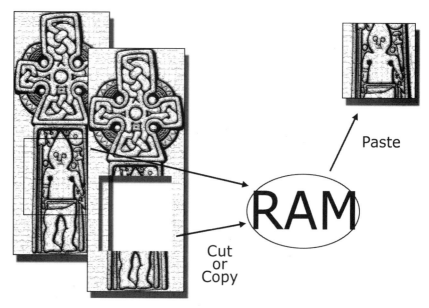

Paste

RAM

Cut
or
Copy

FIGURE 3.26 Pasting a section of an image.

Skew: Some image manipulation programs allow you to skew (slant, deform, or distort) an image, as shown in Figure 3.27.

Rotate: Rotating is pretty self explanatory. You can free rotate an image or rotate it precisely a certain amount, as shown in Figure 3.28.

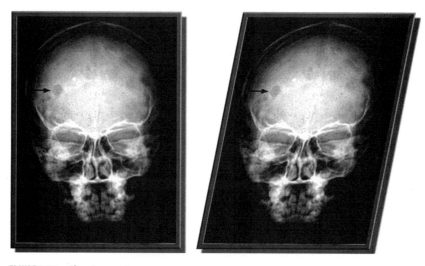

FIGURE 3.27 Skewing an image.

FIGURE 3.28 Rotating an image.

Resize: Resizing an image is useful, but be careful. Any severe ma-
nipulation of an image degrades it, and resizing does a lot of dam-
age. Caution: If you reduce an image and then enlarge it again,
you will seriously degrade it. This is because, in effect, you are
enlarging a small image. The degradation takes place going down
as well as going up in scale. This is illustrated in Figures 3.29,
3.30, and 3.31.

Crop: Cropping actually cuts an image smaller to a defined area, as
shown in Figures 3.32 and 3.33.

FIGURE 3.29 A smaller image blown up; pixel rip.

FIGURE 3.30 An image reduced.

FIGURE 3.31 The same image enlarged to its original size. Notice what this has done.

Image created by Jennifer Meyer 1999-2000

FIGURE 3.32 Cropping an image. The crop outline.

FIGURE 3.33 The image cropped. Everything outside the crop outline is now gone.

Flip (horizontal and vertical): Finally, you can flip images horizontally and vertically (see Figures 3.34, 3.35, and 3.36).

The image

FIGURE 3.34 The image.

Flipped horizontally

FIGURE 3.35 The image flipped horizontally.

Flipped vertically

FIGURE 3.36 The image flipped vertically.

ADVANCED IMAGE MANIPULATION

In the previous section, we looked at some basic information related to editing an image. This obviously only scratched the surface of what we'll need to do in order to create graphics for a game.

Sprites

Sprites are small pictures of things that move around—characters, buttons, and items in your games. Sprites can be animated as well. A sprite is a graphic image that can move within a larger image. Notice that the sprite image in Figure 3.37 has a solid border around it, and in Figure 3.38, the solid part is not seen.

FIGURE 3.37 A sprite image. Notice the solid part surrounding the image.

FIGURE 3.38 A sprite image in a game. Notice that the solid part is not displayed. You can see the background.

Sprite animation is done just like cartoon animation. A series of images is played in sequence to make it appear that a character is walking or a logo is spinning, for instance. Examples of sprite frames can be seen in Figures 3.39 and 3.40.

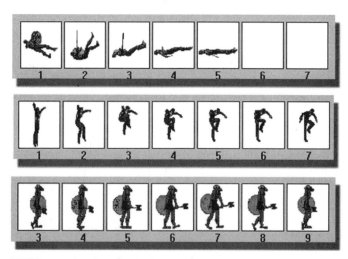

FIGURE 3.39 A series of sprite images for a game animation.

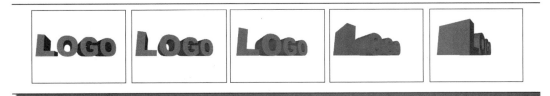

FIGURE 3.40 A series of sprite images for a spinning logo.

Masking

A mask is a special image that is used to "mask" off portions of another image. A mask works like a stencil. Since an image is square or rectangular, the mask allows the edges to be any shape, as the game will render the masked portions invisible (see Figures 3.41, 3.42, and 3.43).

Color Masking

Masking can also be achieved by dedicating a specific color to be rendered as clear or transparent. This color is usually an ugly green or purple that most likely will not be used any other time in the game art.

FIGURE 3.41 An image of a ghost.

FIGURE 3.42 The mask for the ghost image.

FIGURE 3.43 The mask and image combined in a scene.

Palette or Positional Masking

Finally, some games use a specific position on the color palette to determine what color will not render or be clear. Remember, the computer cannot see color, only the numbers. This method for masking has the computer looking at the position on the palette, not the color, to determine transparency. Usually the last color place on the palette is used, so instead of rendering a certain color as transparent, it will render whatever color is in the designated position of the color palette as clear.

Opacity

Images can also be displayed in games as opaque—halfway between solid and clear (like our ghost image). This is done by looking at each pixel in the image and the pixel directly under it and creating a new pixel that is a blended value of the original pixels (see Figures 3.44 and 3.45).

Anti-Aliasing

Look really closely at the computer-generated images in Figures 3.46, 3.47, and 3.48. See those jagged edges on the letters? Those are actually the pixels we have been talking about. They look really jagged if made from a solid color. But using various shades of that color and gradually blending the edge color with the background color will make the transition smooth and will fool the eye from a distance. Yes, this is similar to opacity.

FIGURE 3.44 The masked ghost image with opacity set at 50%.

FIGURE 3.45 A close-up detail of the ghost image.

This technique is called *anti-aliasing*. This is also the reason more colors look better in an image, because you can blend more gradually. This is also the reason high resolution (more pixels) makes an image look better—the blending is smoother between pixels.

FIGURE 3.46 This image has no anti-aliasing.

FIGURE 3.47 This image has anti-aliasing.

FIGURE 3.48 Here is a close-up of both of the images' edges.

Graphic Formats

Graphic images are stored in many formats for many reasons. In business, this may be for technical support and product design reasons, competitive reasons, and security reasons. But the main reason is image quality and usefulness. Some image formats are quite large because they retain a lot of image data, whereas some formats allow compression and strip out data for a smaller file size. Still others degrade the image so that it can be really small for uses like Web sites. In Figures 3.49 and 3.50 you see two versions of an image. The degradation is not that bad (see Figure 3.51), considering that the file size of the BMP is almost 20 times the size of the

FIGURE 3.49 This 640 × 480 image is in the BMP format. It is 900 KB.

FIGURE 3.50 This 640 × 480 image is a compressed JPEG and is only 40 KB.

JPG image. The specifics you need to know about graphic formats are discussed further later in this book and in the documentation of any applications you will be working with.

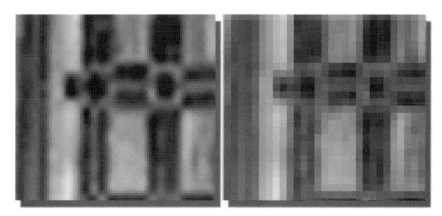

FIGURE 3.51 Here is a close-up of the same area of both images.

CHAPTER REVIEW

In this chapter, we looked at the basic elements of images and got some ideas of how they are created. Now that you are familiar with graphics, you are almost ready to start the creation of content for a game. Before we get ahead of ourselves, we will look at the creation of music and sound effects in the next chapter.

DESIGN DOCUMENTS

Project Name : Fun Racing
Designer : John Doe

Description of Scene
Intro Screen with Options

Text: The buttons will use Bedrock as a font.

User Input: Must pick a car before continuing. They also have access to help and options buttons.

Audio: Opening.MP3

Animation: Rotating 3D cars.

Play

Options

Help

Scene ___3___ of **16**

In Chapter 1, "Game Programming Overview," we looked at the positions that make up a game team and their respective responsibilities. We'll do something similar in this chapter, but this time our attention will be focused on the creation process. Instead of jumping right into the technical aspects of the game such as creating the levels or writing some code, it's important to begin with the creation of a design document.

This chapter will serve as a complete overview of the design document. If you'd like to follow along with an actual design document, Appendix A, "About the CD-ROM," contains the complete version for the game project that we are going to be working on in this book. Additionally, you can use this as a basic template for the creation of your own design documents.

ON THE CD

The CD-ROM that is included with the book also has the design document/template in Word format for you to use. It is located in the Project directory.

WHAT IS A DESIGN DOCUMENT?

A design document is often overlooked in the rush and excitement of a game idea. After all, if you have a unique idea that could conceivably be a great game, why would you want to waste your time working on something that doesn't really get you any closer to the end product?

Many times, even relatively large development teams don't spend the time to create a fully functional design document. Most game developers will try to stay away from unnecessary work, but the long hours spent creating a thorough design document will actually save countless hours down the development road. You might be lucky enough to create a very good quality game without a design document, but the key word in this is *luck*. Most often, a game that begins without a properly developed design document will be delayed for months or may not even be finished.

The creation of a design document is similar to the creation of a movie script. In it, you will write details of an exact story (if you have one—for example, racing games would probably not have a story), an overview of the characters or opponents you are intending to create, detailed descriptions of every level, and so on. If this is the first time you've ever considered creating a design document, there are a few things you should be aware of.

First, the design document is not chiseled into stone. That is, it can and should evolve as the game does, but it shouldn't be drastically altered. The design document will serve as a sort of road map to how the project will develop and should be as complete as possible. That being said, it can be changed when necessary to include a new character or a slight change in the plot. Design documents are team oriented and therefore should

include as many contributions as possible from the individuals who make up a team.

IMPORTANCE TO TEAM MEMBERS

A design document is important for a number of reasons. To a potential publisher, it details the game and gives them a vision of what you are actually hoping to accomplish. The purpose of a design document to a team is rather simple: It lays out the responsibilities of everyone involved. Depending on the team member, a design document will mean different things.

It is the document from which a producer will base his estimates, while programmers may look at the design document as a series of instructions for completing their role. Artists will use the document to help them visualize the characters they need to create. Designers often take things from the document such as the mood for a level. Audio personnel require some sort of a basis for the development of sound effects and music, and the document may be the only place they can truly acquire the appropriate knowledge.

CHAPTER REVIEW

While the design document is very important, it doesn't take the place of meetings that a development team should go through. Getting the thoughts of team members at regular intervals is also very important. Again, these meetings don't have to be formal and can be in person or over some electronic medium such as a discussion board. Like most things, it's not really important how they occur, it's only important that they actually do. In the next chapter, we are going to look at this further, discussing the actual elements that should be included in the design document.

ELEMENTS OF THE DESIGN DOCUMENT

In the previous chapter, we looked at the basic concept of a design document. We will expand that basic coverage in this chapter by looking at the individual components or ideas that make it up. Many teams will include information such as legalities, target audience, and market analysis for a game in their design document. While this works, it would make sense to include those types of business-related materials in a game proposal to a publisher, which is looked at in more detail later in this chapter. It's counterproductive to have team members scrolling through pages of information they really don't need to review.

GAME OVERVIEW (STORYLINE)

This may be the most important piece of the entire document puzzle. Without a solid story or game overview, the later steps will be much more difficult to create. Be very thorough with the game overview. If you leave something out, go back and fix it immediately. Sometimes the smallest details can make a big difference in a large project.

Because you don't know exactly who will read this, make sure to include as many details as possible as you would if you were creating a good storybook. You would be surprised at the number of simple spelling errors that are present in most design documents. While everyone misses a word every now and then, you should try your best to keep grammar and spelling mistakes to a minimum. This is not directly important to you, but again, you don't know who might end up reading it.

Many teams place background information in its own category, but because it relates to the story, it can be placed within the game overview category. Some genres, such as a sports simulation, wouldn't have a background section and can therefore be passed over.

LEVELS

The next item you need to address is the levels that make up a game. If you do a thorough job in the preceding step, this one is very easy. You compile a list of levels, in the order in which they will be encountered in your game, adding any details you deem necessary. Some optional materials include ideas such as the layout, a general description, or the placement of enemies, to name a few. Creating a mood for a level at this time can be a big bonus because a designer or artist can simply browse this area to get a feel for what needs to be created.

The creation of a set of maps for the levels is helpful to the members of the team, especially the programmers and level designers. They can be very detailed pictures but more likely will be a set of simple lines, circles, and squares that form a rough layout of the levels. You can see an example of this in Figure 5.1.

FIGURE 5.1 A level with a map.

HEROES AND ENEMIES

The next section of the design document deals with the characters that will be included in your game. Like the levels area of the document, the character section should basically fall into place if the game overview is meticulous.

There are two basic types of characters in most games: a hero and enemies. You can include details of the hero such as any background information or some rough sketches. These ideas will again help team members to understand what you are trying to accomplish. A list and description of animations should be included with every hero as well. Depending on their roles in the story, you can also include descriptive ideas of their intelligence levels and strength and basic information about how they react to the rest of the characters. Again, this information will be beneficial to the team when they are working with it.

Once you finish with the heroes, you need to create a specific section for enemies you will encounter. This could include anything that will attack a player. For instance, in an FPS, you might include a dinosaur; in a space combat game, you could include an asteroid. You can follow the same basic procedures as the characters, making sure to include similar details and sketches where appropriate. For reference, Figures 5.2 through 5.4 contain sketches of the raptor that we are using in our game project.

FIGURE 5.2 A rough sketch of a raptor. **FIGURE 5.3** The raptor with some color.

FIGURE 5.4 A 3D rendering of the raptor.

Lastly, you need to include information about the types of weapons the characters will have access to. You should include detailed descriptions of every weapon that can be accessed by either type of character. Sketches, such as in Figure 5.5, can be valuable for everyone on the team. You should create a list that contains the damage that the weapon will create, along with the type and amount of ammunition.

Weapons	Damage
Knife	Light damage to guards
Flame Thrower	Strongest Damage Possible
6 shooter	Limited damage.
Automatic Rifle	Only auto repeat weapon.

FIGURE 5.5 List of weapons and damages.

You'll notice the very simplistic sketches in this example. You can make them as detailed or as simple as you need for your particular needs. Often, it's more important to get them drawn than to worry about how great they look. You can always go back to them and clean them up later.

MENU NAVIGATION

The creation of a list that details menu navigation is very important. It helps you to keep track of the way the game is linked to other parts and is very important to the programmers involved. You should create the main menu and a simple illustration of how the screens will be linked together. Nothing fancy is necessary, but all of the menus should be included. For example, you could use something like Figure 5.6 to display information about the opening screen of a racing game.

Project Name : Fun Racing
Designer : John Doe

Description of Scene
Intro Screen with Options

Text:The buttons will
use Bedrock as a font.

User Input: Must
pick a car before continuing.
They also have access to
help and options buttons.

Audio: Opening.MP3

Animation: Rotating 3D cars.

Play

Options

Help

FIGURE 5.6 A fictitious racing game opening screen.

USER INTERFACE

The user interface goes hand in hand with the menu navigation system. For convenience, you could place it under the same category because it deals with many of the same ideas. The information for this category can be text-based information about what you are planning to do, but ideally, some type of sketch works the best (like Figure 5.7). Like most of the design document, they don't have to be fancy, but details are important.

MUSIC AND SOUND EFFECTS

This section is important to the audio personnel on the team and the programmers who will try to use their sounds in the game. You can discuss the possibilities of tools that you plan to employ and the types of sound effects that you have in mind for some of the game and possibly detail the music you might have in the levels that you listed earlier in the process.

The most important step in the first draft of the document is to include what formats and sound API (application programming interface) you are planning to use and what types of music and sound effects you are planning. For instance, you should decide if you are going to use

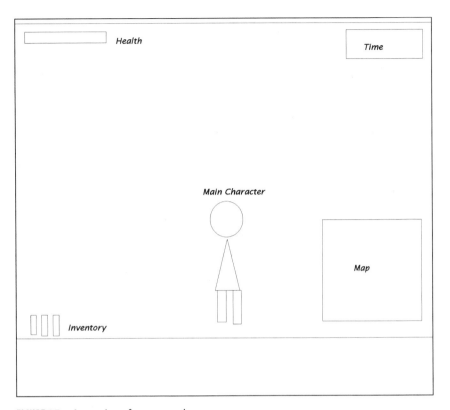

FIGURE 5.7 A user interface example.

MIDI, WAV, or MP3 files for the music and if you'll need things like explosions or footsteps for sound effects. You should also list the genres of music you'll be planning, such as rock or pop. This keeps the programmers and audio personnel thinking the same way so that they are not surprised two months into the project.

SINGLE OR MULTIPLAYER

The next step focuses on the gameplay itself. If you worked hard on the game overview, you may have already covered this. If you have, this section is much easier. If not, you should begin by determining if it will be a game that implements single player, multiplayer, or both. For example, if you are planning an FPS clone like Quake, you might decide that it is single player only. If you are doing a sports game like basketball, you'll

probably want to have multiple player support. Sometimes the information in this area of the document is discussed in other areas, but you shouldn't worry about duplication of ideas. This is especially true on a first draft, as you can always change the document after a later inspection.

If it's a single player game, you can describe the game experience in a few sentences and perhaps break down some of the key elements of the single player game. For example, if it's a Quake clone, you could begin by setting up the location of the game. Next, you could detail the types of enemies you'll be facing and the route to complete the game, such as, "You have to finish 10 levels before the game is over." You could also list how the game ends, such as when a level isn't completed on time. Another idea that you can include is a projection on the number of hours the game is going to take before a player finishes and how he ultimately wins the game. A single player game is usually easier not only to design but also to discuss in the design document.

A multiplayer game description begins the same way as a single player. You can take a few sentences to describe the basics of the game play. The basketball game we mentioned earlier could begin by mentioning the type of game it is: a street ball type of game, college, professional, or international rules game. You can also decide what types of options you'll have, such as franchise mode for a professional game or what types of parks you'll include for a street ball game. Now is a good time to decide how many players will be allowed to play simultaneously and how you plan to implement the client-server or peer-to-peer system. For instance, do you plan to use something like DirectPlay or another API, and how many individuals do you plan to allow to play against one another? In our basketball example, you need to decide how many people you will allow to play on the same team or against one another on different teams. You don't need to have complete technical details, but you should discuss the possibility of the protocol you plan to use at a minimum. It would be even better to begin looking at potential pitfalls that are common in multiplayer games.

MISCELLANEOUS AND APPENDIX

The final area of the document is for miscellaneous information that may be specific to a certain type of genre or doesn't fit neatly into another category. You can name this category anything that works well for you. For example, suppose you decided to do a basketball street game, and you wanted to include information about the way the basketball players will dress so that you can keep track of players from both teams. You could have one team play in white shirts and another in red shirts, for instance. If you have multiple additions, you should split them up into multiple categories to keep everything easy to read and follow. The appendixes are

a good place to put items such as sketches or concept drawings. This way, you can refer the reader to an appendix instead of cluttering up your text.

WRAPPING IT UP

Once it's finished, and everyone on the team has had a chance to read it and make changes, you should print a copy for everyone and keep the original in a safe place where it will not be altered unless the necessary parties agree. If you leave the document on a server where everyone can access it, team members may decide to alter it as they would like, which would ultimately defeat the entire purpose.

GAME PROPOSALS

The game proposal is a much more formal document than the design document. It will be used to approach a publisher for possible funding for a project. If you are planning to develop the project with your own money, a game proposal is probably unnecessary.

A game proposal takes the design document to another level. It involves several issues that should not be included in a design document. After the design document has been thoroughly digested by the lead programmers or the senior members of the team, it should be included with the game proposal. Additional information should be included such as technical specifications, marketing, financial, and legal. I'm not going to break these down into great details, but the major sections are included. For a quick overview, you can refer to Figure 5.8.

Basic Parts of Game Proposal

FIGURE 5.8 Basic parts of a game proposal.

GAME MARKET

The game market is a good place to begin. You can determine a market simply by looking at titles that are similar to the one you are developing. By looking at sales figures, you can determine what size of market a particular style or genre has and your potential for sales. An excellent source of game market data can be had at *www.pcdata.com*. You can search information on PC sales, Mac sales, and even home education sales. An example of the data available at PCData can be seen in Figure 5.9. If you are planning a game to run on multiple platforms, you should try to break down this information among them.

Top Sellers

January 2001
Top Selling Personal Productivity Software

1. TurboTax Deluxe
 Intuit
2. TurboTax
 Intuit
3. Taxcut 2000 Deluxe
 Block Financial
4. Taxcut 2000
 Block Financial
5. Quicken
 Intuit
6. Quicken Deluxe
 Intuit
7. Microsoft Money
 Microsoft
8. Turbo Tax State CA
 Intuit
9. TurboTax Home & Business
 Intuit
10. Taxcut 2000 All State
 Block Financial

Weekly	More Lists

FIGURE 5.9 Example from PCData showing market sales for February 2001.

TECHNICAL INFORMATION AND ASSOCIATED RISKS

The most important things that should be listed in this area include the teams' experience in developing a game similar to the one you are working

on. For instance, if the lead programmer has developed 3D engines in the past, you should mention that the 3D engine would be similar to the one he created before. On the other hand, if this is your first 3D engine, you should convey this as well. If you are using third-party software such as a code library or sound effects, it should be listed.

In any project there are technical risks. You should try to provide the possibility of a workaround if you encounter one. For example, you could purchase a 3D engine from company XYZ if the engine you are working on does not pan out.

REQUIRED RESOURCES AND SCHEDULING

The final area that you should be sure to include is the required resources and scheduling information. The schedule should include an estimate as to the completion of a final project, along with specific steps that are reached along the way, such as an alpha or beta product. The required resources should include all financial related estimates such as the cost of employees, hardware, and software.

CHAPTER REVIEW

Although we have gone over this process in some detail, we are really only scratching the surface. There are entire volumes of books written on much of the information we have briefly looked at. That being said, with the material from this chapter, you shouldn't have a problem creating a functional design document for yourself or a team. Be careful not to get offended if someone suggests that you change or alter something in the document. The input from others is important to the process, and the information you receive is usually invaluable. It's important to look at the creation of this document as an inexact science.

ON THE CD

Feel free to alter the layout of the document as you deem necessary for any projects you are working on. You should definitely look over the sample document located in the Project folder of the CD-ROM to get a better feel for the process.

6

WHAT PROGRAMMING LANGUAGE OR TOOLS SHOULD YOU USE?

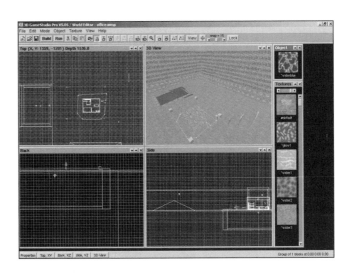

In this chapter, we are going to look at several development tools. Although this book is based on the premise of game creation without programming, you may eventually wish to look into the development side of things. Additionally, it will allow you to appreciate the types of games you can create and, more importantly, the tools that will allow you to create the games without writing a single line of code.

OVERVIEW

While many issues are debated in game development, the ones that get the most attention and are the most heated are those related to the choice of programming languages and tools. Game programming is certainly not immune to the argument, and depending on who you are talking to at any given time, you will receive a completely different answer to the same question. Therefore, rather than try to direct you to a specific language or development environment, we'll look at several, discuss their strengths and weaknesses, and let you decide which language is best for you. This book is slanted toward game creation without programming; that being said, this chapter takes a well-rounded approach to the topic by looking at some traditional programming languages and some game creation tools.

One of the most important things to remember is that a good game design can often overcome a slower language and bad programming practices. This is not to say that the tool you choose isn't important, it is obviously the largest focal point of any project. It's just to serve as a reminder that nothing in game development, including programming languages and environments, is as important as becoming comfortable with any tools you choose.

Assembly

Assembly was the first computer language and is a representation of the actual instructions a computer processor runs. It has a very bad reputation that is hard to overcome. Many programmers feel that there aren't enough benefits in using a language such as assembly. This line of thinking is becoming more prevalent as the speed and storage capacity of computers continue to rise at a seemingly exponential pace.

The most often heard complaint about assembly language is that it is hard to learn. While this is true, it is probably not tremendously more difficult than any other programming language you are learning. As a whole, learning assembly is probably not much more difficult than learning any other programming language, especially when you consider that most programs are not based on assembly alone.

Historically, many games have used assembly in places where it could benefit the most. For instance, most 3D engines have been written in C or C++, but many of them have a few bits of code that were coded in assembly to improve performance. Most often, these routines are used for displaying information to the screen and are called thousands of times in the execution of a program.

Advantages

A programmer who is well versed in assembly can be a huge asset to a programming team. While most will use other languages such as C to do some of their programming, they will use the speed of assembly in the routines that need it. Thousands of games have used assembly to optimize their performance.

Disadvantages

It is not portable in any way because it is designed for a single processor. It has been given such a bad name in programming circles that many are afraid of attempting to learn it. It also takes a little longer to program a sequence in assembly than in any of the high-level languages.

Additional Information

If you are planning to write for a specific platform, you should check out the Web sites of the hardware manufacturers for that particular platform. For instance, for X86 machines, you should check out Intel and AMD, the two biggest producers of processors for PCs.

C

Dennis Ritchie created C in the 1970s. Its original purpose was for writing system-level programs such as operating systems, but at the same time, it was intended to be a language that anyone could use and learn. Before its introduction, operating systems were coded in assembly language, a very arduous task even under the best of circumstances. Because of its initial purposes, it interfaces well with assembly language, which, as we mentioned in the previous section, can be an advantage when you are trying to squeeze everything you can out of a system.

Advantages

C is at its best when writing small and very fast programs. As was previously mentioned, it can be interfaced with assembly languages very easily.

It is also very standardized, so platform changes are not nearly as noticeable in C when comparing it to other languages. Many aspects of the language are platform independent, although you are generally required to write user interfaces for every platform you intend to use. It's not too difficult a process, which makes C a popular choice for multiple platforms.

Disadvantages

The syntax of the C language takes some time to get used to and might not be the best choice for beginning programmers. It does not lend itself to object-oriented techniques, which can be problematic for individuals who are used to object-oriented programming (OOP).

Additional Information

There are so many books and so much documentation available for the C language that it could conceivably take an entire chapter to simply list them. With that in mind, you can look in discussion groups or online bookstores such as Barnes and Noble (*www.bn.com*) to look at the most popular of the many books.

C++

C++ is an object-oriented successor to C. If you are unfamiliar with the concept of OOP, it simply means that the programs are built out of objects. Theoretically, using this type of programming allows you to create an application with libraries designed by yourself or others, piecing them together as needed. There are countless libraries available for C++, covering everything from sound to graphics and databases. It's often a much easier solution for programming, but many game developers do not embrace C++ because it often adds overhead to a game, which slows it down. Obviously, this is not what most game programmers are looking for.

As was previously mentioned, the advocates of a particular language or environment are very quick to point out the weaknesses in other development environments. The C versus C++ argument is probably going on right now in a discussion group or online chat room. You usually will find individuals who are on one side or the other, although you will occasionally find someone who likes both and understands the strengths and weaknesses of each. The independent members of the discussions usually will point out that C++ is much easier to use and that the extra overhead associated with it is more than worth it.

A smaller problem within this much larger one is that many individuals try to decide which language they should learn first, C or C++. Again, this is not easy to determine. Although C is probably easier for a beginning programmer to learn, you will not learn object-oriented approaches and will therefore be required to relearn a new way of programming if you want to use most of the newer programming languages.

Advantages

With its object-oriented approach, C++ is much easier to use, and some people like the enormous number of libraries that are available. It is probably easier to manage programs in C++ than in C, too, especially when they can become extremely large and complicated, as games tend to do. It's slightly more portable than C, and the vast majority of commercial games is probably written in C or C++. Also, tremendous IDEs for C++ exist, such as Visual C++ (seen in Figure 6.1) and C++ Builder.

FIGURE 6.1 The Visual C++ IDE is an advantage for developers.

Disadvantages

Depending on the situation, C++ may be slower than its C counterpart. It can also take some time to get used to if you are unfamiliar with structured programming.

Additional Information

Like C, there are too many resources to limit this to only a list. Check the listings at any online bookseller's Web site to determine which books are best for the version of C++ you are using. There are also many good programming classes at your local community college that might be helpful to a new programmer.

Visual Basic

Basic has been around for some time now, although Microsoft has clearly captured the market with one of the most popular languages for development of business applications. It is the most widely used language in the world because often it is easier for beginners to learn and use. One of the problems with Visual Basic has been its lack of support for heavy-duty multimedia work, although this problem has quickly disappeared with many third-party 3D engines and tools written exclusively for the VB programmer. Also, DirectX has had support for VB since Version 7.

Visual Basic's strength lies in its ease of use. It is nearly impossible to write an application in C or C++ and do it as quickly as you can in VB. Most of its users are corporate programmers developing databases with VB on a daily basis. However, because it is the most popular language in the world, it was only a matter of time before support was available for multimedia and games. During the past several years, third parties have released countless ActiveX controls and add-ons that allow VB programmers to take advantage of DirectX and OpenGL. The controls allow VB programmers to do things they had only wished for. Now that Microsoft is supporting VB with DirectX, the language is becoming more popular for game programmers, and with the impending .NET release, it appears VB is poised to become a serious contender for game developers.

Advantages

It is the most popular language in the world and has a tremendous user base and support system. The VB IDE, which can be seen in Figure 6.2, is excellent, and even a novice programmer can pick it up and use it rather easily. Visual Basic can use DirectX, which enables it to compete with historically more popular game programming languages such as C and C++. Over the next few years, we are certain to see more commercial games written entirely in Visual Basic.

Disadvantages

The biggest disadvantage for VB is that it is a proprietary language. That is, a program developed in VB can run only on the Windows platform.

FIGURE 6.2 The VB IDE is easy for beginners to pick up.

That being said, many games are written only for Windows anyway because it is by far the most popular operating system on computers today. Additionally, the .NET framework may change all of this.

Additional Information

There are countless user groups and training materials for Visual Basic, and like C and C++ it would be impossible to list even a fraction of them. Most colleges offer low cost courses in Visual Basic. For beginning programmers, you can check out the book *Learning Visual Basic with Applications*. It's a shameless plug, but it is a good beginner and intermediate programmers' book, with complete instructions on building many types of applications, ranging from games to an MP3 player to a paint program.

OTHER CHOICES

While the previously mentioned programming languages seem to offer the most, there are a few additional choices when it comes to game programming. They range from programs very similar to Visual Basic to others that are designed specifically for game programming.

Delphi

Delphi is very similar to Visual Basic in that its ease of use and IDE are its most important features. Like VB, Delphi has had tremendous support from the large user base, including complete 3D engines and third-party controls for accessing DirectX. We'll not get into the VB versus Delphi argument in this book because it is very heated, with programmers from both sides of the fence defending their favorite environment.

Delphi has been a Windows-only product, although a recently released program called Kylix is essentially Delphi for Linux. This could be a big plus for those out there looking for an easy way to develop applications for Linux. There are several books available for Delphi as it relates to game programming, along with several user groups and message boards on the Internet.

Java

Java is a portable language developed by Sun to compete with C++. It has borrowed many aspects of the C++ language, although it seems to be a little easier for beginning programmers to learn. The programs you develop can be platform independent, and most can run embedded in Web pages. The language became popular seemingly overnight, with thousands of developers rushing to learn the new offering. There are thousands of Web sites, newsgroups, and message boards for Java programmers. Add to this the large numbers of books and learning resources, and you have a relatively easy to learn language with a tremendous number of resources.

Similar to Visual Basic, Java uses a runtime engine called a *virtual machine* to execute Java programs. This makes applications slower than truly compiled programs, but new technologies like *just-in-time compilers* have greatly enhanced the speed at which Java programs execute. It is very portable, but user interface elements often have to be rewritten to work on different platforms. There are not many commercial games written in Java, but this will probably change in the future as many developers become better acquainted with the language and speed improvements continue to unfold.

Macromedia Director

Authoring tools such as Macromedia Director have long been used for the development of games. Many current and past commercial games have been developed using these types of programs. Director, which is arguably the leading development tool in this area, has several strong features that make it a possibility for the right type of game project. First, it is cross-platform capable, which is a big factor for certain projects. There are also many *Xtras* (a term for Director add-in controls) available that increase the productivity of Director applications.

The newest release of Director (version MX 2004 at the time of writing) continues to enhance this already popular program. It includes a complete 3D engine courtesy of Intel's Internet 3D graphics software, which offers adaptive geometry and rendering. The algorithms of the software rendering engine enable 3D content to scale to the user's machine. It includes support for DirectX and OpenGL hardware acceleration. Of particular interest to game developers is a third-party Xtra that will enhance the capabilities of the 3D engine with the addition of Havok's real-time interactive physics.

Director uses a language called *Lingo* to add custom programming to a project. Because of the popularity it has managed to gain throughout the years, there are many third-party books and training resources for Director, making it a possibility for certain types of projects.

3D Game Studio

Another authoring system, 3D Game Studio, offers the capability to create 2D and 3D computer games. As its name implies, it was designed first and foremost as a game development environment, a point that is very important because it has been optimized for the development of games. It includes several modeling and level-building tools, which can be seen in Figure 6.3. 3D Game Studio uses a JavaScript-style programming language with an integrated 3D engine and a 2D engine. It also includes a Visual C++ interface, along with a map and model editor. 3D Game Studio has a nice mix of features if you are a beginner or an experienced game programmer.

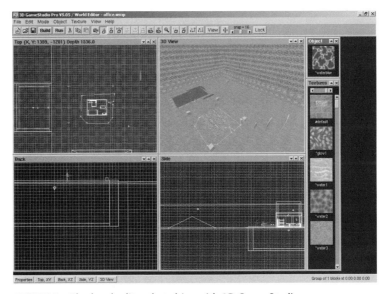

FIGURE 6.3 The level editor that ships with 3D Game Studio.

3D RAD

3D RAD is perhaps the easiest to use authoring tool of any mentioned here, although it is probably not the best choice for commercial-quality games. It offers several interesting features, including prebuilt objects that can be used in a program without the need to alter them. For example, you can place one of the 3D car models into a scene, and the model will already have basic movement capabilities and collision information. Unfortunately, the models are very generic, and the movements are really too simple for a commercial game; in addition, the 3D rendering needs some speed and quality improvements. This is a program that is best suited for a beginner, and if a few items are changed, it could offer a complete solution for 3D games.

CHAPTER REVIEW

Now that we've looked at the many languages and several authoring tools, you are probably wanting an answer to "which language or tool should I use?" Unfortunately, there is not a single solution that will work in every instance.

Assembly is by far the fastest language available, but it is probably not a good solution for a complete game. C and C++ are the most common languages used by game programmers, although they may not be the best choice for beginners. Visual Basic is definitely making headway as a game development solution, but it is currently limited to the Windows OS. Lastly, there are several authoring tools, Java and Delphi, that you can consider, each with its own strengths and weaknesses.

With all of this information in mind, you are probably in a better position to determine the language or authoring tool that will best suit your needs. For example, C++ might be a great choice for a heavily used multi-user 3D game but is probably not the best choice for a card game like Poker. Therefore, it's often easiest to determine which language best fits into the type of game you are working on rather than the other way around.

INTRODUCTION TO MULTIMEDIA FUSION

In this chapter, we are going to turn our attention to our first game-making application, called Multimedia™ Fusion™. This development tool is mostly used for 2D games, but because it is the most well-rounded game development tool available in the non-programming category, it's a perfect way to start out. With it, you can create a wide variety of games, and the support from Clickteam (*www.clickteam.com*) is top notch.

INSTALLATION

Before we can use Multimedia Fusion, we must first install it. The installation process begins by double-clicking the file called MMFDemo.exe, located on the CD-ROM in the Applications folder. When you double-click the file, it will begin the process of extracting the installation files, and a screen similar to Figure 7.1 will be displayed.

FIGURE 7.1 The opening screen for extracting the files.

Click the Next button on the first screen; this brings us to the second window (see Figure 7.2) of our installation. This screen will display a quick overview of the installation process we are now going through. Click the Next button again, which displays a window that allows us to choose the extraction location. This will be a temporary location to which the setup files will be extracted. You can leave this at its default (seen in Figure 7.3) unless you are low on hard disk space or have another reason for wanting to change to another drive or folder.

FIGURE 7.2 An overview of the installation process is displayed.

After you have decided on the extraction folder, click Next to display the next step for the extraction (see Figure 7.4). This screen allows you to verify the location that will be used for storing the files. You can verify this and then click Next, which will start extracting the files as seen in Figure 7.5.

FIGURE 7.3 The default extraction folder is displayed.

FIGURE 7.4 Verify the location before clicking Next.

FIGURE 7.5 The files are being extracted.

The final step in the extraction will be to click Exit on the last window that is displayed (see Figure 7.6), but before doing so, make sure that Launch the Install Program is selected.

FIGURE 7.6 The last step in our extraction is complete.

Immediately after you click Exit, the window seen in Figure 7.7 is displayed, and you are ready to start the installation process. The first window doesn't really offer much in the way of information, but it does confirm that we are in the actual installation program.

FIGURE 7.7 The first step in the installation.

The next step is the license agreement for Multimedia Fusion, a part of which can be seen in the Figure 7.8. You should read through the agreement and click on Accept when you are satisfied with it. When you click Accept, you will move to the next step of the installation process. This window, seen in Figure 7.9, allows you to enter your user information. After filling out the form, click the Next button. This displays Figure 7.10, which allows you to verify your user information. After verifying your information, you can click the Next button.

The next step in the installation is to choose the type of install you wish to perform. In Figure 7.11, you can see the Typical and Custom options. The Typical install is the easier of the two options and is the one we'll select, after which we'll click the Next button.

FIGURE 7.8 A license agreement is displayed.

FIGURE 7.9 Your user information can be entered.

FIGURE 7.10 Verify the information you entered.

FIGURE 7.11 Typical and Custom options are available.

Our next window, seen in Figure 7.12, allows us to choose a destination folder. You can choose any location you like, but we'll assume that it is installed in the default location.

FIGURE 7.12 The destination folder can be changed.

After choosing a new location or leaving it to be installed to the default location, you can click the Next button, which will allow us to choose the shortcut folder, which can be seen in Figure 7.13. Leave it as is and then click Next to display the final options window for our install (see Figure 7.14). This window allows you to verify your selections, and you can click Install after you have done so.

The files will begin copying, which can be seen in Figure 7.15. Once all files are copied, you will see a window like that in Figure 7.16. This window may be displayed for some time while the installation process finishes, and another window is displayed, which can be seen in Figure 7.17. You can click OK to end the installation; this requires a reboot of the computer to finish (see Figure 7.18).

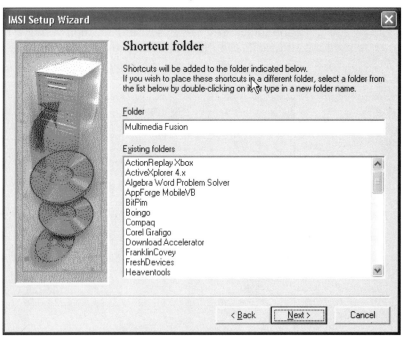

FIGURE 7.13 The shortcut folder can be changed.

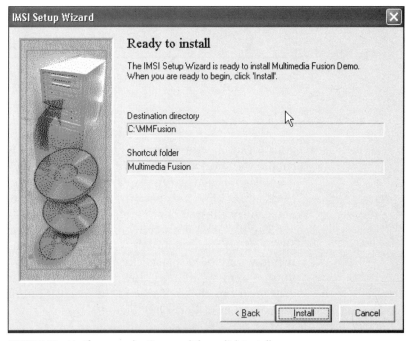

FIGURE 7.14 Verify your selections and then click Install.

FIGURE 7.15 Files are being copied.

FIGURE 7.16 The installation is nearly finished.

FIGURE 7.17 Our install is complete.

FIGURE 7.18 The computer needs to be rebooted.

CHAPTER REVIEW

In this chapter, we looked at Multimedia Fusion and went over the installation. In the next chapter, we are going to look at Multimedia Fusion in more detail. We'll cover the editors that make up Multimedia Fusion before moving on to creating our first MMF game.

8

MULTIMEDIA FUSION
EDITORS

In the next few chapters, we are going to build our first game step by step. Once you have been led through the process of making a mock 3D game, you have the basis you need to go further into game development. Much of what you learn here will apply to more complex games and tools later on. You will find it easier to pick up new software and tools and learn them after having learned one application.

We'll begin this chapter by getting to know Multimedia Fusion, or MMF, as it is commonly called. Once you are comfortable with MMF, you will be able to use it to produce games and interactive applications with ease. MMF is a very powerful 2D/3D game-creation package. It contains state-of-the-art animation tools, sound tools, multimedia functions, and fabulous game structuring routines that make it very easy to produce your own games with no programming.

QUICK GUIDE TO MMF

MMF is built around three main editing screens that allow you to control the main aspects of your game. The Storyboard Editor is the screen that allows you to decide the order of the levels in the game. The Level Editor allows you to decide which characters, backgrounds, and objects to put in your level and how to animate them. The Event Editor allows you to assign the actions and responses that will make your game come alive.

Let's start MMF and take a look at some of those windows. When you first open MMF from the shortcuts that were created during the installation, a window will appear, reminding you that it is the demo version (see Figure 8.1). You can click Continue after reading through this information. The main interface of MMF now appears, and a Tip of the Day window is usually visible, an example of which can be seen in Figure 8.2. Reading through these tips can offer some insight into various aspects of MMF development.

FIGURE 8.1 Demo information is displayed on startup.

FIGURE 8.2 Tip of the Day window.

You can close the Tip of the Day to display the interface of MMF (see Figure 8.3). As you can see along the left side of the window, a smaller window is visible, which is called the Multimedia Fusion Library window. You can close this window by clicking the small X at its upper right. We will prefer to open this window if needed rather than allowing it to consume so much free space all the time. Figure 8.4 represents the much larger space that we now have to work with.

FIGURE 8.3 The main interface.

FIGURE 8.4 We have gained a considerable amount of space by closing the window.

Click New from the File menu (see Figure 8.5) to begin creating your first application. You will be presented with a window, which appears in Figure 8.6 and allows you to choose what you are creating. From this window, you can choose Application and then click OK.

FIGURE 8.5 Creating a new application.

FIGURE 8.6 Choose Application from this window.

Our MMF interface has now changed dramatically. If you refer to Figure 8.7, you can see two new windows that are at our disposal. On the left is the Project Explorer, which provides an easy way to navigate through the application. On the right is the Storyboard Editor, which displays a visual overview of the application in the form of a thumbnail and also allows you to quickly access every frame a game uses. Let's take a more in-depth look at these and all the editors we are going to use. The following descriptions should give you a better understanding of the editor screens, and you can refer to the help file included with MMF if you would like additional information.

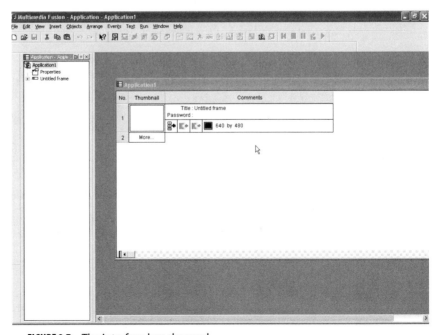

FIGURE 8.7 The interface has changed.

Storyboard Editor

Most games are composed of several different levels, and this screen allows you to add levels to your game, copy levels, and change the order of the levels by moving them around. This is also where you decide on the size of your playing area, add and edit professional-looking fades to each level, and assign passwords to enter each level (see Figure 8.8).

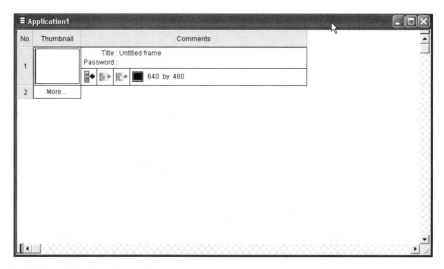

FIGURE 8.8 The Storyboard Editor.

Frame Editor

The Frame Editor (see Figure 8.9) is the initial "blank page" for each of your levels. It displays your play area and is where you put background objects and the main characters of your game. You generally access this screen from the Storyboard Editor screen.

This is also where you can create your own animated objects, text, and other object types. Basically, all the objects that you want to play with have to be placed on this screen first before you can start manipulating them. It is also here that you change the animation and movement of objects and change the basic setup of all your objects. You will frequently find that, before you can manipulate an object from the Event Editor, you must make sure it is set up correctly on this screen.

Event Editor

This is where your game will really come to life. The actions you assign here are called *interactivity*. Once you become experienced with MMF,

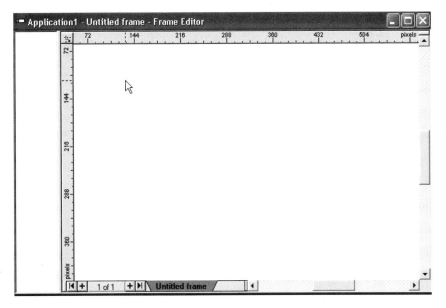

FIGURE 8.9 The Frame Editor.

you will find that this editor is where you will spend most of your time. It is here that you decide all the events in your game.

The Event Editor (see Figure 8.10) is set up like a spreadsheet, where you can assign relationships to each object in your game. This setup

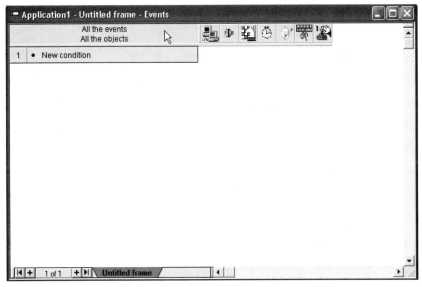

FIGURE 8.10 The Event Editor.

makes game-building easier because you can visually see what happens in your game. Examples of the gameplay you can build are aliens colliding with a spaceship; the main character collecting a power-up or getting hit by a missile; setting a time limit; or assigning a sound event. You can create an explosion, destroy an object, add to the score, subtract a life, or even add complicated events such as changing the direction of a character or randomly moving object.

That was the quick tour of MMF. We saw that a game is built in MMF in three stages: First you lay out the flow of your game in the Storyboard Editor, then you lay out your level and its objects in the Frame Editor, and finally you use the Event Editor to assign relationships and behaviors to your objects.

CHAPTER REVIEW

In this chapter, we started an application in MMF and looked more closely at the various editors we'll use for our games. In the next chapter, we'll continue work with MMF and will begin constructing our first game.

9

OUR FIRST GAME IN MMF

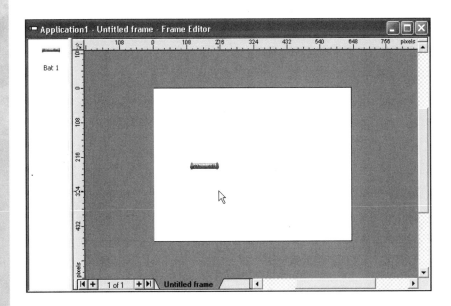

Now that we have a foundation in MMF, we can move on to building our first game. This project will be the easiest in the book because we'll try to cover a variety of topics that we can use again in later projects.

LET'S GET STARTED

The first step in our project is to open MMF. Once it is open, from the File menu choose New. This will open a window that allows us to create a new game. Choose Application from the window and click OK. You now see many of the editors that we spent time looking at in the last chapter.

A frame and a level are the same concept in MMF and are used interchangeably. Most often, a level refers to the gameplay aspect, whereas a frame refers to the game design.

The numbers along the left of the Storyboard Editor indicate the various levels that are available in our game. At this time, we have only a single level, which is created automatically. We can open this by clicking on the number 1. This will open the Frame Editor for our first level. You can see this in Figure 9.1.

FIGURE 9.1 The Frame Editor is opened.

At this time, we have a blank level, so we need to begin adding the pieces that will make up the game. From the Insert menu, choose Object from Library (see Figure 9.2). This will display a window like that seen in Figure 9.3.

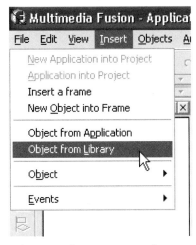

FIGURE 9.2 The Insert menu allows us to insert objects.

FIGURE 9.3 Insert an existing object is displayed

As you can see in Figure 9.3, there is a + symbol next to the Multimedia Fusion Library folder. You can click the + symbol to open the folder. This will display a new series of folders. Continue to click the symbols until you see the Game folder displayed. Open this folder in the same manner and find the item called bat1. Single-click this item and then click

inside the frame, which has been empty up to this point. You should now see the item in the frame (see Figure 9.4 for an example).

FIGURE 9.4 The bat is now visible in the frame.

You can now zoom out so that you can see the entire frame. Choose Zoom Out from the View menu. Continue to zoom out on the frame until you can see the entire frame within the Frame Editor, similar to Figure 9.5.

FIGURE 9.5 Your frame should now look like this.

The reason we wanted to see the entire frame was so that we could place items within the frame as needed. We can position the bat by clicking it and dragging it so that it is similar to Figure 9.6.

FIGURE 9.6 Position the bat using this figure as a reference.

The next two steps are to insert additional objects, repeating the same steps as before. You can use any of the game objects for the ball and the bricks. Figures 9.7 and 9.8 display the Ball 1 and Brick 1 objects in their respective positions.

You can save your project at this time. It is called Chapter 9 and is located in the Project folder on the CD-ROM that accompanies this book, but feel free to save it with this or any name you would prefer by using the Save command from the File menu.

Although MMF is very stable, it is a good habit to save your work often when developing games. We have done this as a reminder, and you should continue doing so as you work through the examples in the book.

A single brick doesn't really make for an exciting game. In fact, one collision between the brick and ball would most likely end the game. With that in mind, we're going to duplicate the brick so that all the original brick's properties will be given to the duplicates. We can then handle the collisions as if we had added a single item to our project. First, position the brick in the upper left, as in Figure 9.9.

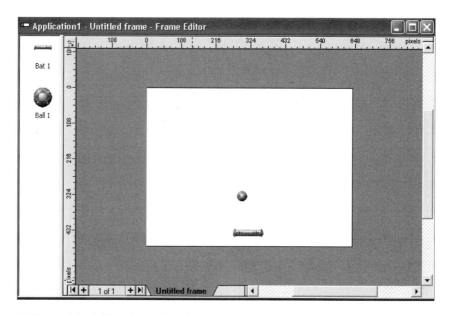

FIGURE 9.7 The ball has been placed.

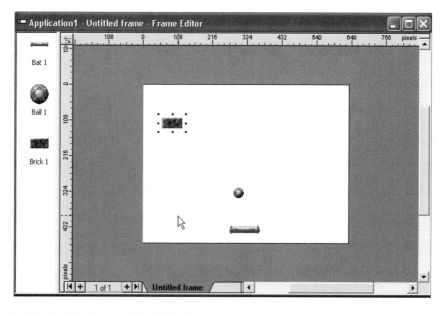

FIGURE 9.8 We also need a brick to destroy.

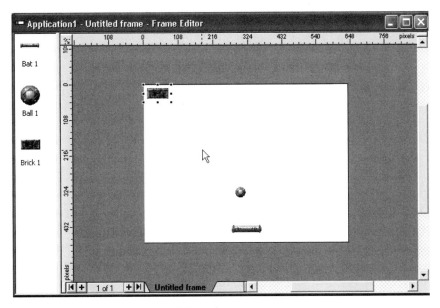

FIGURE 9.9 The brick in the upper left.

Our next step is to right-click the brick and choose Duplicate from the pop-up menu. This will display the Duplicate Object window, seen in Figure 9.10. This window gives us several things we can select, which are all self-explanatory. You can use the following settings for this project and then click OK when finished:

Rows: 2
Col: 9
Space Row: 5
Space Col: 5

FIGURE 9.10 The Duplicate Object window.

Movement

Our level now looks like Figure 9.11. If we were to run the game at this time, we would be left with a screen of stationary objects. For any type of game project, we'll need to create movement of objects. Let's begin with the ball. Right-click on this object and then choose Properties, New Movement from the pop-up menu (see Figure 9.12).

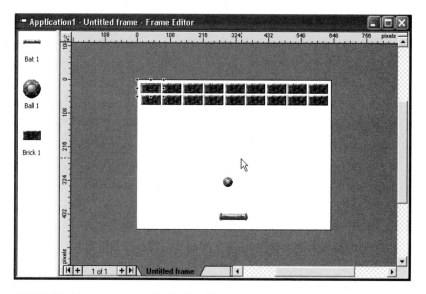

FIGURE 9.11 Your screen now looks like this.

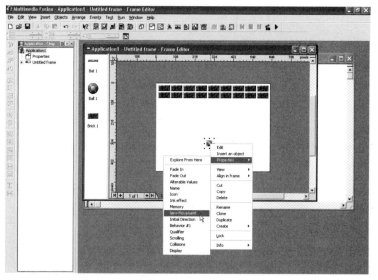

FIGURE 9.12 The first step in creating a new movement.

You should now have the Choose Move window on your screen (see Figure 9.13). As our luck would have it, there is a bouncing ball movement option. Select this option, and although there are a number of options seen in Figure 9.14 called Ball movement setup, you can simply leave these settings with their default values at this time and click the OK button to close it.

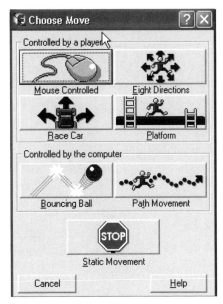

FIGURE 9.13 Choose Move allows us to set up the type of movement for our object.

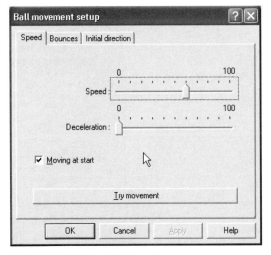

FIGURE 9.14 The Ball movement setup window has specific options for ball movements.

The ball now has movement, but the bat in our object is left without any. Right-click the bat, choose New Movement, and then choose Eight Directions. The Eight directions movement setup screen is now displayed (see Figure 9.15).

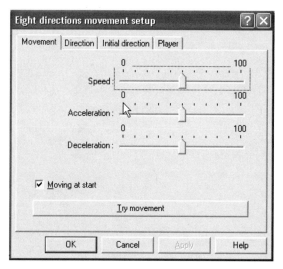

FIGURE 9.15 The Eight directions movement setup screen.

Unlike the ball movement, which was fine with its default settings, we are going to need to change some of the options for this movement. Click the Direction tab, which will change the window so that it looks like Figure 9.16. You can deselect all other movements by clicking on the black squares so that left and right are the only directions selected. Your window now looks like Figure 9.17.

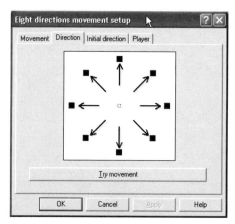

FIGURE 9.16 The Direction tab with default options.

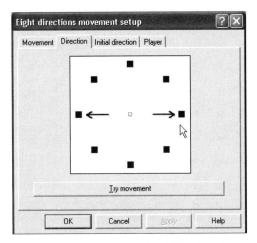

FIGURE 9.17 Left and right should be the only options selected.

The next step is to click the Initial direction tab, which looks very much like the Direction tab we were just looking at. We need to remove all directions and can do so by clicking each of them, or we can click the button at the lower right to deselect all of them simultaneously (see Figure 9.18). Click the OK button to close the settings.

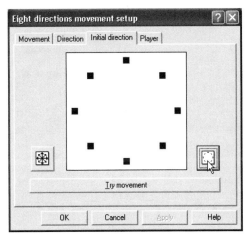

FIGURE 9.18 Deselect all directions.

Events

We now have a game that contains objects, and their movements have been set, but nothing will happen when the objects collide with one another. This would obviously limit any type of fun we would have with this game. To set this up, we are going to need to open the Event Editor. There are several ways to open the editor. First, you can click on its icon (see Figure 9.19). You can also open the Event Editor from the View menu. Lastly, you can use the shortcut combination of Ctrl+E to open it. Whichever method you prefer is fine.

FIGURE 9.19 The icon is one way to open the editor.

Once the window is open, double-click New Condition, which displays the New Condition window (see Figure 9.20).

FIGURE 9.20 The New Condition window.

Double-click the ball icon in the window. This will display the pop-up menu displayed in Figure 9.21. We are setting up the collision that will occur between the brick and the ball, so we need to choose Collisions, Another Object. This will open the Test a collision window seen in Figure 9.22. Choose Brick from the available objects and then click OK. Your Event Editor is now updated with this collision (see Figure 9.23).

FIGURE 9.21 The pop-up menu as displayed.

FIGURE 9.22 The test a collision window.

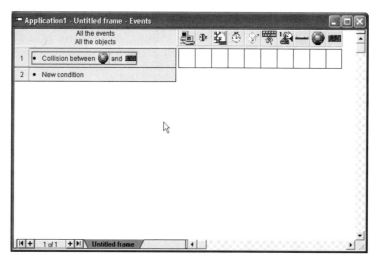

FIGURE 9.23 The event has been created.

Now we have a collision event that will be executed every time a ball and a brick collide. When the objects collide during the game, the Event Editor will cause an action to occur, but we have yet to create the exact action we would like to have. At this time, we are going to right-click on the square beneath the column in which the brick is displayed (see Figure 9.24). You can choose Destroy from the pop-up menu. A check mark is now visible in the Event Editor at the intersection point of the action and the brick column, like the one seen in Figure 9.25.

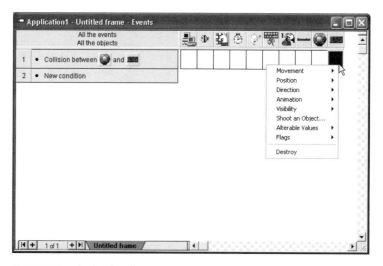

FIGURE 9.24 The brick column.

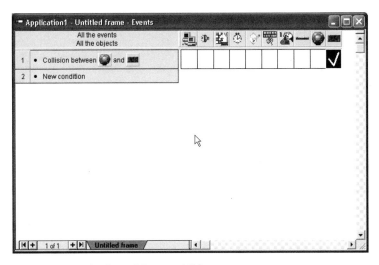

FIGURE 9.25 A check mark is now visible.

Now the brick is going to be destroyed when a ball collides with it, but if the ball collides with the bat, it will simply continue through it. We need to make it bounce during such a collision. We can create the event the same way we did for the brick and ball, but this time, we need to substitute the bat (see Figure 9.26).

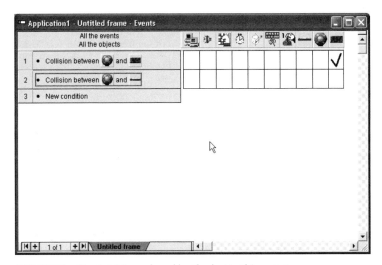

FIGURE 9.26 The brick is replaced by the bat in this event.

We have the event, and now need to create the action. As already mentioned, we would like the ball to bounce with this collision, so we don't want either the ball or the bat to be destroyed with this collision. Right-click the square beneath the ball and then choose Movement, Bounce (see Figure 9.27).

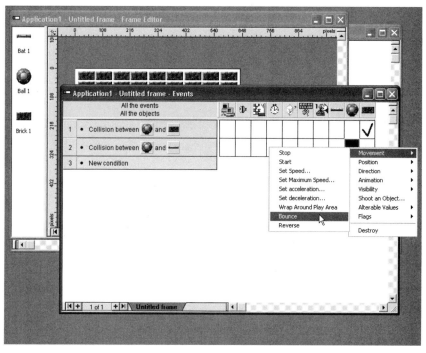

FIGURE 9.27 The ball will now bounce.

We now have the ball moving and colliding with the objects on the screen, but if the ball reaches any of the screen borders, it will continue to move into empty space. We will create an event to handle this as well. First, double-click New Condition and then double-click Ball. Choose Position, Test position of "Ball 1," which can be seen in Figure 9.28. The Test position of "Ball 1" window is displayed (see Figure 9.29). Click on the arrows inside the square for left, right, and up but not down and click OK. The reason for this is simple. If the ball tries to leave in the left, right, or up direction, we need to have the ball bounce. If it leaves the bottom, we need an entirely different approach. The new entry in the Event Editor is seen as the ball leaves the play area on the top, left, or right (see Figure 9.30). Right-click the column beneath the ball and choose Movement, Bounce.

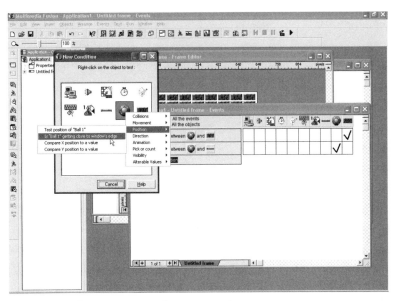

FIGURE 9.28 The pop-up menu has many options.

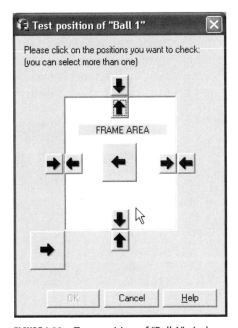

FIGURE 9.29 Test position of "Ball 1" window.

The last event in this chapter again deals with the ball and testing its position, but this time, we need to create the event with the ball leaving

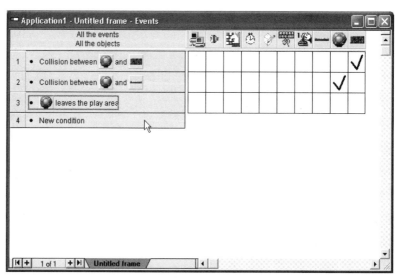

FIGURE 9.30 The new entry in the Event Editor.

the bottom position. After we create the event, right-click on the chessboard square and choose End the Application. Save the game and then choose Play to try out the application. Depending on your screen resolution, you may not see much of the action. Instead, choose Run, Application or hit F8 to see the running game (see Figure 9.31). Because this is a demo version, you may also see a notice such as that in Figure 9.32. If you get this window, click Continue to display the game.

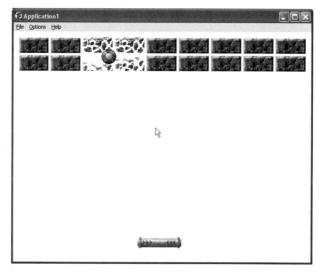

FIGURE 9.31 The game is running.

FIGURE 9.32 Because we are using a demo version, you may see this screen.

CHAPTER REVIEW

We have a functional game at this time, but it lacks several things. In fact, if you play the game, you'll quickly see that there are several things that we have left to do in order to create a more playable game. In the next chapter, we'll continue working on this game by adding music, sound effects, player lives, scoring, and so on.

10

FINISHING TOUCHES FOR OUR FIRST GAME

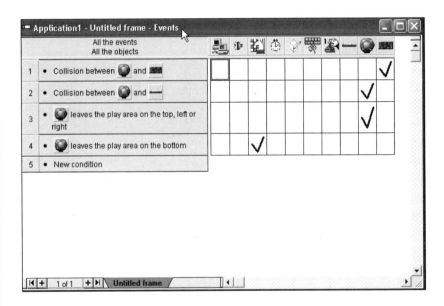

In the previous chapter, we started the development of a game. If you want to play the game at this time, there are several things we have left to do. In this chapter, we'll continue working on this and add music, sound effects, player lives, scoring, and so on.

CONTINUING THE PROJECT

If you have not already done so, you should open the game from Chapter 9, "Our First Game in MMF." Next, open the Event Editor (see Figure 10.1) and click on New Condition to open the New Condition window, seen in Figure 10.2.

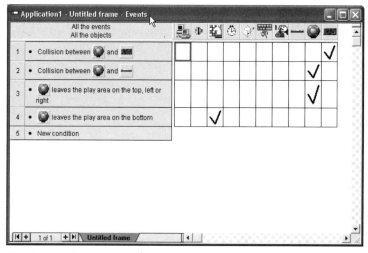

FIGURE 10.1 The Event Editor in MMF.

The New Condition window has several items within its boundaries. We need to double-click (or right-click) the icon that looks like a chessboard to display a menu like the one seen in Figure 10.3.

In this case, the menu being displayed has items in it related to the frame, such as its beginning and ending. We are going to set the number of lives for our game and begin playing some music, so we'll use Start of Frame. Choose it from the list to create the event in the Event Editor (see Figure 10.4).

We can now right-click the square beneath the sound icon and to the right of the new event to display the menu seen in Figure 10.5. Choose Play and Loop Music from the menu. The Play and Loop Music window is displayed (see Figure 10.6). In this window, click the Browse button and

FIGURE 10.2 Creating a new condition.

FIGURE 10.3 A pop-up menu is displayed.

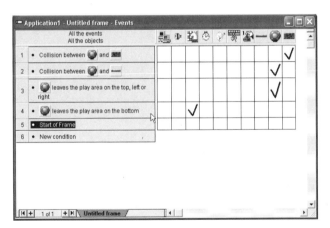

FIGURE 10.4 A Start of Frame event is now shown.

locate the Chapter10.mid file from the CD-ROM that accompanies this book (it is located in the Music and SFX folder). Click OK after you locate it. A new window is now shown, which is also titled Play and Loop Music, but this window has a new set of options (see Figure 10.7). This window allows us to set how many times we want the music to play. As we want it to continue playing constantly throughout the life of the frame, we'll choose 0, which makes it loop infinitely, and then click OK.

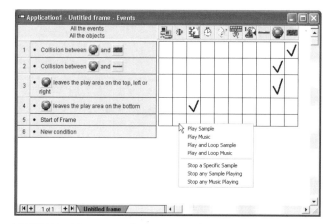

FIGURE 10.5 The menu allows us to pick various options.

FIGURE 10.6 The Play and Loop Music window.

FIGURE 10.7 We set how many times the music loops in this window.

Inside the same Start of Frame event, we'll also set up the number of lives by right-clicking the square to the right of the event and beneath the player 1 object. Choose Set Number of Lives, located in the pop-up menu, an example of which is seen in Figure 10.8. The Add to Number of Lives window (see Figure 10.9) is displayed. Change the value (Val) to 3 and click OK. This gives us an initial value of three lives.

FIGURE 10.8 Choose Set Number of Lives from the pop-up menu.

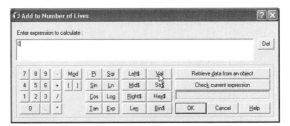

FIGURE 10.9 The Add to Number of Lives window.

Scoring and Sound Effects

We now have three lives and music playing, so we can turn our attention to the scoring and sound effects of the game. The player will add to his score when a collision occurs between the ball and the bricks, which results in the brick being destroyed. We have already created the collision event between the ball and the brick. This event is where we have already set the brick to be destroyed during the collision and the ball to bounce. This event is probably the first event if you've been following

along. Right-click on the player 1 object next to this event and choose Score, Add to Score (see Figure 10.10). A new window (see Figure 10.11) is displayed that allows us to set a score. In this case, a value of 100 is entered, and then we can click OK. Inside the same event, right-click on the icon beneath sound and choose Play Sample from the pop-up menu seen in Figure 10.12. Browse to Chapter10.wav, which is in the Music and SFX folder on the CD-ROM that accompanies this book, and click OK. You can create this sound for the collision between the ball and bat objects, but we should not create the scoring aspect.

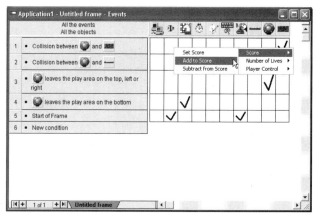

FIGURE 10.10 Adding to the score.

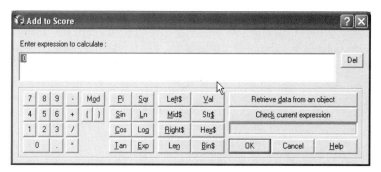

FIGURE 10.11 Increasing our score by 100.

Although we have created an event that deals with the ball leaving at the bottom of the play area, at this time, the application ends. As you know, we have already set up our game to allow for three lives. Therefore, instead of ending the application, we'd like to remove one of the lives. Before decreasing the lives, we need to remove End Application

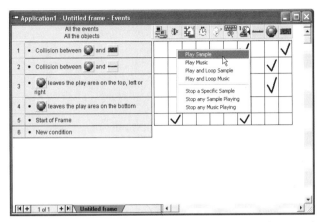

FIGURE 10.12 The pop-up menu allows us to choose Play Sample.

from the event. Right-click the checkbox that is located in the Ball Leaves the Play Area on the Bottom event and then choose Delete from the pop-up menu to remove it from the game.

The event should now be void of any checkboxes. Right-click the box beneath player 1 inside the event to display the pop-up menu seen in Figure 10.13 and choose Number of Lives, Subtract from Number of Lives. A new window is displayed, as seen in Figure 10.14. Set a value of 1, as we'd like to subtract one life every time the ball leaves the window on the bottom, and then click OK.

The lives will now be subtracted, but we still have a problem. We have been ending the application when the ball exited the window, so we were not concerned with the position of the ball after it leaves the

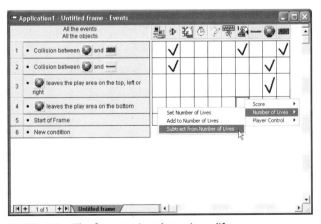

FIGURE 10.13 The first step in subtracting a life.

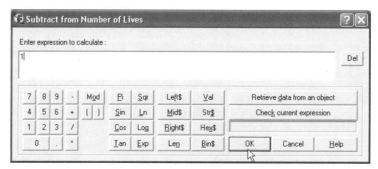

FIGURE 10.14 We can choose the number of lives we would like to subtract.

screen. Now we are removing a life from the player, and if we want to continue to play, we need to reset Position of Ball after losing the life. Beneath the ball (and inside the same event) right-click to display a pop-up menu and choose Position, Select Position. The Select Position window is opened (see Figure 10.15). The default values are 320 and 240, which is in the middle of our screen and is a good location for the ball to be positioned. We can click the OK button to close it.

FIGURE 10.15 The Select Position window.

The ball is now positioned in the middle of the screen, and now we need to set the direction to a random upward direction so that we don't just quickly lose another life. Right-click the square beneath the ball and inside the same event to display a menu from which we can choose Direction, Select Direction. This displays another window, seen in Figure 10.16, which shows us that the ball is traveling to the right by default. We need to click the square in the right direction to remove it and then click the squares going up to match Figure 10.17. Click OK to close the window. The ball will now randomly travel in one of the directions we have selected.

FIGURE 10.16 The ball is traveling to the right by default.

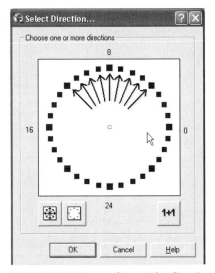

FIGURE 10.17 We need to set the directions.

If you save and then run the game at this time, you cannot see the current score and lives, so we'll add these now. Click on the Frame Editor to open it (or bring it to the front). Right-click an empty area inside the frame and choose Insert an Object (see Figure 10.18). This will display a

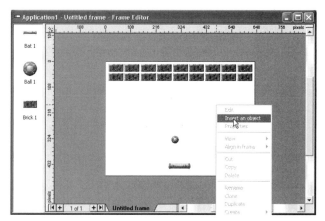

FIGURE 10.18 Choose Insert an object.

window like that in Figure 10.19. Choose Score from the list and click OK. This will change your cursor to a plus symbol. Move to the lower right of the frame (see Figure 10.20) and then click the mouse to position the score. This will open a window like that in Figure 10.21. You can hit the X in the upper right of the window to close it. Figure 10.22 now shows the score on the screen.

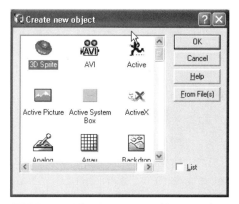

FIGURE 10.19 The Create new object window.

Displaying the lives involves nearly the same process. Right-click an empty area inside the frame and choose Insert Object. Next, choose Lives from the window and click OK. The Lives Setup window is shown (see

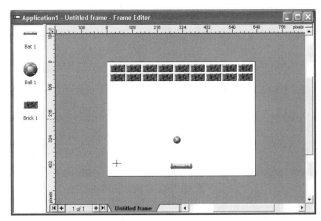

FIGURE 10.20 Position the + in the correct location.

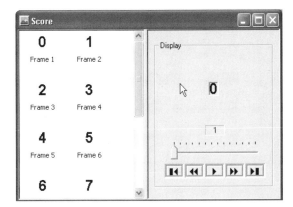

FIGURE 10.21 You can close this window.

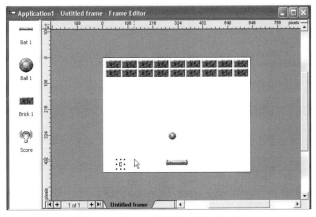

FIGURE 10.22 The score is now displayed in the frame.

Figure 10.23). Choose Picture from the drop-down list and click OK. We'll now position our cursor at the lower right of the frame and left-click to display the lives (see Figure 10.24).

FIGURE 10.23 The Lives Setup window.

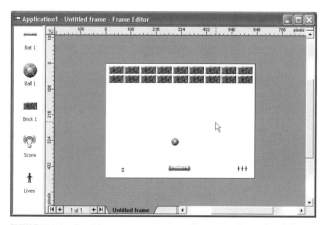

FIGURE 10.24 Position your cursor on the opposite side of the screen.

CHAPTER REVIEW

In this chapter, we continued the project we started in Chapter 9 to create a playable game, which now keeps score, tracks lives, and has music and sound effects. We'll use each of the concepts in games throughout the book. In the next few chapters, we're going to look at the process of creating graphics (2D and 3D), music, and sound effects using several different tools, beginning in the next chapter with ACID.

INTRODUCTION TO MUSIC AND SOUND EFFECTS

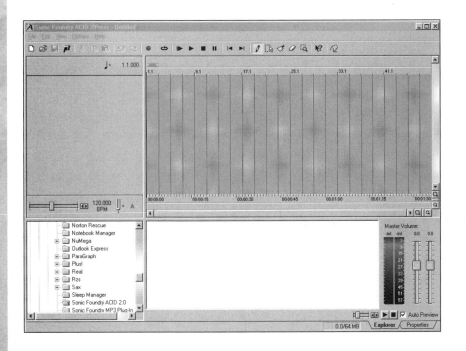

Although a good concept and good graphics for your game are very important components in the game development process, they are not enough in a competitive marketplace. Music and sound effects have very important supporting roles in a completely successful game. Music and sound effects should convey information that helps set up a level without being overwhelming to a player.

In this chapter, you'll be introduced to ACID, which will be used to create the music loops we'll use in our game. Adobe Audition, which will be covered in the next chapter, will be used for recording and editing the sound effects.

INTRODUCTION TO ACID

ACID is perhaps the easiest to use loop-based music-creation tool ever created and can be used in many game development projects. As far as software goes, it is undoubtedly one of the easiest tools to simply pick up and use. Before we begin using the software, we'll look at the installation process and the user interface. Finally, we'll make a simple loop for our project.

During the writing of this book, Sony acquired ACID from Sonic Foundry. Some of the figures may be slightly different from the versions you will find available in any newly released versions from Sony.

INSTALLATION

Before we begin discussing specifics of Sony ACID, we need to install it. You can download a demo of the most up-to-date version available from *http//mediasoftware.sonypictures.com*.

The first step in the installation process is running the executable file. It will begin the installation process, and you will be presented with a screen that looks similar to Figure 11.1. This screen displays the Sony license agreement. To continue the installation, you need to read through the agreement and click on the Yes button.

From the next screen, which can be seen in Figure 11.2, you should just click the Next button.

The next step is to enter your information into the registration screen, which should look something like Figure 11.3. After you enter your information, you should click the Next button to continue.

At the next screen, which appears in Figure 11.4, you can leave the directory as it is listed or change it as you need. After you've decided, click the Next button to continue the installation.

FIGURE 11.1 The installation program begins with this screen.

FIGURE 11.2 Continue the installation by clicking the Next button.

FIGURE 11.3 Registration information that will be used by ACID.

FIGURE 11.4 Click Next after changing the installation directory.

In the screen that can be seen in Figure 11.5, you should click the Next button. When you have clicked the Next button, the files will begin to be copied, and a window that looks like Figure 11.6 will be displayed.

FIGURE 11.5 Your Ready to Install window should look similar to this.

FIGURE 11.6 A window similar to this will be displayed when the files are copied to the installation directory.

When the files have finished copying, you will be presented with a window similar to Figure 11.7.

FIGURE 11.7 The final step in the installation process.

If you click the Finish button, the installation program will close, and ACID will open. The first screen that you will see will be a serial number entry screen similar to Figure 11.8. If you have a serial number, you can enter it now. Otherwise, you should simply click the Next button.

If you did not have a serial number in the previous step, you will be presented with a window similar to Figure 11.9. From this window, select the option I Would Like to Use ACID XPress. This will give you an unlimited use version of ACID without all the features of the full version. Unfortunately, the XPress version limits the types of files you can export, so we'll be forced to deal with this limitation. If you have a serial number, you should follow the instructions as they are given.

Click on the Finish button to run ACID for the first time. You should see a window similar to Figure 11.10.

FIGURE 11.8 If you don't have a serial number, you should click on the Next button.

FIGURE 11.9 Unless you have a serial number, we'll set up ACID as ACID XPress.

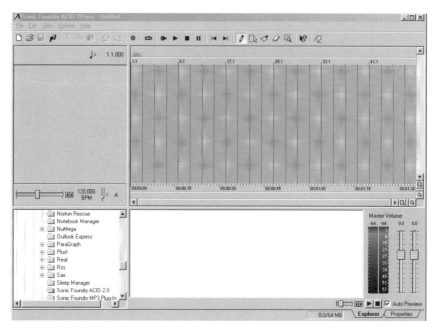

FIGURE 11.10 The ACID interface is displayed.

ACID SPECIFICS

One of the greatest attributes of ACID is the interface, which is quick to learn and very easy to master. It's a great choice for game development, especially for individuals with graphics or programming experience who have been given the task of developing music for their game. For those with a music background, ACID becomes another extremely powerful tool in their arsenal of choices. For those without any music background, Sony offers royalty-free loops that you can use to create your music.

The Interface

To begin, let's look at the screen and identify the various elements that make up the ACID window, which can be seen in Figure 11.11. At the top of the window you will see the familiar Windows title and menu bars. Below that is a toolbar that gives you quick access to the most commonly used commands. These tools can be used to edit, play back, and save your composition. We'll look at these tools in more depth later in this chapter.

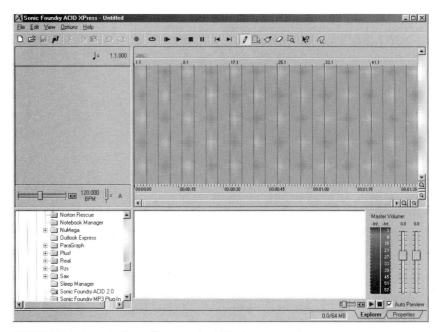

FIGURE 11.11 The interface offers standard Windows menu bars.

Again looking at Figure 11.11, you can see three main areas that the rest of the screen has been divided into. First, in the upper-left portion of the screen, you can see the ACID Track List. To its right, you will find the Track View, and at the bottom, you will see the Multi-Function area. The Multi-Function area contains the Media Explorer and Properties windows (ACID Pro contains additional windows, but we won't cover them here). Finally, along the bottom of the window you will see the status bar, which displays useful information such as available system memory. Figure 11.12 displays the interface with labels so that it's easier to see the different areas of ACID's interface.

Altering the Interface

You can resize the main windows that make up the interface. For instance, you could lengthen the Track List, Track View, or Multi-Function sections. To try this, you can place your mouse over a border between the Track List and Multi-Function sections and then click and drag to the top. You will see the windows change. When you wish to stop, simply end the click. Once you have the windows the way you like them, ACID will automatically remember the settings every time you open it.

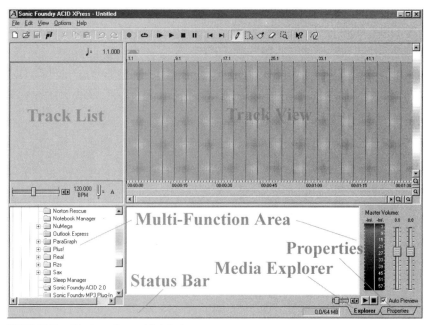

FIGURE 11.12 The interface with labels.

The Media Explorer

The Media Explorer is very much like the standard Windows Explorer that you are probably already familiar with. On the left is a directory view of the drives on your computer and drives on the network if you are connected to a network. When you click on a drive or a folder in a drive, you will see the contents displayed on the right. Click on the plus (+) to the right of the C: drive icon to display the contents of your computer hard drive. You can see an example of this in Figure 11.13.

You use the Media Explorer to locate and find tracks that you would like to add to your project. Once they are located, you can simply double-click them or drag them to the Track View or Track List.

The Track View

The Track View is used to compile the project. By "drawing" the tracks in the Track View, you are able to compose a track. Figure 11.14 contains a labeled drawing for the Track View window.

FIGURE 11.13 The Media Explorer works similarly to Windows Explorer.

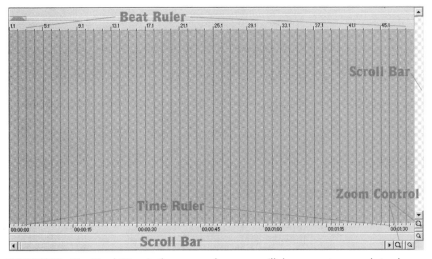

FIGURE 11.14 The Track View is the space where you will draw events on each track.

Beat Ruler

The Beat Ruler is displayed along the top of the Track View and allows you to place events in reference to the musical time of bars and beats. The

timeline has a fixed length and will not change when you alter the tempo. In Figure 11.15, the 1.1 represents beat one of measure one, and each ruler mark represents one beat.

FIGURE 11.15 Close-up of the Beat Ruler.

Time Ruler

The Time Ruler (Figure 11.16) is displayed along the bottom of the Track View. To change the format of the display, right-click on the timeline and choose an option from the shortcut menu. This timeline will change with tempo because the number of bars and beats per second of real time will change with tempo.

FIGURE 11.16 Right-clicking the Time Ruler changes the format.

Scrollbars

The horizontal scrollbar is displayed below the Time Ruler. Click and drag the scrollbar to pan left or right through the project. The scrollbar also functions as a zoom control. Click and drag the edges of the scrollbar to zoom in and out, or double-click the scrollbar to zoom out so that the entire length of the project will be displayed.

The vertical scrollbar is displayed on the right side of Track View. Click and drag the scrollbar to pan up and down through the project. Double-click the scrollbar to zoom out the project so that as many tracks as possible will be displayed.

Zoom Controls

The magnifying glass icons displayed at the ends of the scrollbar allow you to change the magnification level of your ACID project. The large

icon, seen in Figure 11.17, increases the track height zoom level; the smaller icon decreases the level. You can also display a zoom tool by clicking on the box located between the sets of zoom tools.

FIGURE 11.17 The zoom controls give you control over the entire area.

Track List

The Track List contains the master controls for each track. From here you can adjust the volume, mute the track, and reorder tracks. You can see a sample of the Track List in Figure 11.18.

FIGURE 11.18 The Track List gives you control over each of the tracks.

There are a few areas within the Track List that we should look at further. The Volume and Pan drop-down control, which can be seen in Figure 11.19, is very useful. It allows you to alter the volume and the pan of a track. By selecting Volume from the list, you can determine how loud a track is in the mix. A value of 0 dB means that the track is played

with no boost or cut from ACID. Clicking and dragging the fader (which is directly to the right of the drop-down) to the left decreases the volume, and clicking and dragging to the right boosts the volume.

FIGURE 11.19 The volume controls how loud a track is in a mix.

Pan controls the position of a track in a stereo field. Clicking and dragging the fader to the left will place the track in the left speaker more than the right, while moving the fader to the right will place the track in the right speaker.

Another thing that the Track List is used for is the placement of tracks. They can be moved around to create logical groupings at any time during a project's creation. To do so, you click on its icon in the Track List and drag it to a new location. While you are dragging it, a new location is indicated by a highlighted line separating the tracks, a sample of which can be seen in Figure 11.20. You can move multiple tracks by using Shift or Control to highlight them before dragging.

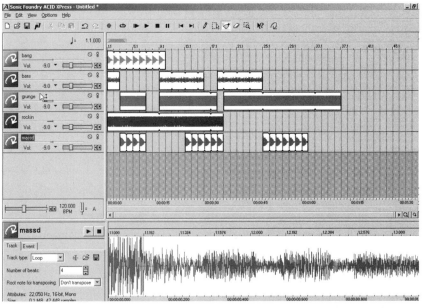

FIGURE 11.20 The highlighted line indicates the new position for a track.

Lastly, you can rename a track using the Track List by right-clicking the track label and choose Rename from the shortcut menu (you can also double-click the track label). Renaming a track applies to the project only and does not change the file associated with a track. Figure 11.21 shows a track being renamed.

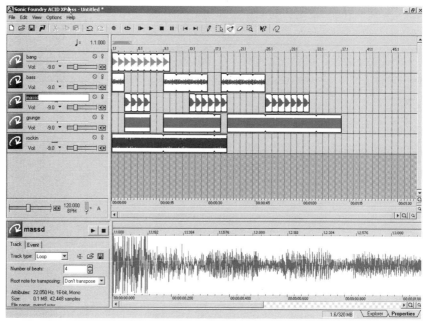

FIGURE 11.21 The track is being renamed within the project.

Properties Tab

The Properties tab, which is located at the bottom of the ACID window and can be seen in Figure 11.22, contains options to modify the behavior of whole tracks or events on a track. From this tab, you can ACIDize files, modify a track's stretching properties, or edit the start point and pitch of a specific event.

ACIDizing a file involves adding extra information that is ACID specific to the audio file. This is information such as stretching properties, root note, and number of beats or tempo of the file. This information is then used by ACID to time-stretch and pitch-shift the file for you automatically when you open it. You can alter a file and then save it, or you can simply save the ACID-specific information for a given project.

FIGURE 11.22 The Properties tab offers several options to modify behaviors.

To adjust the properties that are saved when a file is ACIDized, you also use the Properties tab. Figure 11.23 displays the track properties that determine how a file behaves in ACID.

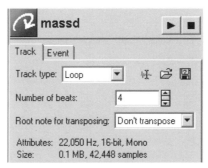

FIGURE 11.23 The Properties tab is one of the most powerful features offered in ACID.

CHAPTER REVIEW

As you have seen, there is a tremendous number of features in ACID that make it an extremely useful program for game developers. It's one of the easiest programs that you'll ever use and one that you undoubtedly will make a spot for in your toolbox. In the next chapter, we'll look at Adobe's Audition, the software that we'll use to create sound effects and edit individual tracks for use in ACID. Later, we'll use ACID to create the music for a game.

ADOBE'S AUDITION

In the previous chapter, we looked at ACID, which is going to be our application of choice for the creation of music for our game. In this chapter, we are going to look at Adobe's (*www.Adobe.com*) Audition, a program that we'll use for recording and editing sound effects for our game.

INSTALLATION

Before we begin discussing specifics of Audition, we need to install it. You can visit the Adobe Web site to download the most up-to-date version available.

The first step in the installation process is running the executable file. It will begin the installation process, and you will be presented with a screen that looks similar to Figure 12.1. To continue the installation, you need to click the Next button.

FIGURE 12.1 The installation program begins with this screen.

From the next screen, which can be seen in Figure 12.2, you need to choose a language and then click Next.

In Figure 12.3, you will see a small sampling of the license agreement for Audition. Read through the license agreement and click Next.

In the screen that can be seen in Figure 12.4, you enter your name and company information. After filling this out, click the Next button to continue.

FIGURE 12.2 Click Next after selecting an installation directory.

FIGURE 12.3 The license agreement.

FIGURE 12.4 You can set your name and company name.

The next window should look like Figure 12.5. You can set a new desti-
nation or choose the default location and click the Next button to continue.

FIGURE 12.5 The destination can be set.

At the next screen, which appears in Figure 12.6, you can choose to
set Audition as the default editor for specific types of audio files. This
process is known as setting up file associations in Windows. If you have
other editors, you can choose to have Audition be the default application
only for specific types of files or simply leave it as the default. It's impor-
tant to realize that you can deselect every item and still use Audition to
open them. You would have to open the files manually using the File,
Open menu rather than double-clicking them in Windows Explorer.

FIGURE 12.6 Setting up default file associations.

The next window looks like Figure 12.7. You can click Next on this
window to begin copying files.

FIGURE 12.7 The files will soon be copied to your computer.

In Figure 12.8, you can see the start of files being copied. After they are finished, you will see the final window of the setup, as in Figure 12.9.

FIGURE 12.8 The files are now being copied.

FIGURE 12.9 The last step in the setup process.

The actual installation process is complete. When you start the application, you will display the page in Figure 12.10, which will occur every time you execute the program unless you buy the registered version. Click the Try button to continue.

FIGURE 12.10 A warning is displayed that details the trial version options.

 Audition is both feature limited and time limited unless you register it.

THE INTERFACE

Like ACID in the previous chapter, we'll now look at the user interface and some basic operations of Audition. In the next chapter, we'll use it to record and edit sound effects for our game.

 The interface displayed in this chapter has the Organizer window hidden via the View menu. If you choose to leave the window visible, the layouts you see will be slightly different, although the processes will remain the same.

To begin, let's look at the screen and identify the various elements that make up the Audition interface, which can be seen in Figure 12.11. At the top of the window you will see the familiar Windows title and menu bars. Below that is a toolbar that gives you quick access to the most commonly used commands. These tools can be used to edit, play back, and save your composition.

FIGURE 12.11 The interface offers standard Windows menu bars.

Along with the standard toolbars, there are also several interface items that are unique to Audition, including the Time window, Transport, and Horizontal Zoom, to name a few. Figure 12.12 has been altered to reflect these areas that we'll look at in more detail.

FIGURE 12.12 The areas of Audition's interface are clearly marked here.

Toolbars

The Audition toolbars, some of which can be seen in Figure 12.13, contain button shortcuts to functions and are grouped into menus. Each grouping has a specific background color. The toolbar groupings can be displayed or hidden through the File Menu Options, Toolbars. Most of the functions you'll use are available in the menus that offer ToolTips for individual buttons when you leave your mouse pointer over one of them for a moment. If you'd like to add or remove toolbars, you can right-click on the toolbar, and a list will appear from which you can choose.

FIGURE 12.13 The toolbars contain shortcuts to common functions.

Display Range Bar

The Display Range Bar can be seen in Figure 12.14 and indicates which part of the waveform is currently being viewed in the Waveform Display. When you zoom in or out, this bar will get smaller or larger to reflect the portion currently being viewed. You can left-click and drag the bar to scroll forward or back without affecting the zoom level. If you right-click it, your mouse changes to a magnifying glass, and dragging it left or right will zoom in or out, respectively. Lastly, you can double-click on the Display Range Bar to bring up the Viewing Range dialog box. This dialog box allows you to enter values for the viewable area.

FIGURE 12.14 The Display Range Bar indicates the part of the waveform currently in view.

Amplitude Ruler

The Amplitude Ruler (Figure 12.15) measures the volume of audio data. In Waveform view, the ruler's display format can be set to either Samples (exact sample value of the data), a percentage (from –100% to 100%, where 100% is 0 dB), or as a normalized value (–1 to 1). Left-click and drag on the Amplitude Ruler to scroll the waveform display vertically. Like the Display Range Bar, you can right-click and drag to zoom.

FIGURE 12.15 Audition's Amplitude Ruler measures the relative amount of audio data.

Waveform Display

The Waveform Display (see Figure 12.16) is the area in which you view your audio material in the form of a waveform. You can use your mouse in the Waveform Display to select data in several ways:

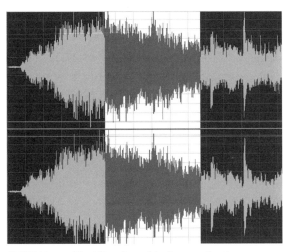

FIGURE 12.16 The Waveform Display area is where you view the audio materials.

- Left-clicking anywhere in the display to position a playback cursor.
- If you are using stereo files, you can disable or enable either channel by positioning the mouse in either channel and clicking. That way, you can edit only one of the channels if you need to.

- A left-click and drag will create a selection in the waveform.
- A right-click and drag will increase or decrease a selection.

TIME DISPLAY FIELDS

These fields display beginning, end, and length information for the visible portion of the current waveform and for the currently selected range. The top row relates to selection times, and the bottom row to the viewing range, as seen in Figure 12.17. The format that is used for the display is the currently selected format you specify in the File menu View, Display Time Format. You can left-click in any of the Time Display fields and enter a value to adjust either the selection or viewing range.

FIGURE 12.17 These fields display various time elements related to the current waveform.

Level Meters

Audition's Level Meters (Figure 12.18) are used to monitor the volume of incoming and outgoing signals. The signal is represented as the peak amplitude in decibels. A level of 0 dB is the absolute maximum before clipping occurs. Yellow peak indicators will remain for about 1.5 seconds before resetting to allow for reading of the peak amplitude. When displaying stereo audio, the top meter represents the left channel, and the bottom the right. To access the Level Meters configuration menu, you can right-click in the meter area.

FIGURE 12.18 Level Meters are used to monitor the volume of incoming and outgoing sounds.

Time

The time readout simply displays current cursor position of the file in playback or record mode, as seen in Figure 12.19. You can change the

format by selecting Edit, Display Time Format from the File menu. You can make the readout as large or small as you like, and the window floats, meaning it will stay on top of the rest of Audition when open. You can open and close the Time window by choosing View, Time Window from the File menu.

0:04.210

FIGURE 12.19 The Time window displays the current cursor position.

Status Bar

The Status Bar (Figure 12.20) can display a variety of information related to your computer and a file's properties. It can be turned on or off by selecting View, Show Status Bar. You can right-click the status bar preferences to alter its display options.

| 44100 · 16-bit · Stereo | 0:12.438 | 4409.09 MB free |

FIGURE 12.20 The Status Bar displays various information related to the file.

Transport

The Transport toolbar (Figure 12.21) is the control center for functions such as play, stop, record, and so on. It works very similarly to a standard VCR except that you can right-click the Fast Forward and Rewind buttons to select varying speeds of advancement and rewind.

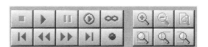

FIGURE 12.21 The Transport toolbar is the control center for rewind, stop, play, and so on.

Zoom

The Vertical Zoom buttons, shown in Figure 12.22, increase or decrease the vertical scale in the Amplitude Ruler, and the Horizontal Zoom buttons allow you to get more or less detail on a waveform or session.

FIGURE 12.22 The zoom buttons allow you to alter the vertical scale or get more or less detail.

CHAPTER REVIEW

In this chapter, we looked at many of the basics of Audition. In addition to learning the basic features of the software, we also learned about many of the features and tools that make Audition so popular. In the next chapter, we'll use this along with ACID to create music and sound effects for the game.

CREATING MUSIC AND SOUND EFFECTS

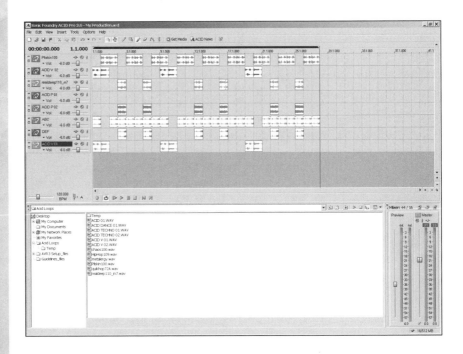

Of the many components that go into making a video game, perhaps none is given less attention than music and sound effects. The addition of quality music and sound effects is one of the best ways to add production value to your games. For single developers or small teams, there is now a tremendous array of software and low-cost hardware that aid in this process. With believable sound effects and music, the game player's emotional experience will be greatly enhanced.

WHY IT'S IMPORTANT

There are many parallels between making a movie and the development of a game. Hollywood has long realized the benefits of music and sound effects to the moviegoer. Over the past decade, there has been tremendous time and resources spent on improving these aspects of a movie, during which time we have seen the use of surround sound in both theatrical and home movie releases.

The long and varied history of the movie industry offers us a tremendous amount of guidance. While you will find very little documentation on the creation of music and sound effects for games, there is a plethora of information available for the moviemaker, both professional and amateur. Countless books have been written over the years, and vast resources are available at Web sites, not to mention the movies themselves, which can often provide inspiration and ideas.

Beginning with the 42nd Annual Grammy Awards, the video game industry has started to receive recognition for its work. The NARAS (National Academy of Recording Arts and Sciences) approved three new categories to include music written for "Other Visual Media." This is the term they are using to include the music from games.

BASIC IDEAS

When you are given the assignment to create music for a game, you usually begin with a basic understanding of the type of music being requested. For instance, if you are creating music for a wrestling game, classical music is probably not going to be part of the piece. With this in mind, your research often begins with discussing the piece or watching a specific type of program. Looking at the wrestling sample, you might watch wrestling on television or perhaps visit a live version in person. This would allow you to get a very good understanding of what the fans would be interested in.

On the other hand, if you were writing music for a game that reenacts the Civil War, you might watch movies on the Civil War or even talk with music historians about the types of instruments or music that would have been popular in the time period.

It's important to understand that you would not do this research so that you could simply copy the music but would instead use this approach to discover what in the music makes it fit the time or era. Keep your mind open as you might come up with completely unique ideas, or perhaps you'll find the original composers' work is adequate and choose to use their basic premise.

We're going to use ACID, a program we looked at previously in this book. This program offers several advantages over other applications. First, even if you don't have a music background, you can use ACID. Additionally, it comes with several samples that can be used in many ways. There are also several Web sites with clips readily available for download to use.

ACID Loops

ACID is based on the ability to create music from loops, much like mainstream music being produced today. In the past 15 years, the vast majority of the music industry has used loops or samples in one aspect or another. This concept has drastically altered the music landscape, changing the way both amateur and professional producers create their music. A quick glance at many modern albums will disclose their use of samples.

The use of samples in many forms of music has brought about an entire industry that produces music especially for this purpose. There are literally thousands of CDs that contain materials that can be used for almost any purpose. Along with the CDs that are filled with music in standard CD Audio format, there are also those that have been built with the file formats used by many leading music programs, including ACID.

There are two basic ways these CDs are distributed. One is a royalty-based system in which you are required to pay for every time the sample is used. The CDs are often free, but you pay as you use them. The other option usually involves paying a fee up front, but you then receive a royalty-free license that allows you to do most anything with the loops. With either option, you usually cannot distribute the material as a new collection of loops.

Recently, the Internet has offered a third solution for obtaining samples. There are countless Web sites that offer fee-based downloads, and others allow you to download their loops freely. There are several sites that offer free loops, but the first one we'll look at specifically is the Sony-run ACIDPlanet.com. It has a freely available download every week

called an 8Pack, which is essentially an ACID project file that includes eight loops arranged into a song. An 8Pack will not only help to teach you how to combine loops into a final project, but it also comes with tips and tricks that were used to put it together.

Another site that is excellent is PocketFuel.com. It offers the largest collection of files for ACID on the Internet, and they are royalty free. For the production of this book, I downloaded files from this site. If you register at the site, you can also download the same files as we'll use in the next section.

Creating the Music

Because of licensing issues, I have included only the final project on the CD-ROM in MP3 format. This was to make certain that I complied with the licensing information located at PocketFuel. You should thoroughly read the licensing agreement before downloading anything from this Web site. To begin our composition, you should first locate and download several types of loops from the Web site. I'm not going to try to get you to duplicate this project exactly, as the files that were downloaded may no longer exist.

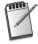 *The screen shots in this chapter are from ACID Pro 3. They may look slightly different from the free version of ACID you can now obtain from Sony. However, you should have the ability to follow along, as the project we'll create is limited only in that it uses the capabilities available in the free version.*

When you open ACID, you'll be presented with an empty project such as that seen in Figure 13.1.

Next, from the File menu choose Properties and set the information for your project, such as the title of the project and the copyright information. The Project Properties window can be seen in Figure 13.2.

Next, add your first loop to the project. Double-click a file in the Explorer or drag it to the Track List to add it to your ACID project. If you add a file that is longer than 30 seconds in length, ACID's Beatmapper Wizard will automatically be displayed. Right-click and drag a file to the Track View or Track List to specify the type of track that will be created. When you drop the file, a shortcut menu is displayed that allows you to choose whether the file will be treated as a loop, one-shot, Beatmapped track, or autodetected type. Your project should look something like Figure 13.3.

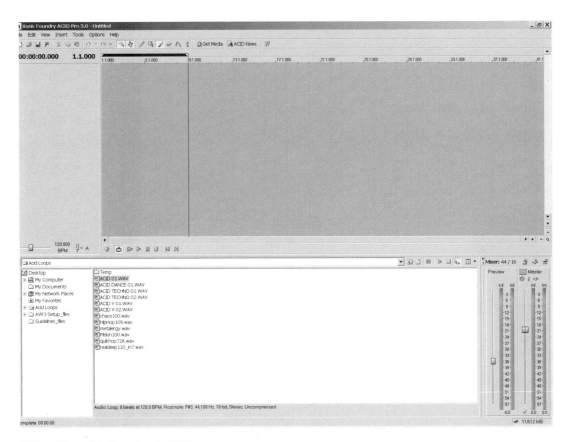

FIGURE 13.1 A blank project in ACID.

FIGURE 13.2 The Project Properties window.

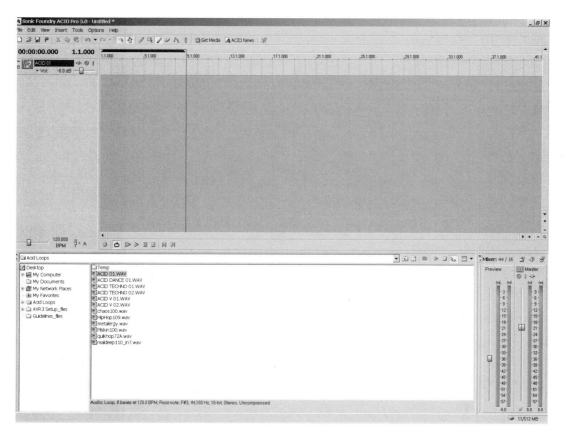

The project with a single loop added to it.

Next, drag the time so that it ends at approximately 21 seconds. Your screen should now look like Figure 13.4. If for some reason your ruler has a different measure of time, you can change it by choosing View, Time Ruler and then selecting the appropriate format.

Next, you should select the Paint tool. If you remember Chapter 8, "Multimedia Fusion Editors," the Paint tool is designed to paint events across multiple tracks. With the Paint tool selected, you can paint events across multiple tracks by clicking and dragging the mouse. This tool is also useful for inserting one-shot events evenly along the grid, which is basically how we are planning to use it.

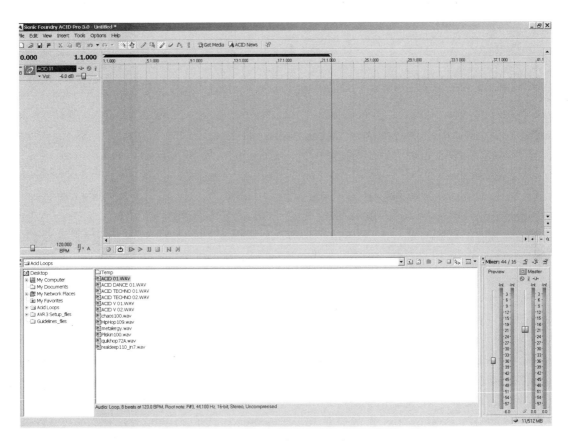

FIGURE 13.4 The Time Ruler with a time of approximately 21 seconds.

With the Paint tool, draw in the first location in the grid directly to the right of the filename that can be seen in the Track List. Your project should look like Figure 13.5.

You can click the Play button to test the project before moving on. If it plays correctly, it would be a good time to give your project the name MyFirstACIDProject.

The next step is to add the rest of your loops to the project. Once you have finished, you can begin creating your music by drawing with the Paint tool or Draw tool inside the grid next to the individual tracks. For an example, see Figure 13.6 to see the finished project.

If you have any problems with this project, you should take the time to download the 8Packs available at ACIDPlanet.com. They have preconstructed projects that will give you an idea of how to put things together better.

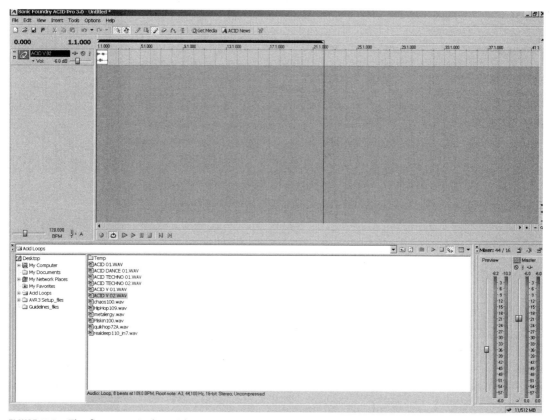

FIGURE 13.5 The first entry in the grid.

Once you have finished your project, you need to save it in WAV format for our project in MMF.

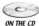

ON THE CD

The final project can be found in several formats on the CD-ROM that accompanies this book, including MP3, WAV, and RM. It is in the Music and SFX directory.

Creating SFX

Sound is everywhere in our daily life, so it's obvious why it would be so important to a gameplayer. Sound effects often take on meaning in a game. A dark alley with a strange noise coming from behind an overflowing dumpster delivers a message of fear more than the dark alley would by itself. People yelling loudly draw our attention to an area or might make us want to flee in the opposite direction. You can also use sound effects to

FIGURE 13.6 The finished project.

establish a time and a place. For instance, crickets in the background or waves beating a shore can add a great deal to a setting without visually displaying anything.

Sound effects can also convey actions such as a gun being fired or a car colliding with a wall in a racing game. It is this part of sound effects, the part that adds emotion or action to a scene, that game programmers are most interested in.

Like the CDs that are available with loops, there are also sound effect libraries that can be purchased. For the vast majority of sound effects, there are probably CD libraries that contain something that will work or can be modified slightly to work.

For those sounds that are unique or for sounds you'd just prefer to do yourself, it is often a very simple process. If you have a PDA or a portable recorder of some sort, you can often visit a site to obtain sound recordings. For instance, if you have a game with animals, a visit to a pet store or local zoo is often all you would need to do to get the appropriate

noises. If you are creating a sports title, visiting a local sporting even will give you all the crowd and background noises you would ever need.

If you choose to visit local areas to record your noises, keep in mind that you often need more than you would have imagined. This is true for many reasons, such as the noises not being as good as you had thought or, after editing, you are left with only part of a 10-minute recorded segment. Again, you should always try to get more material than you think you'll need.

The other basic type of sound effect for a game is the sounds that occur when some type of action occurs. The action types take a great deal of time to produce and may require a tremendous amount of specialized equipment. Fortunately, with a little effort and common items, you can use some very simple ideas to record these types of sound for our game.

Recording Sounds

It doesn't really matter what type of device you are using to record the sounds. Ultimately, we have to get the data into the computer. For our setup, we'll assume you are using a tape recorder, digital recorder, or PDA to record your sounds. We'll then connect these devices to the sound or microphone inputs on your sound card. We'll then use Audition to edit these noises after changing them into digital form.

How to Record

The first step in this process is creating the recordings. We're going to create a basic 3D shooter, and with this in mind, we'll need to create effects for gunshots, footsteps, and perhaps even noises of collision. These are actually quite easy to record.

The following lists several types of actions that you can record easily with common household items. Of the list, we actually need to record the footsteps and a body collision.

SOUND TYPE	HOW TO RECORD
Car Crash	Fill a box with scrap metal and chunks of wood. Shake vigorously while recording.
Fire	Take a piece of cellophane and crinkle it with your hands.
Door Slamming	You can use a real door and simply place the recording device near the hinges. You can slam the door and then open and close the door slowly if you also need this type of noise.

Body-Type Collisions	You can use items such as a pumpkin or watermelon and strike them with a piece of wood or rubber mallet. Try various methods to get just the right sound. Watch out, though, this one can be very messy! Another method is to wrap wet towels around wood planks and then strike them together or let them fall a small distance to a concrete or hardwood surface.
Rain	You can simply record rain on a roof or metal sheet, or if you are in a hurry, you can simulate the effect by taping together five plastic cups with the bottoms cut into different shapes such as a square, a star, or an ellipse. After taping them together, you can pour uncooked rice into the top, and as it falls through, it will sound like rain falling.
Thunder	Thunder can be recorded during a storm, but like rain, it can be simulated using other methods. You can make up a simple "thunder sheet" by getting a piece of sheet metal cut approximately 18" by 50". Then fit it with 1" by 2" boards on one end and multiple holes in the other to hang it from a ceiling or beam. You can shake the end with the handle to simulate the thunder. This can take some practice to master, so be patient if it doesn't sound realistic at first.
Footsteps	Depending on your needs, it is probably easiest to simulate footsteps by recording the real thing. You can record in gravel areas for outdoor simulations, or you could use a hardwood floor with a hard-heeled shoe for indoor areas. If you prefer, you can actually construct a wooden box that is large enough to step into. It would need to be approximately 3' x 3'. Additionally, you can flip it over for recording step noises or you can fill it with things like straw or newspaper to vary the noises. To simulate walking in snow, you can use a shoe to press on an old strawberry container or against a couch cushion or similar type of furniture. If you do this at the approximate stepping rhythm, it will simulate this very well. You can also simulate animal footsteps using similar methods. For instance, you can simulate a horse by striking small squares of wood together or by striking together halves of a coconut with all of the pulp removed. You could use your box along with the coconut by adding some sand and then striking the halves with the box.

Machines	You should try to record the actual machine noises. For instance, if you are creating a car racing game, you might get the best effects by visiting a race and recording the sounds yourself. Additional sounds that work well in games include saws, drills, and even hammers.
Gunshots Hitting Wood	You can cut plywood into thin strips and break it while recording. It will sound as if the shots are splintering the wood.
Gunshots	Gunshots can be simulated by hitting a leather seat with a thin wooden stick such as a yardstick or ruler. For different types of sounds, you can experiment by hitting other materials with the wooden stick.

For practice, let's look at the last item in the table, a gunshot. Using a thin wooden stick, strike various objects with varying strengths to get used to the idea. Creating these types of sound effect is very much trial and error. As such, you should spend some time finding several objects that sound good and record all of them.

Using a PDA

The next step is to connect your recorder to the computer. If you are using a PocketPC or Windows CE-based PDA, you can simply connect it to the computer and transfer the recordings, which will already be in WAV format. If you are using this method, you can skip the next section, "Using a Recording Device." Depending on the sound quality of your PDA, the sounds will be of varying quality. If they are not of good quality, you will probably be forced to use another method to record your sounds.

Using a Recording Device

If you are using a tape recorder, mini-disc recorder, or other recording device, you will have to attach it to your computer's sound card. On most sound cards, there are probably four connectors: Line In, Line Out, Microphone, and a MIDI/Game Port. Figure 13.7 displays a diagram of a typical sound card.

Most modern sound cards also use diagrams to label the connections. You can view a sample of this in Figure 13.8.

FIGURE 13.7 The layout of a typical sound card.

FIGURE 13.8 Sound cards often have labels.

The following list details the various connectors:

MIDI/Game Port: This is a port that is most commonly used to connect a game paddle or joystick to the computer. This port will also allow you to connect a device such as a MIDI keyboard to the computer.

Line In: A connector that allows you to connect a cassette tape, CD, or other recording device to the computer.

Line Out: This is used for speakers or headphones that can be connected to get sound out of the sound card.

Microphone: It allows you to connect a microphone to the computer and record your own sound files. If necessary, you can also connect a recording device to this port.

Once you have located the Line In or Microphone connection, you should attach your device to the computer. Depending on the device, you may need different types of cables and connectors. The vast majority of sound cards use 1/8" (miniplug) jacks for Microphone and Line In.

After connecting the device, the next step is to open up your sound card's mixer panel by double-clicking on the yellow speaker icon in your System Tray, which is near the clock on your task bar. A standard sound card mixer looks like Figure 13.9.

FIGURE 13.9 The mixer panel allows you to choose options related to the sound card.

When you first open the mixer, you will see all of the possible playback volumes. Make sure that Wave is not muted and that its volume slider and the master volume slider are both at least halfway up.

Next, set the sound card's recording devices by going to Options, Properties and then select Recording. Each of the devices your sound card can record from will be listed in the window. The next step is to click the OK button, which will display the Recording Controls window. Make sure that the volume of the category you plan to use is halfway up. For instance, if you are using Line In, you should make sure that Line In is halfway up. Figure 13.10 displays Line Up as it should appear.

FIGURE 13.10 Line In with the correct settings.

The next step is to open Audition and select Options, Settings and then click on Devices. Make sure that the correct device is selected for both Waveform Playback and Waveform Record. Create a new file by clicking File, New. Choose the WAV file type, and click OK. Next, click the Record button in Audition and start the playback of the device. When you have finished recording, press the Stop button. Depending on your sample, you should see something like Figure 13.11.

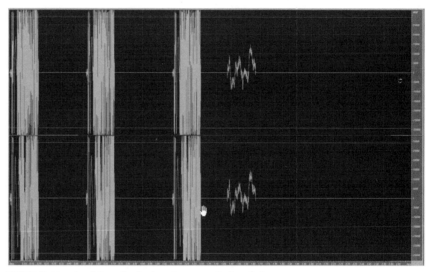

FIGURE 13.11 Audition displaying the recorded sample.

You should test the playback volume in Audition before moving on. If the volume is too low, you can rewind or reset your device, increase or decrease its volume as necessary, and then record it again to a new file. Once it is within Audition and the volume seems OK, we can save it and then begin editing it as needed. First, you may notice that there are basically three areas that can be seen in the figure. These areas represent the three times that the stick was used to strike a leather chair in my sample recording. Our plan will be to alter this file such that there is a single "shot." We'll begin by selecting one of the first areas and then choose Edit, Copy. Next, place your mouse at the end of the selection and single-click. If it appears that you have selected the area directly next to the first sample, choose Edit, Paste. The area should now look like Figure 13.12.

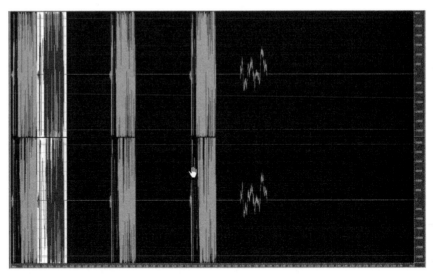

FIGURE 13.12 The newly pasted area.

The next step is to select Transfer, Amplitude and then Envelope. Drag the line down in the window so that it looks like Figure 13.13. Next, click OK.

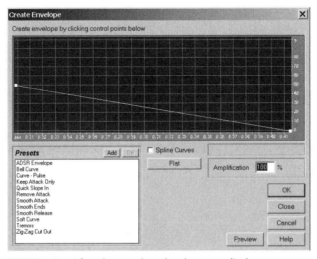

FIGURE 13.13 After the envelope has been applied.

The tapered effect will act as a sort of echo type of effect to the gunshot. The next step is to highlight areas past the first gunshot and newly pasted area and then press the Delete button. This will leave only the single gunshot and echo. You can see the final result in Figure 13.14.

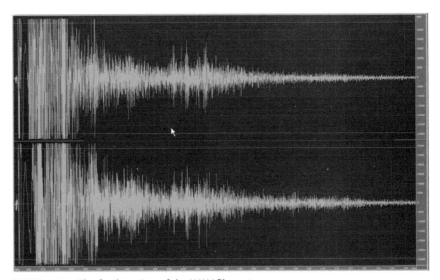

FIGURE 13.14 The final version of the WAV file.

You may notice in the previous figure that there is an area within the taper that actually begins to increase in volume before falling back down. This adds to the echo effect and is accomplished by selecting an area and then choosing Transfer, Amplitude and then Amplify. From this window, drag Amplify to create a higher value. You can also use Amplify to increase or decrease the volume of the entire sample if your volume is too high or low.

That's all there is to the creation of a gunshot. You can follow this same basic process for creating the other sound effects using the methods we looked at previously.

CHAPTER REVIEW

It's easy to see why music and sound effects are so important to the development of a game. They can add so much to the experience of a game-player by setting a mood or location. Well thought out music and sound

effects go hand in hand with the eye candy that so many developers focus upon. It has become an integral part of the game development process.

In this chapter, we used two of the best tools available for game developers: ACID, with its easy-to-use interface to create a very simple song, and Audition to record and edit sound effects for games. In the next chapter, we'll look at creating 3D models in MilkShape 3D.

INTRODUCTION TO MILKSHAPE 3D

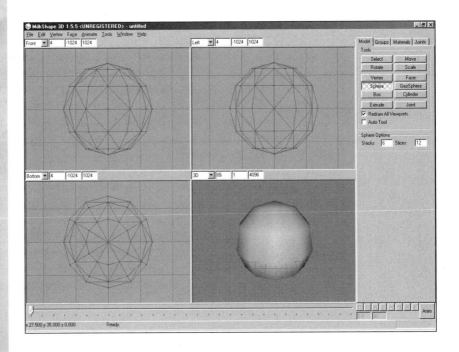

Before we move on to the 3D simulation in Multimedia Fusion, we'll look at several tools that we'll use to construct the various elements that will make up the final game project. These software packages include MilkShape 3D for the creation of 3D models and Paint Shop Pro for bitmaps and textures. We'll begin by looking at the basics of these applications and will then move forward to use them for our project.

There are many good 3D modelers on the market today, but you would be hard pressed to find an application that is as inexpensive as MilkShape 3D. Obviously, price isn't the only factor in choosing tools, and fortunately, MilkShape offers everything you would need for the type of low-polygon modeling necessary for real-time game development.

 We'll use the terms MilkShape, MS3D, and MilkShape 3D interchangeably throughout the text, although they are in fact the same product.

INTRODUCTION TO MILKSHAPE 3D

MilkShape 3D is a low-polygon modeler that was initially designed for the creation of Half-Life models by Mete Ciragan. During the development of the product, Ciragan has added many file formats to the package, including most common game formats.

MilkShape 3D offers a full set of basic modeling operations such as select, move, rotate, scale, extrude, and turn edge, to name a few, and allows low-level editing with the Vertex and Face tool. MilkShape also includes a set of primitives such as spheres, boxes, and cylinders.

The most important feature that MilkShape provides is the capability to do skeletal animation. This allows you to export to morph target animations like those offered by the Quake model formats or to export to skeletal animations like Half-Life or Genesis3d. For our gaming project, we'll use the Half-Life model format because it offers one of the easiest and most powerful game formats.

INSTALLATION

Before we can begin using MilkShape, we first need to install it.

It's located on the CD-ROM for this book in the Applications\ MS3D155 zip file. Otherwise, you can download the most up-to-date version from *http://www.swissquake.ch/chumbalum-soft/*.

Once you have acquired the software, the next step is to run the setup.exe file. It will begin the installation process where you will be presented with a screen that looks similar to Figure 14.1.

Click the Next button to continue the installation. From the next window, which appears in Figure 14.2, you should enter an installation

FIGURE 14.1 The installation program begins with this screen.

FIGURE 14.2 You should set the appropriate installation directory for MilkShape.

directory or use the default value of C:\Program Files\MilkShape 3D 1.5.5.

The default installation directory contains version information. As a result, it may be different, depending on the version you have.

You need to click the Start button from a window that looks similar to Figure 14.3 to copy the files to the hard drive.

FIGURE 14.3 Clicking Start copies files to the hard drive.

The last step in the process is to click the Exit button in the window, which is displayed in Figure 14.4.

Once you have finished the installation, you can run MilkShape by clicking the shortcut that was created in the installation. When you open MilkShape for the first time, a window will open that is similar to Figure 14.5. This window will be displayed only when it is executed the first time and is very important. As you will notice, it displays your current system date and time.

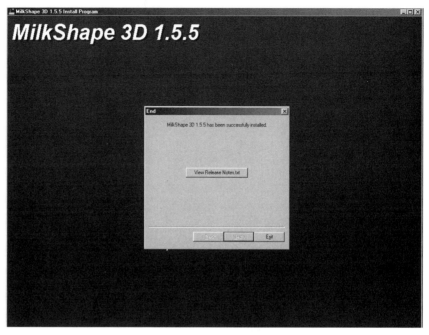

FIGURE 14.4 This is the final step in the installation process.

FIGURE 14.5 Make sure the system date and time are accurate before you click Yes.

You need to make sure the information is accurate because Milk-Shape allows you to use its software for only 30 days without registering it. If the information is incorrect, you need to correct it before you click Yes. Otherwise, if you attempt to correct it at a later time, the software will not function unless you register it. You should take the 30 days to try

MilkShape, and if you like it, you should consider registering it. It's currently only $20, a small price for a modeler with so many features.

Once you have determined the date is correct, you can click the Yes button, which will display the standard MilkShape interface that appears in Figure 14.6.

FIGURE 14.6 The standard MilkShape 3D interface.

MILKSHAPE 3D INTERFACE

Before we begin looking at the modeling features of MilkShape, you first need to understand some of the basics of the MilkShape interface. Like the vast majority of modeling tools, you have the capability to alter the view windows. First, you can customize any individual window by right-clicking on it and selecting from the available options. You can see the commands that are available in Figure 14.7.

Along with options for changing the individual viewports, you can also display the viewports in several types of sets. To change the viewports, you can click on the Window, Viewports menu option, which is displayed in Figure 14.8.

FIGURE 14.7 You have many options available for the individual view windows.

FIGURE 14.8 The viewports can be changed to your liking.

Depending on your personal preference, the viewports can be displayed in several ways. First, you can display four viewports, which is the standard view and displayed in Figure 14.9. Otherwise, you can display the viewpoints in three window views with two windows on the left (see Figure 14.10) or two windows on the right (see Figure 14.11).

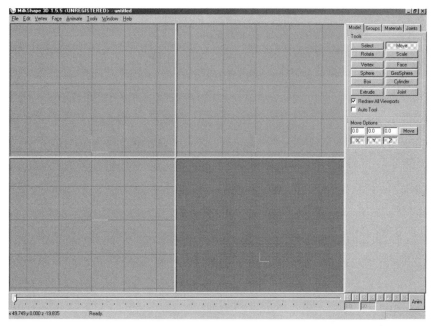

FIGURE 14.9 Viewports in standard four-window setup.

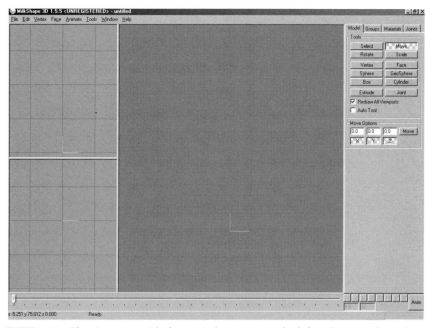

FIGURE 14.10 The viewports with three windows: two on the left and one on the right.

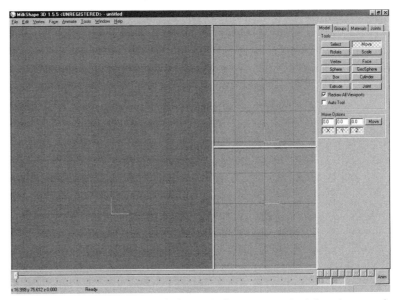

FIGURE 14.11 The viewports with three windows: one on the left and two on the right.

You can further customize the individual viewports by displaying captions in them. This allows you not only to enter parameters, but also to change the viewports from a drop-down list. You can see these options in Figure 14.12.

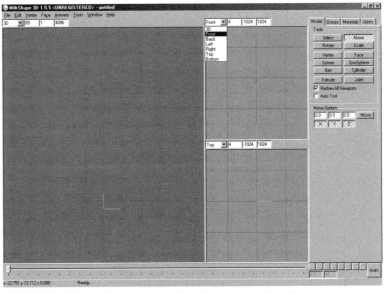

FIGURE 14.12 Displaying captions in the viewports can be a big timesaver.

Viewport Controls

Now that you have a basic understanding of the user interface, we'll move on to the basic functions of the viewports. A viewport can be zoomed by holding down the Shift key and the left mouse button and dragging the mouse vertically. It is important to note that zooming will not work if the Select button under the Model tab is selected. If the viewport is 3D, holding down the Shift key and the left mouse button will rotate it in a 360-degree arc. The viewport can also be panned by holding down the Ctrl key when the left mouse button is selected and dragged.

Basic Modeling Functions

In Chapter 9, "Our First Game in MMF," we used MilkShape 3D to construct models for the project we are creating in this book. You need to be accustomed to the basic features that MilkShape offers.

Primitive Objects

To create models in MilkShape, you use the built-in primitive objects that MilkShape offers. They are located in the upper-right corner of the interface under the Model tab and can be seen in Figure 14.13. The vast majority of 3D programs provides geometric primitives such as spheres, boxes, and cones to use as building blocks.

FIGURE 14.13 The primitives are used to construct models.

Sphere

To draw a sphere, you need to place the pointer on the screen where you want the sphere's center point and then click and hold down the left mouse button while dragging the pointer to create the radius of the sphere. You'll see the sphere drawn as you drag the mouse. When you are finished, simply release the button, and the sphere will be placed in the available views. A sample sphere can be seen in Figure 14.14.

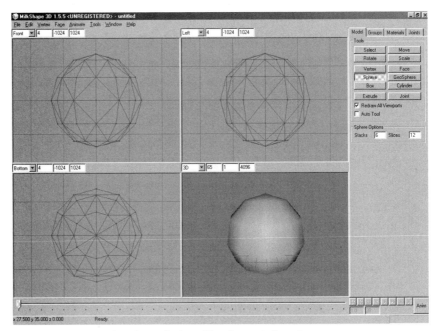

FIGURE 14.14 A sample sphere displayed in a four-window viewport.

Geo-Sphere

This is another form of sphere, but it is very smooth compared to the standard sphere. Creating the sphere is similar to the standard version as you click and hold the left mouse button at the desired center point of the geo-sphere and then drag the mouse to the desired radius of the sphere. The geo-sphere, a sample of which can be seen in Figure 14.15, will be displayed as you drag the mouse.

Box

Just as it sounds, a box is a six-sided cube. You draw it in much the same way as a sphere. Instead of placing the mouse where you'd like the center

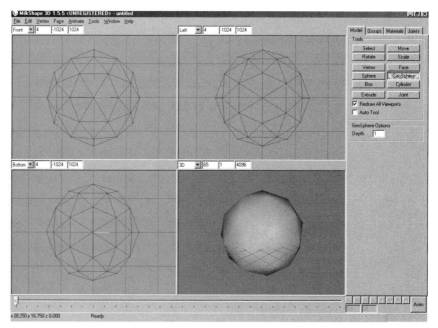

FIGURE 14.15 The geo-sphere is smooth, compared to a standard sphere.

to be placed, you place it where you want the initial corner. Next, you click and hold the left mouse button while dragging the mouse until you reach the point where you would like the opposite corner placed. You'll see the box being drawn as you move the mouse. A sample box can be seen in Figure 14.16.

Cylinder

A cylinder is created like the other primitives, but it will always be drawn with the ends facing up and down. For instance, in the vertical views (which are front, back, left, and right) you position the pointer where you want the cylinder to begin and then hold down the left mouse button and drag the pointer. The cylinder will be drawn as you drag the mouse. The diameter of the cylinder is scaled uniformly as you drag left or right, and the height is set by the distance you drag vertically. In the vertical views, it appears that you are drawing a rectangle, but you can verify that you are drawing a cylinder in the 3D view.

If you draw a cylinder in the top or bottom view, you click and drag the mouse similarly to the vertical views. However, you will notice that when you drag the mouse, you'll actually see a circle being drawn that scales uniformly. Again, you can verify you are actually drawing a cylinder by looking at the 3D view. You can view a sample cylinder in Figure 14.17.

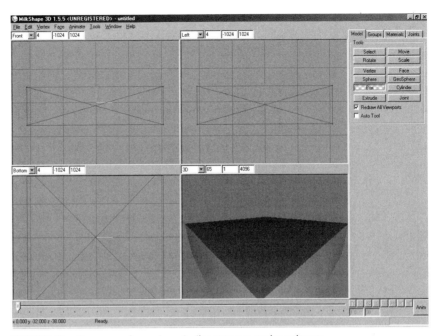

FIGURE 14.16 Boxes are drawn in a similar manner as the spheres.

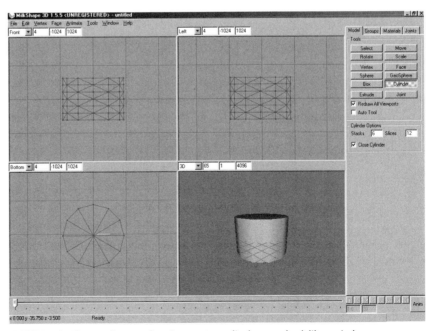

FIGURE 14.17 Depending on the viewport, a cylinder may look like a circle or a rectangle.

Mesh Editing Tools

Along with the modeling tools, MilkShape provides several tools for moving, scaling, extruding, and rotating your selected vertexes or faces. Like the modeling tools, the mesh tools are located in the Model tab, which is seen in Figure 14.18.

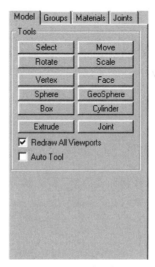

FIGURE 14.18 Mesh editing tools are available in the Model tab.

The mesh editing tools work only on a selected vertex or face and will not work in a 3D view.

Vertex and Faces

Before we look at the mesh editing tools, we'll look at two of the basic components of MilkShape and 3D modeling in general: vertices and faces. A vertex (or vertices for more than one vertex) is simply a point in 3D space. You can combine them to form a face, which is a series of vertices that defines a plane in 3D space.

You create a vertex by selecting the Vertex button and clicking inside a viewport. Once you have placed the vertex, you will see a red dot that represents it. To create a face, you need to have a minimum of three vertices,

which are then clicked on in a counterclockwise manner to create a face. Don't spend too much time worrying about this right now. We'll cover it in more depth when we create some actual models.

Select Tool

Now that you understand vertices and faces, we'll look at the mesh editing tools. The Select tool is used to select a vertex, vertices, or faces. This is the first step before you move on to the other tools, which work only if a vertex or face is selected. You select them in several ways but one of the easiest is by drawing a selection box around the vertices or faces you want to select.

Drawing the selection box in MilkShape, which can be seen in Figure 14.19, works like most other graphics applications. You click in a viewport to set your initial corner, and while holding the left mouse button, you drag the mouse. You will see the box being resized as you move the mouse, and when you release the button, you'll notice that the selected vertices or faces will turn red to show that they are selected. The selected faces can be seen in Figure 14.20.

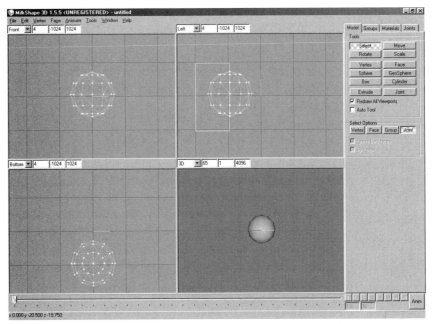

FIGURE 14.19 The selection box allows you to select multiple faces or vertices at a single time.

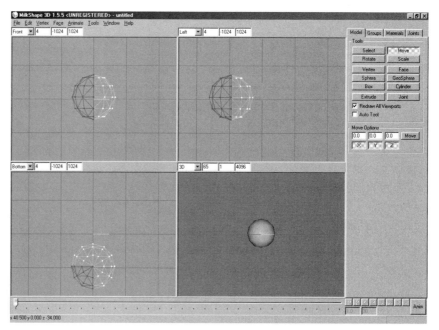

FIGURE 14.20 The faces or vertices that are selected will be red to distinguish them from the others.

You may have already noticed the additional options available for the selection tool. Using these options and clicking on vertices or faces, you can select faces individually.

Depending on your accuracy when using either selection option, you will probably select unwanted faces or vertices. In that case, you should hold down the left mouse button and deselect any face or vertex that you do not want selected. They will return to their normal white color when you deselect them, which allows you to determine the remaining selected items. The last two selection options allow you to select an entire mesh group or a joint, although we will not cover them at this time.

The next step is to look over the mesh editing tools Move, Scale, and Rotate.

Move

The Move tool works as you would expect. When you click on selected vertices or faces and drag them while the Move tool is selected, they will move in the direction you are dragging. There are several options available

when the Move tool is selected. First, you can restrict movement of the faces or vertices by deactivating any of the X, Y, or Z buttons.

 X, Y, and Z coordinates refer to the directions in 3D space. X is the horizontal direction (left to right). Y is the vertical direction (up and down). Z is the 3D dimension (back and forth).

Besides having the capability to move the vertices and faces by dragging the mouse, you can also enter exact amounts in the boxes, which are displayed in Figure 14.21.

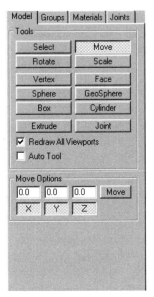

FIGURE 14.21 The faces have been moved −3 in all directions using the input boxes.

Scale

Scale is used to resize the selected faces by dragging the mouse or using the input boxes. It works very similarly to the Move tool in this respect. You can also restrict the movement as you can with the Move tool.

There are a few additional options for the Scale tool that originate with three radio boxes called Center of Mass, Origin, and User Point.

Center of mass means that the faces will be scaled from the center point of the selected faces. Origin can be seen at the center of a viewport. It is the two lines that are displayed in Figure 14.22. If you select the Origin button and then scale a face, the scale will be based on the origin point. The final option, User Point, makes the scale radiate from the original position of the mouse when you click the button.

FIGURE 14.22 MilkShape's Origin option.

Rotate

Rotate works similarly to the others, with a click-and-drag operation being used to rotate the selected vertices or faces. The direction of rotation depends on the view you are in. As with the other tools, you can restrict the direction of rotation, and you can manually input rotations into input boxes. It also has the same type of center point options that Scale offers, including Center of Mass, Origin, and User Point.

Extrude

The extrusion tool obviously allows you to extrude a face in a certain direction. You cannot extrude vertices, and if you attempt to do so, some very strange things will happen. It becomes very unpredictable, so you shouldn't even attempt to do it. The Extrude tool has similar options that the other mesh editing tools offer, including the capability to enter exact

values into X, Y, and Z input boxes. Figure 14.23 displays a face that has been extruded.

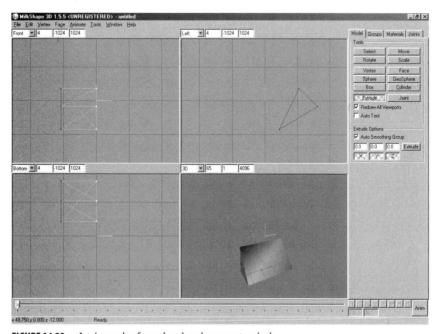

FIGURE 14.23 A triangular face that has been extruded.

ANIMATION TOOLS

MilkShape 3D offers a variety of animation tools that are excellent for game developers.

Joints

You can create joints for models with the Joint tool. You use it very similarly to many of the MilkShape tools with one exception. Instead of clicking and dragging to create bones, you first click a single time, which creates the first part of a bone, and then move your mouse and click again to create the second part. A sample bone can be seen in Figure 14.24.

MilkShape uses keyframes to create animation sequences. We'll look at this further when we do a step-by-step tutorial later in the book.

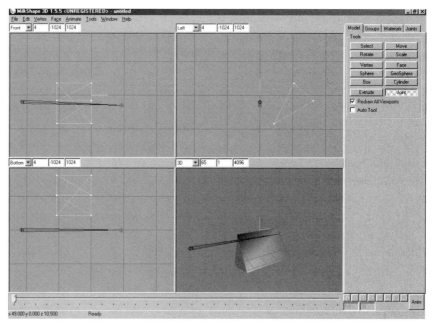

FIGURE 14.24 Creating joints and bones in MilkShape is a very easy process.

MENU

The menus in MilkShape 3D are consistent with the majority of Windows-based applications.

File

The last thing we'll look at in this introduction to MilkShape is the File menu, which can be seen in Figure 14.25. There really isn't much to discuss with this menu. It contains all of the standard file operations such as Open, Close, and Save. Most of the items in the File menu are self-explanatory, with the exception of Merge, which does just what its name implies. It merges two 3D files together.

FIGURE 14.25 MilkShape has a standard Windows menu.

Lastly, the Import and Export options offer a great deal of functionality for game developers. Perhaps the most important aspect of any modeler is the file formats they offer. MilkShape excels in this area. Depending on your needs, MilkShape can export models to many popular game formats, including the following:

- Half-Life SMD
- Quake I MDL
- Quake II MD2
- Quake III Arena MD3
- Vampire t:MR NOD
- Lithtech ABC v11, v12
- Genesis3D BDY 1.0
- Genesis3D MOT 1.0
- Unreal/UT 3D
- Nebula Engine
- Wavefront OBJ
- 3dstudio ASC
- Lightwave LWO
- AutoCAD DXF
- POV-Ray INC
- VRML1 WRL
- Autodesk 3DS
- MilkShape 3D
- ASCII RAW
- Renderman RIB

Edit

The Edit menu is missing several of the normal features you might expect in a Windows application. It does not offer the standard Cut, Copy, and Paste commands. Instead, you can use Duplicate Selection, which will copy any faces you currently have selected. It will not copy vertices. Also, the duplicated section will be placed in the exact location as the original, so you may not see it at first glance.

Vertex

The Vertex menu offers several options, all related to vertices. First, you can snap two vertices together with Snap Together. You can also snap a vertex to the grid or weld them together, which you always do after you snap them together. Flatten allows you to flatten all of the vertices to a particular plane. Lastly, the Mirror commands are particularly useful when you have duplicated an object.

Faces

This menu offers options for faces in MilkShape. The first menu option, Reverse Vertex Order, will make a visible face invisible or an invisible face visible. It does this because a face has only one visible side. You can just think of it as a type of toggle that allows a face to be on or off. Subdivide 3 and 4 both subdivide a face into three or four parts, respectively.

In Figure 14.26, you can see a square with two faces selected. If you click on Faces, Turn Edge, you will notice that the edge will turn and will now appear like that seen in Figure 14.27. The last command we'll look at is Face to Front, which works the opposite of Reverse Vertex Order.

FIGURE 14.26　A square with two faces selected.

FIGURE 14.27　The edge between two faces has been turned.

Others

The remaining menus can be covered very quickly. The Animate menu contains everything related to animation. We will look at it in greater detail in a later chapter. The Tools menu contains information specific to individual model formats such as Half-Life and Quake III Arena. If you are planning to use MilkShape for a specific type of file format, you may

want to invest a little time to work through this menu. The last menu, Window, was already looked at earlier in the chapter. It gives us the option to arrange our viewpoints in specific ways.

CHAPTER REVIEW

While there are several great 3D modelers on the market that cost in the thousands of dollars, MilkShape provides some of their functionality at only $20. It would be difficult to find such a bargain in another software package. Not only is the program inexpensive, it also offers everything you need for the type of low-polygon modeling necessary for real-time game development. With the basic information you have gained in this chapter, it will be possible to move on to creating simple game models with MilkShape. In the next chapter, we'll look at Paint Shop Pro, which will be used for creating 2D graphics and textures for our 3D models.

INTRODUCTION TO
PAINT SHOP PRO

Paint Shop Pro™ is an excellent graphics editor and is a great choice for game developers. Currently in its seventh release, Paint Shop Pro offers a tremendous number of features in a very low-cost product. It supports both bitmap and vector objects, which allow you to have access to both types of graphics without purchasing another tool. For game designs and texture creation, Paint Shop Pro offers everything you need in one easy-to-use package.

INSTALLATION

ON THE CD

Before we begin discussing specifics of Paint Shop Pro, we need to install it. It's located on the CD-ROM that shipped with the book in the Applications directory and is called PSP702ev.exe. If you would prefer, you could download the most up-to-date version from *http://www.jasc.com*.

The first step in the installation process is running the executable file. It will begin the installation process, and you will be presented with a screen that looks similar to Figure 15.1. You can leave the directory as it is listed. It's only a temporary directory for the installation files.

FIGURE 15.1 The installation program begins with this screen.

Click the Next button to continue the installation. The next step will take a few moments before another window will finally appear. It should look similar to Figure 15.2. You need to click the Next button at this window.

FIGURE 15.2 Click Next at this window to continue the installation.

The next window that is displayed is a license window, which can be seen in Figure 15.3. It displays the Paint Shop Pro license agreement that you should read. In order to continue the installation, you need to accept the terms of the license.

FIGURE 15.3 You need to accept the license agreement before you can continue.

After you accept the agreement, click the Next button. The window seen in Figure 15.4 is displayed and allows you to select a complete installation or a custom installation. Leave the installation set at Complete and click Next.

FIGURE 15.4 Choose a Complete installation from this window.

The last step is to select the Install button from the window that looks similar to Figure 15.5.

FIGURE 15.5 This is the final step in the installation process.

Once you have finished the installation, the InstallShield Wizard will display a window that looks something like Figure 15.6. You should choose to create a shortcut on the desktop from this window and click Next. In the last window, you should click Finish.

FIGURE 15.6 Clicking Finish in the next panel ends the installation process.

Once the installation has been completely finished, you will find a shortcut to Paint Shop Pro on your desktop. Double-click the Paint Shop Pro shortcut. When it is first started, a window will be displayed that looks like Figure 15.7. If you would like to purchase Paint Shop Pro, you can do so by clicking on the Order button. It will give you details on how to purchase Paint Shop Pro. If you do not choose to purchase it, you can use Paint Shop Pro freely for 30 days by clicking the Start button to move on.

Paint Shop Pro will function correctly for only 30 days unless you purchase it.

Another window will be displayed that asks you to pick your file associations. If you are unfamiliar with file associations, they allow a program such as Paint Shop Pro to be opened simply by double-clicking a file it is associated with. Unless you have some specific files in mind, you should leave the standard files selected, some of which are displayed in Figure 15.8.

FIGURE 15.7 This window allows you to purchase Paint Shop Pro or use it in trial mode for 30 days.

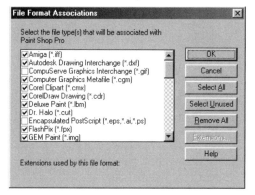

FIGURE 15.8 You can select certain files to be associated with Paint Shop Pro.

Once you have determined the correct files, you can click the OK button to display the standard Paint Shop Pro user interface.

USER INTERFACE

Now that the software has been installed, we'll look at the basics of the user interface and a few of the most important tools that are available in Paint Shop Pro. In Chapter 8, "Multimedia Fusion Editors," we used Paint Shop Pro for designing textures and a user interface for the first person shooter we created.

The Paint Shop Pro user interface can be seen in Figure 15.9. It's a very good design for a user interface because it provides excellent functionality but is very easy to learn.

FIGURE 15.9 Paint Shop Pro has an interface very similar to most Windows applications.

Figure 15.10 illustrates the user interface elements.

In the following sections, we'll look at several of the labeled entries in more detail.

The Toolbar

The toolbar contains options for doing many routine tasks such as opening, closing, saving, copying, and pasting. The toolbar displays buttons corresponding to the menu commands. It's much easier to click the toolbar

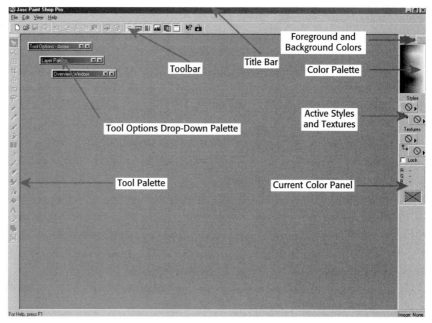

FIGURE 15.10 The Paint Shop Pro interface with everything labeled.

button instead of looking through the menu for the corresponding option. If a command is available, you can click on it. Otherwise, it will be grayed out and will be unavailable for selection.

Tool Palette

The Tool Palette contains the painting, drawing, and retouching tools. You can see the tools in Figure 15.11.

Tool Options Palette

When you click a Tool Palette button, the Tool Options Palette displays the options associated with the tool, and the status bar displays a short description of its use. Depending on the current tool, you can select a single tab of options or multiple tabs. The palette has a permanent tab that allows you to modify the appearance of the cursor and the settings for a pressure-sensitive tablet.

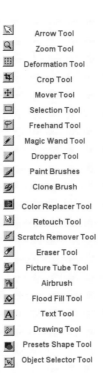

Arrow Tool
Zoom Tool
Deformation Tool
Crop Tool
Mover Tool
Selection Tool
Freehand Tool
Magic Wand Tool
Dropper Tool
Paint Brushes
Clone Brush
Color Replacer Tool
Retouch Tool
Scratch Remover Tool
Eraser Tool
Picture Tube Tool
Airbrush
Flood Fill Tool
Text Tool
Drawing Tool
Presets Shape Tool
Object Selector Tool

FIGURE 15.11 The Tool Palette contains a variety
of drawing, painting, and retouching tools.

Color Palette

You use the Color Palette to select the colors, gradients, patterns, and tex-
tures that you want to apply to an image. When you move the cursor
over the available colors panel, it changes to the eyedropper tool. A single
click will change the foreground color, and a right-click will change the
background color. Directly above the available colors, you will see the
currently selected foreground and background colors.

Style and Texture

The style and texture tools are useful for determining if you want to paint
with a solid color, a texture, or a pattern. The upper boxes display the
foreground and stroke styles, and the lower boxes display fill and back-
ground styles.

PAINTING TOOLS

Paint Shop Pro provides several tools that you can use for painting. The painting tools, which are available on the Tool Palette, can be used only on raster layers; the drawing tools, which are also available on the Tool Palette, can be used on either raster or vector layers. We'll look at several of the most important features of the tools.

Paintbrush

The paintbrush is useful for painting freehand, much as you would with a regular paintbrush. You simply select the Paintbrush tool and click and drag the cursor while holding a mouse button. If you want to apply the current foreground and stroke style, you use the left mouse button. The right button applies the background and fill style. Releasing either button ends your current painting. If you would like to create straight lines, you should hold down the Shift key and click the beginning point. Then, move to where you would like the line to end and click again. Figure 15.12 displays the differences between freehand drawing and holding with a mouse and holding down the Shift key to draw straight lines.

FIGURE 15.12 Painting freehand with the mouse.

Eraser

You can use the eraser to remove colors from an image, replacing them with the background color or transparency. Although you should be careful when using the eraser, you can easily restore a mistake by pressing Ctrl+Z or selecting Undo from the Edit menu.

Airbrush

The airbrush works in much the same way as the standard Paintbrush tool, but instead of a solid color, it simulates an airbrush or spray can. You can use it to draw freehand or, by holding the Shift key, you can force it to draw straight lines. Figure 15.13 displays a sample of painting comparing the standard paintbrush and the airbrush.

FIGURE 15.13 The airbrush works similarly to the standard paintbrush.

PICTURE TUBE

Paint Shop Pro's picture tubes, some of which can be seen in Figure 15.14, are one of its best features because they allow you to paint with a variety of preexisting objects. You can add everything from raindrops to flowers to an image very quickly. There are hundreds of picture tubes available on the Internet, or you can use the ones that come with the program. You can even design your own with Paint Shop Pro.

FIGURE 15.14 Some of the picture tubes in Paint Shop Pro.

You can quickly see the power of the picture tubes by looking at Figure 15.15. Every object in it was added with the Picture Tube tool, and the entire image was created in less than 30 seconds.

FIGURE 15.15 You can quickly create entire scenes with picture tubes.

FLOOD FILL TOOL

The last tool we'll look at is the Flood Fill tool. It fills an area with a color, pattern, or gradient. You can use this to quickly add patterns or solid colors to the entire background of an image. You can also fill only a selection using the selection tool.

There are many more tools available in Paint Shop Pro, and you are encouraged to spend time going through its Help file. This chapter is here to introduce you to some of the concepts of Paint Shop Pro. When we later use it for creating graphics and textures, we'll do everything in a step-by-step manner.

VECTOR DRAWING TOOLS

One of the newest trends in raster editing tools such as Paint Shop Pro is to add vector drawing and editing tools. Paint Shop Pro has added several tools that allow you to use raster and vector graphics in a single application, which makes your job much easier.

VECTOR VERSUS RASTER

Before we move on to look at the vector drawing tools, it's important that you have a basic understanding of the difference between vector and raster formats.

Vector images are not made up of pixels. Instead, they are composed of mathematical instructions that draw an image. This has several advantages over pixel-based images. First, every object is stored as a separate item in an image. This information stores data such as position, width, height, and color, to name a few. Vector-based images are resolution independent. That is, they can be freely resized without losing image quality. You may wonder how a monitor, which uses pixels, can display these mathematical computations in a manner we understand. The vector images go through a process so that the monitor can see them. The rasterized images can then be displayed on the screen.

A *raster file* is composed of units of light, each of which is called a pixel. By grouping these pixels, a raster image can be created. The pixels can be blended to create smooth transitions for objects, which makes it good for gaming. Raster images are resolution dependent. That is, you specify the resolution and pixel dimensions when you create the image. If you later decide to increase or decrease the image, this can have a negative impact on the image's quality.

LAYERS

Default Paint Shop Pro images consist of a single layer—the background layer—which is comparable to a canvas you would paint on in the real world. You can create additional layers, stacking them upon one another. Paint Shop Pro supports up to 100 layers per image, although the number might be smaller, depending on your computer memory.

The Layer Palette allows you to switch between the various layers in an image with a single mouse click. As you can see in Figure 15.16, it lists details about each layer. By clicking on the layer visibility toggle (it looks like a pair of glasses), you can display or hide any layer in the image. If you save your image to the internal Paint Shop Pro file format (PSP), the layers will be saved with the image. Otherwise, the image will be flattened when it is saved in another format.

FIGURE 15.16 The Layer Palette allows you to quickly view layer information.

You can create three types of layers in Paint Shop Pro: raster layers, vector layers, and adjustment layers. Raster layers, like raster graphics, contain pixel-based information. Vector layers contain mathematical instructions for drawing vector lines, shapes, and text. Lastly, adjustment layers contain color correction information that is used to alter layers placed beneath them. It's easy to distinguish between vector and raster layers in the Layer Palette. The Layer Palette displays the vector icon, and when the layer contains vector objects, a plus sign appears next to the icon. You can see an example of this in Figure 15.17. If you click the plus sign, the individual objects that are on the vector layer can be seen.

You cannot place vector objects on raster layers. Likewise, you cannot place raster objects on vector layers.

FIGURE 15.17 Vector and raster layers are distinguishable in the Layer Palette.

DRAW TOOL

The Draw tool may be the most powerful tool available in Paint Shop Pro. You can use the Draw tool for both raster and vector drawing, depending on the type of layer you are working on. It can draw straight lines, free-hand lines, or even Bezier curves. Vector-drawn objects can be moved, deformed, and edited after they are created without affecting anything else in the image.

CHAPTER REVIEW

As you have seen throughout this chapter, Paint Shop Pro offers a tremendous number of features and is easy for beginners to learn because the user interface can be mastered with relatively little effort. We have just touched on the basics of this software and will use it later to create textures and 2D graphics for our game project.

SIMULATING 3D WITH MMF

In the chapters leading up to this one, we have briefly turned our attention to some of the other tools that we have at our disposal. In this chapter, we're going to get back to the development tools and will take a more in-depth look at Multimedia Fusion. More specifically, we are going to look at how we can simulate a 3D game environment with a tool that offers a mostly 2D set of tools.

3D SPRITE OBJECT

The most obvious way we can do 3D in MMF is with the 3D Sprite object. This object lets you display and manipulate 3D objects in your applications. You can rotate the 3D Sprite object around or translate it on the x-, y-, or z-axis, effectively allowing you to simulate a 3D environment in your applications. 3D Sprite objects appear larger as they move forward and smaller as they move away in your applications.

It's very easy to add 3D Sprite objects to an application. In fact, within a few steps, you can have a fully functional object representing a 3D model in your programs. We'll take a moment now to look at how easy it is to add a 3D Sprite to an application and how we can manipulate it once it's available.

First, open MMF and create a new application. Next, open the Frame Editor and choose Insert New Object into Frame from the Insert menu. This displays a window that should look like Figure 16.1. Choose 3D Sprite from this window.

FIGURE 16.1 The Create New Object window.

Your interface will now indicate that you have the 3D Sprite object selected as the Create New Object window will be gone, and your mouse

pointer will be replaced with a cross hair (see Figure 16.2). You can now position the cross hair and click the left mouse button to open the 3D Object Editor (see Figure 16.3).

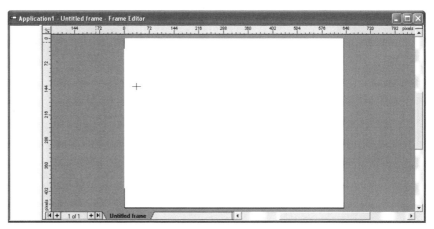

FIGURE 16.2 A cross hair will replace the standard mouse pointer.

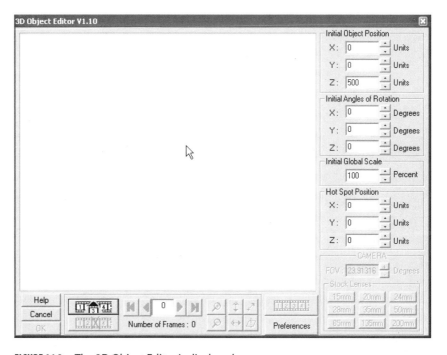

FIGURE 16.3 The 3D Object Editor is displayed.

Along the bottom of the 3D Object Editor window, you should see a button that looks like a filmstrip with frames numbered 1 to 5 and the third frame resting above the others (see Figure 16.4). When you click this button to load a 3D object, a standard dialog box is displayed (see Figure 16.5). You can browse the CD-ROM that accompanies this book to load the sphere.3ds model that is included in the Graphics folder. Once the file is loaded, set the initial Z value to 250. The editor should now look like Figure 16.6.

FIGURE 16.4 We are interested in the button that looks like a filmstrip.

FIGURE 16.5 The standard dialog box is displayed.

Click on the Preview Animation button (see Figure 16.7) to open a new set of options in the editor (see Figure 16.8). Click the Material Color button and choose the blue color seen in Figure 16.9. Click the OK button

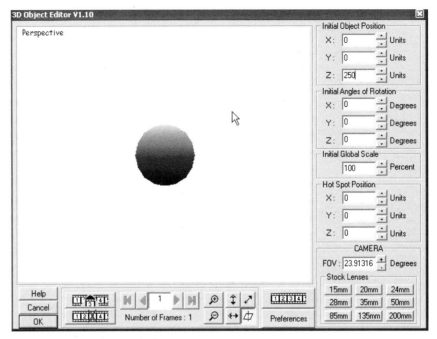

FIGURE 16.6 The editor with changes.

FIGURE 16.7 Click the Preview Animation button to open the 3D Object Preview window.

to go back to the original editor screen and then click the OK button on this editor as well. You will be asked if you would like to save your 3D object (see Figure 16.10), and you should choose the Yes button from the window. Give the 3D animated object the name *sphere*. You will now see the item in the Frame Editor (see Figure 16.11). You can use the handles to resize the object so that the sprite is completely visible, although it will not perform any actions if you run the program. We will do this next.

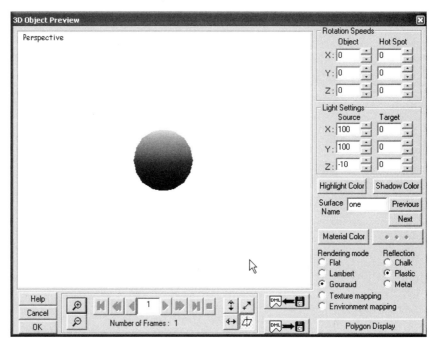

FIGURE 16.8 The 3D Object Preview window provides a variety of options.

FIGURE 16.9 We're choosing blue as a color from the available options.

FIGURE 16.10 A dialog box is displayed, prompting to save the 3D object.

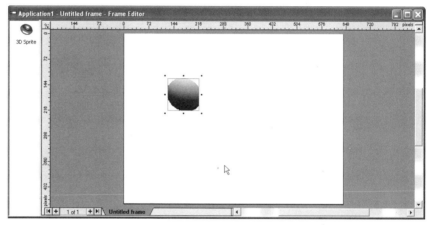

FIGURE 16.11 The Frame Editor is displayed, showcasing the changes we made to the object.

Open the Events Editor and create a new event using Mouse, User Clicks On an Object (see Figure 16.12). This will display a new window (see Figure 16.13), which should be left with the default settings of Left Mouse button and Single Click. Click OK to move to the next step, where we select our 3D Sprite (see Figure 16.14).

With the event created, we can now perform an action that will occur when the button is clicked. Right-click on the square beneath the 3D Sprite and choose Set 3D Position, Set Z Position (3D). The Set Z Position window is displayed (see Figure 16.15). Click the Retrieve Data from an Object button to display a new window (see Figure 16.16). Right-click the 3D Sprite object and choose 3D Position, Z Position. This will retrieve the current position of the 3D Sprite. We'll need to subtract 10 from this position so that the ball moves when clicked on. Append –10 to the expression in the editor (see Figure 16.17) and click OK to add the action.

FIGURE 16.12 A new condition is being created.

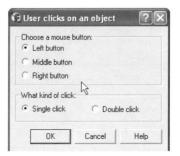

FIGURE 16.13 The default settings are OK.

Test the application to make sure that the 3D Sprite moves when executed. You can see how this type of object will be useful when we begin work on our first 3D program, but it is not our only option when using MMF. In the next sections, we'll look at several additional ways we can simulate 3D in our games.

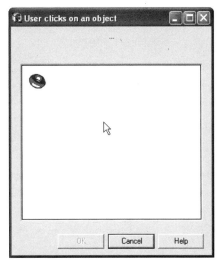

FIGURE 16.14 Our 3D Sprite is the only object available from the window.

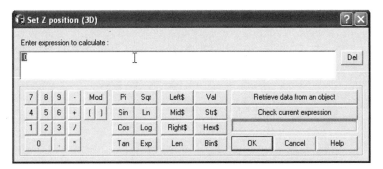

FIGURE 16.15 The Set Z Position window with the Expression Editor.

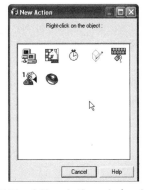

FIGURE 16.16 A New Action window is opened.

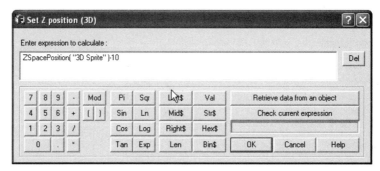

FIGURE 16.17 Our final expression.

THIRD-PARTY EXTENSIONS

If the 3D Sprite object is the most obvious way to add 3D to MMF, then the numerous third-party extensions are a close second. There are several third-party extensions written exclusively for MMF, and because MMF allows some functionality with ActiveX controls written for languages such as Visual Basic, you can take advantage of some solutions developed for other environments. We'll limit our brief look at a couple of the MMF specific extensions.

Mode 7 ex

Mode 7 ex was developed by Cellosoft (*www.cellosoft.com*) and is undoubtedly one of the best of the third-party 3D objects available for MMF. If you have been a game player, you may have already heard of Mode 7, a hardware graphics mode popularized by the Super Nintendo Entertainment System (SNES) for rotating and scaling images. It was used mainly for special effects and to add perspective to maps that would normally be 2D.

According to the Mode 7 ex documentation, it offers numerous new features over the original Mode 7, including:

Heightmap for voxel terrains
DirectDraw compatibility
Internal image support
Auto-redraw handling
New render settings: fog, interpolation, mip-mapping, wrapping
Secondary layer
Vitalize 3 Certified!

We're not going to go through the process of creating a project with the Mode 7 object as several excellent examples are available for download from the Cellosoft Web site. You can see a screen shot from one of these examples in Figure 16.18.

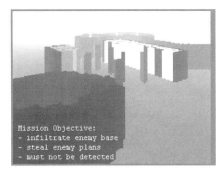

FIGURE 16.18 An example of the power of Mode 7.

ACTIVE PICTURE AND ACTIVE OBJECT

While the first two items we looked at were very obvious ways that we can add 3D to an MMF game, the next option we'll look at probably isn't. At first glance, the use of the standard 2D Active Object or Active Picture to simulate 3D may not make a great deal of sense. However, with a quick example, it's very easy to see how to take advantage of the normally 2D graphics.

Example

It's very easy to see how this concept will work. We can simply resize the Active Picture or Active Object graphics to simulate moving toward or away from the screen. For example, to simulate an object moving away, we'll resize it to make it look smaller. Likewise, we can make it larger so that it appears to be moving toward us. Take a look at Figures 16.19, 16.20, and 16.21. They show a small square object getting smaller to simulate moving away from us.

If Figures 16.19 to 16.21 were executed quickly, it would appear as though the square were moving away. We can add to this by including

FIGURE 16.19 Largest view of object.

FIGURE 16.20 Getting smaller.

things like mock shadows and movement in the x and y 2D coordinates. Unlike the Active Picture, an Active Object does not allow us to resize it programmatically. Instead, we can handle this by designing graphics in the various sizes we'll need and altering them accordingly.

FIGURE 16.21 Smallest view of object.

CHAPTER REVIEW

In this chapter, we looked at 3D options we have at our disposal in MMF. We'll put our theories to work in several ways in the next few chapters as we create a simulated 3D game.

In the previous chapter, we began to look at simulating 3D in MMF. In this chapter, we are going to create the graphics for the game we are now working on. We'll be drawing a background image along with an image of a duck. We'll actually create the duck twice (once in this chapter and once in the next) as a way to compare drawing the graphic in 2D in Paint Shop Pro as opposed to rendering it in 3D with MilkShape.

STEP-BY-STEP DRAWING BACKGROUND

Unlike most of the chapters in this book, this one basically amounts to a series of steps that can be followed in order to get the desired results.

1. Create a new image in Paint Shop Pro using Figure 17.1 as a guide for settings.

FIGURE 17.1 These are the correct settings for the new image.

2. Click Preset Shapes in the toolbar (see Figure 17.2).
3. Choose the triangle shape from the drop-down list (see Figure 17.3).
4. Do not create as a vector (see Figure 17.4).
5. Position your mouse approximately halfway down the left side of the image as seen in Figure 17.5.

FIGURE 17.2 Choose Preset Shapes from the toolbar.

FIGURE 17.3 The triangle shape needs to be selected.

FIGURE 17.4 We do not want this to be a vector.

FIGURE 17.5 Position it near the middle of the screen.

6. Click and drag to draw a triangle similar to that in Figure 17.6.
7. Continue to draw uneven triangles across the middle (see Figure 17.7). Don't worry if they are even at the bottom or top.
8. Choose the Magic Wand tool (see Figure 17.8).

FIGURE 17.6 Draw the triangle using this image as a guide.

FIGURE 17.7 Draw uneven triangles.

FIGURE 17.8 Select the Magic Wand tool.

9. Click above the triangle to select the uppermost portion of the page. You can see the selection box in Figure 17.9.

FIGURE 17.9 The selection box is visible.

10. Choose the Flood Fill tool (see Figure 17.10).

FIGURE 17.10 The Flood Fill tool is selected next.

11. Along the right side of the interface, choose the Style button and make sure Solid is selected (see Figure 17.11).

FIGURE 17.11 Choose a solid style.

12. Change the color to a shade of blue that will represent a sky, using Figure 17.12 as a guide.

FIGURE 17.12 Change the color to a shade for a blue sky.

13. Position the Flood Fill tool inside the selection box created with the Magic Wand and left-click (see Figure 17.13).

FIGURE 17.13 Flood fill the selection box.

14. Choose Invert from the Selections menu to change the selection from the top to the remaining image (see Figure 17.14).

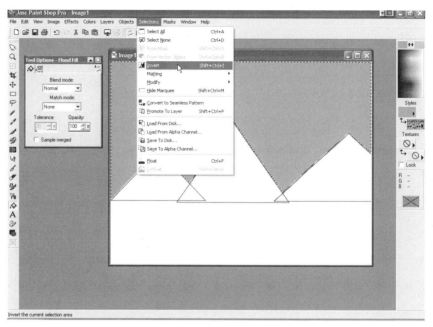

FIGURE 17.14 Invert from the menu.

15. Change the color to dark green and use the Flood Fill tool in the new selection (see Figure 17.15).

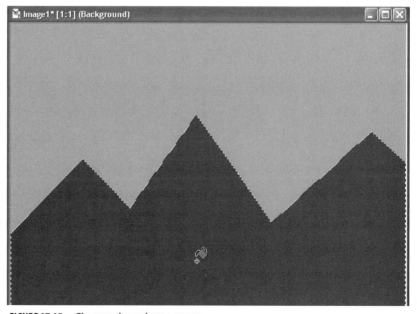

FIGURE 17.15 Change the color to green.

16. Choose the selection tool (see Figure 17.16).

FIGURE 17.16 We need to use the selection tool.

17. Right-click on the image to deselect the current selection.
18. Position the cursor at the lowest point on the leftmost triangle (see Figure 17.17).

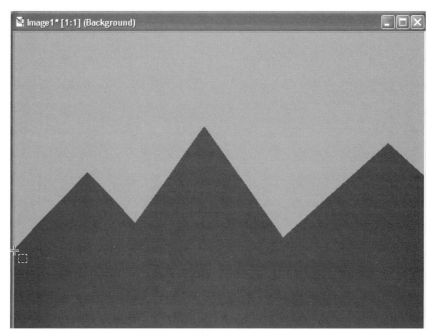

FIGURE 17.17 Position the cursor using this as an approximate guide.

19. Click and drag to the lower right to create a new selection box (see Figure 17.18).

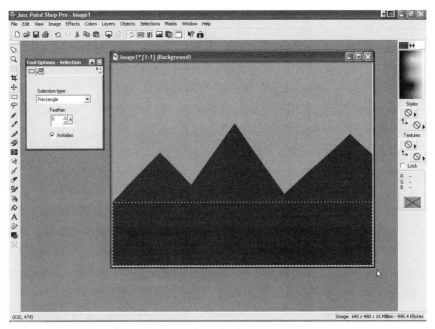

FIGURE 17.18 Click and drag to create the selection.

20. Choose the Flood Fill tool, change the color to darker blue, and fill the selection (see Figure 17.19).

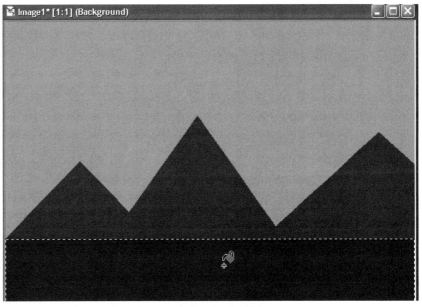

FIGURE 17.19 Change the color to a darker shade of blue.

Drawing Clouds

We now have the basics of our background finished and will move on to add some clouds, again using a step-by-step approach:

1. Create a new layer (see Figure 17.20).

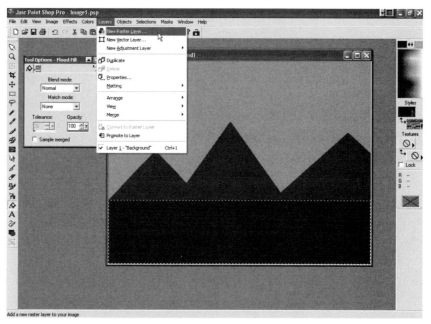

FIGURE 17.20 Create a new layer for our image.

2. The layer default properties, seen in Figure 17.21, can be left as is, so click the OK button.

Nothing appears to have changed, but we are now on the second layer. You can verify this by looking at the layer information in the image heading seen in Figure 17.22 or by attempting to edit the first layer contents at this time. As an example, you could try to erase some of the mountains.

3. Choose the Preset Shapes tool. Select the ellipse.
4. Draw a series of three ellipses, referring to Figure 17.23.

FIGURE 17.21 The default properties are OK.

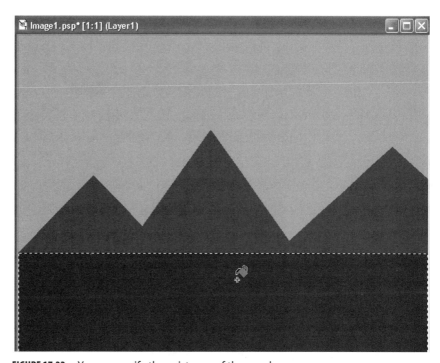

FIGURE 17.22 You can verify the existence of the new layer.

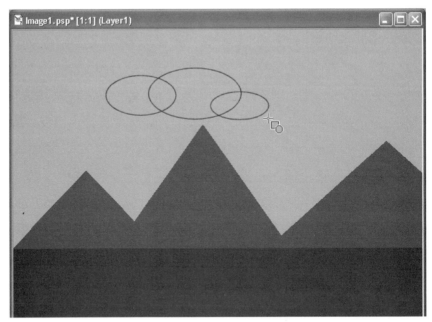

FIGURE 17.23 Draw a series of ellipses.

5. Choose the Magic Wand tool and click inside the three ellipses to se-
lect the layer areas that are not inside the cloud (see Figure 17.24).

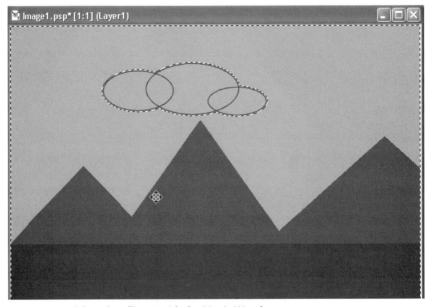

FIGURE 17.24 Select the ellipses with the Magic Wand.

6. Choose Selections, Invert (see Figure 17.25).

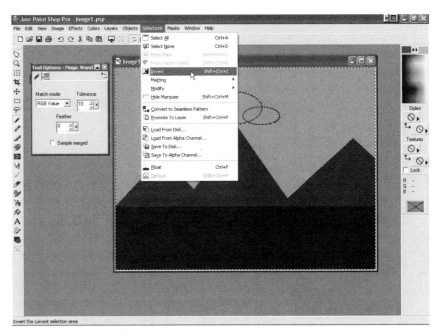

FIGURE 17.25 We need to invert our selection.

We now have the entire cloud selected (see Figure 17.26).

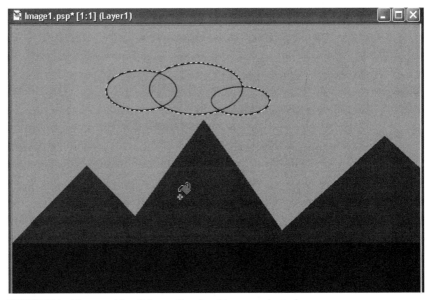

FIGURE 17.26 The outside of the entire cloud is now selected.

7. Choose Expand to make sure we get any areas on the edge that might contain a small amount of black from drawing the outline of the ellipses (see Figure 17.27).

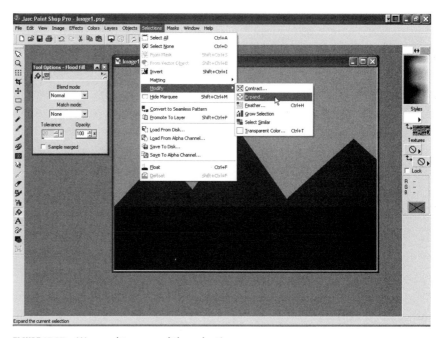

FIGURE 17.27 We need to expand the selection.

8. Expand the selection window and choose 5 pixels (see Figure 17.28).

FIGURE 17.28 We'll use 5 pixels for our width.

9. Choose Flood Fill and fill with white color (see Figure 17.29). The cloud is now finished.

Because it is on a layer by itself, we can now position the cloud anywhere on the image with the Mover tool (see Figure 17.30). Select the tool and click and drag the image to position the cloud in the upper right

FIGURE 17.29 Fill with white.

FIGURE 17.30 Position the cloud with the Mover tool.

using Figure 17.31 as a guide. Our selection is still visible on the figure, so we can use the Fill tool to create another cloud in the position where the original one was located (see Figure 17.32). Fill the inside of the selection again to create the cloud (see Figure 17.33).

FIGURE 17.31 This would be an approximate location.

FIGURE 17.32 We'll create another cloud.

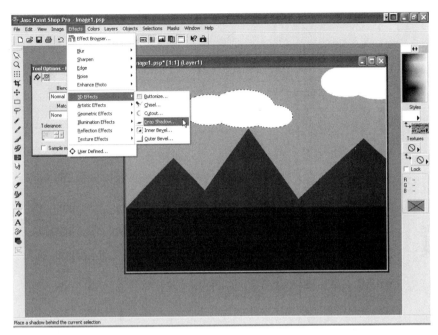

FIGURE 17.33 Fill the cloud again with white.

At this time, save the drawing as a Paint Shop Pro file (name it Chapter 17.PSP) so that you can reopen the file at a later date and edit the layers. Next, you can save a copy as a BMP file. A window will appear (see Figure 17.34) to remind you that you'll lose all layer information. Remember to always keep your original in PSP format so that you can edit it and save copies of the items for the respective packages you'll use them in. You'll see in a minute why this can be so important.

FIGURE 17.34 A reminder will appear whenever you save an image outside the default PSP file format.

CLOUD FOR MMF

Our next objective is to create an empty cloud to import into MMF so that it can move inside the game. Close the Chapter 17.PSP file and then reopen it. You'll see that it is exactly the same as we left it. This is important, as we'll now create a quick cloud based on our last selection.

1. Choose Contract Selection (see Figure 17.35).

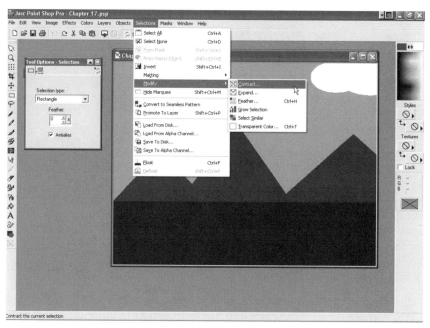

FIGURE 17.35 Contract the selection to make it smaller.

2. The number of pixels to choose is 10 (see Figure 17.36).
3. Now choose Copy (see Figure 17.37).
4. Choose Paste as New Image (see Figure 17.38).

FIGURE 17.36 We'll use a value of 10 pixels.

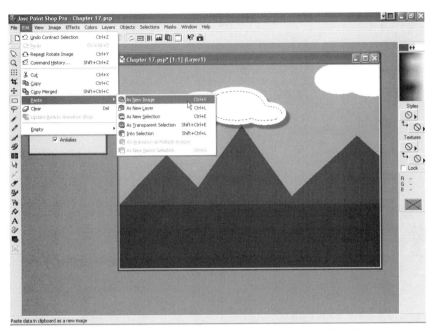

FIGURE 17.37 Choose Copy to place a copy of the cloud on the Clipboard.

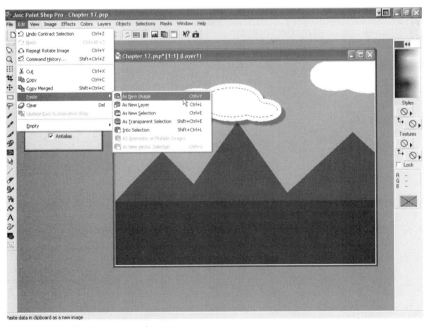

FIGURE 17.38 Paste as a new image.

The new figure is displayed similarly to Figure 17.39.

FIGURE 17.39 The new image looks like this.

5. You can make the image larger by choosing Canvas Size (see Figure 17.40).

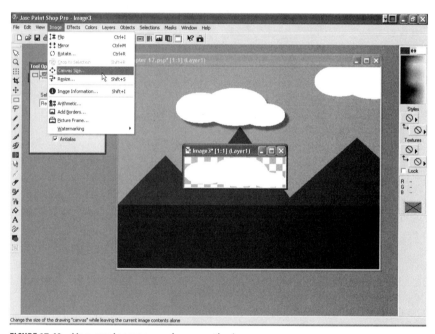

FIGURE 17.40 You can increase or decrease the image.

The Canvas Size window appears and looks like Figure 17.41.

6. You can make it slightly larger such as 300 × 85 (see Figure 17.42).

The image is now larger, and we can rotate it so that it doesn't look identical to the other clouds.

7. Choose Rotate (see Figure 17.43).

FIGURE 17.41 The Canvas Size window.

FIGURE 17.42 Make the image larger.

FIGURE 17.43 We are going to rotate the cloud.

The Rotate window appears (see Figure 17.44).

8. Choose Free and set it at 10 (see Figure 17.45).

FIGURE 17.44 The Rotate window.

FIGURE 17.45 We'll rotate with a few options.

9. Save as cloud.psp and also save a copy as cloud.bmp.
 We'll create one more. Choose Resize (see Figure 17.46).
 The Resize window appears (see Figure 17.47).

FIGURE 17.46 We're going to create another cloud.

FIGURE 17.47 The Resize window.

10. Choose Percentage of Original and 80% as a value (see Figure 17.48).

FIGURE 17.48 We'll make the cloud smaller.

11. Select Mirror and choose Flip.
12. Save as cloud2.psp and a copy as cloud2.bmp.

DRAWING THE DUCK

We now have all the background images finished, so it's time to draw the main character, a duck. We'll ultimately use the image we render in MilkShape for our game, but because it's an interesting comparison, we'll also draw the image in PSP.

1. Create a new image sized 80 × 50 in PSP.
2. It looks very small onscreen (see Figure 17.49), so we can zoom in by 5 by choosing Zoom (see Figure 17.50).

FIGURE 17.49 We need to zoom in.

FIGURE 17.50 The Zoom command is located in the View menu.

It's now much easier to work with (see Figure 17.51).

FIGURE 17.51 We now have a much better picture of the image.

3. Select the Preset Shapes tool and choose Ellipse.
4. Draw two ellipses (see Figure 17.52).
5. Use the Magic Wand to select outside of the ellipses (see Figure 17.53).

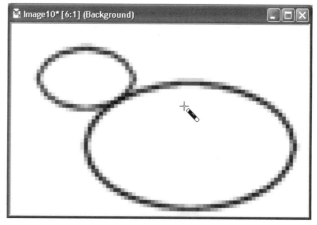

FIGURE 17.52 Draw two ellipses.

FIGURE 17.53 The Magic Wand selects the outside of the ellipses.

6. Choose Selection, Invert (see Figure 17.54).

FIGURE 17.54 Invert the selection.

7. Use the Flood Fill tool and a yellow color to fill (see Figure 17.55).
8. We'll just freehand the small details. Invert the selection again (see Figure 17.56) and choose Paintbrush tool (see Figure 17.57).

FIGURE 17.55 Flood fill with yellow.

FIGURE 17.56 Invert the selection again.

FIGURE 17.57 Choose the Paintbrush tool.

9. Set the brush Size to 1 and Hardness to 1 (see Figure 17.58). If this menu is not visible, right-click on the paintbrush and choose Tool Options from the pop-up menu.

FIGURE 17.58 Set a hardness of 1.

10. Select the orange color and draw a beak (see Figure 17.59). We reversed the selection again so that we did not accidentally interfere with the yellow body with the orange paint.

FIGURE 17.59 Select the color orange to draw the beak.

11. Change the color to dark blue and invert the selection once again and draw an eye (see Figure 17.60).

FIGURE 17.60 The next step is to draw an eye.

At first glance, this seems to be a quick route to produce the duck. However, we have not yet completed any of the "tipping over" animations, which are going to be a time-consuming process in PSP. In the next chapter, you'll see that it takes slightly longer to create the model in 3D, but the simple animation will be very easy to do, which is why the 3D route is ultimately a great timesaver.

Before we move on, let's square off the bottom of the figure so that it looks like it is flat on the bottom. Choose the selection tool and draw a rectangle along the bottom (see Figure 17.61). Press the Delete key on your keyboard several times to remove any yellow from this area (see Figure 17.62). We are done in PSP for the moment and will return to it later in the next chapter.

FIGURE 17.61 Draw a rectangle along the bottom.

FIGURE 17.62 Remove all the yellow along the bottom.

CHAPTER REVIEW

In this chapter, we created a variety of graphics, all centered on the background images for our game. In the next chapter, we'll use MilkShape to create the duck model, and then we'll create the simple animations for the duck.

3D MODELS FOR DUCK BLAST

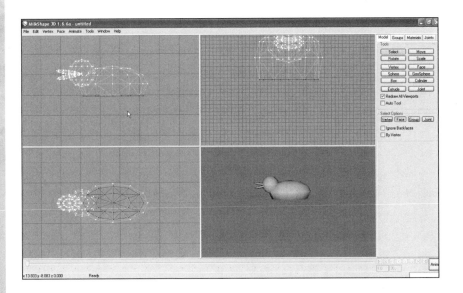

In the previous chapter, we created some graphics in Paint Shop Pro that will be used in our MMF game. One such graphic is that of the main character, a duck. In this chapter, we're going to re-create the duck as a 3D model in MilkShape, the 3D modeling package we introduced earlier in the book.

STEP-BY-STEP MODELING

Creating this model consists of the following series of steps:

1. Create a sphere similar to the one seen in Figure 18.1.

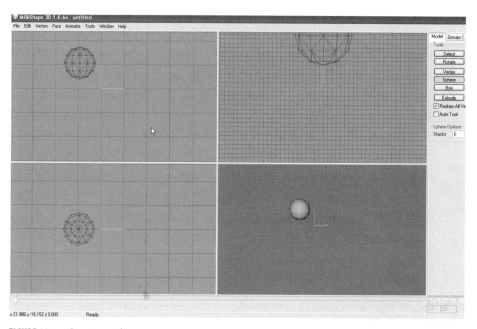

FIGURE 18.1 Create a sphere.

2. Create a second, larger sphere (see Figure 18.2).
3. Scale the second sphere (see Figure 18.3).
4. Create a smaller sphere (see Figure 18.4).
5. Scale the third sphere (see Figure 18.5).

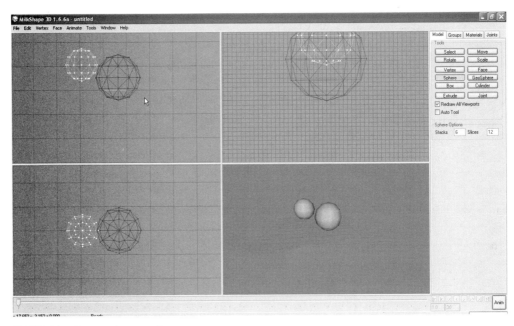

FIGURE 18.2 Create a larger sphere.

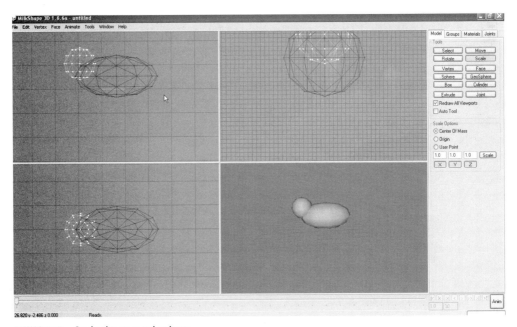

FIGURE 18.3 Scale the second sphere.

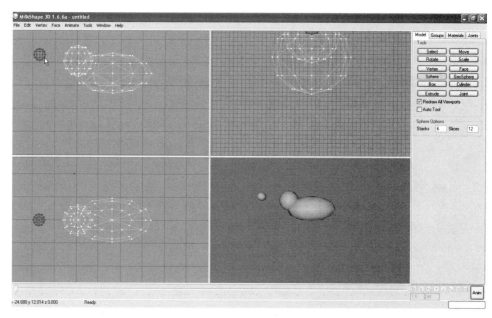

FIGURE 18.4 Create another small sphere.

FIGURE 18.5 Scale the sphere.

6. Move to the appropriate location (see Figure 18.6).

FIGURE 18.6 Position the sphere.

7. Choose Duplicate from Edit menu. At this time, you can't see the original item as it is now hidden under the duplicated version (see Figure 18.7).

FIGURE 18.7 Duplicate the item.

8. Move the duplicated item (see Figure 18.8).

9. Rotate the lower beak (see Figure 18.9).

FIGURE 18.8 Move the newly duplicated item.

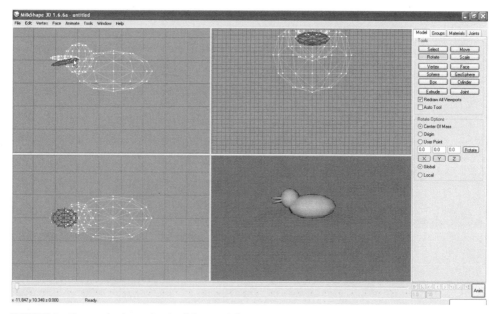

FIGURE 18.9 Rotate the lower beak of the model.

10. Select the upper beak and rotate (see Figure 18.10).
11. Select the faces at the bottom of the duck (see Figure 18.11).

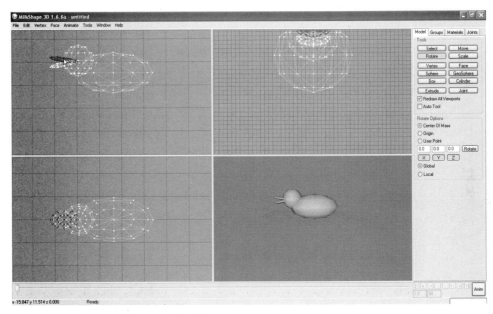

FIGURE 18.10 Select the upper beak and rotate.

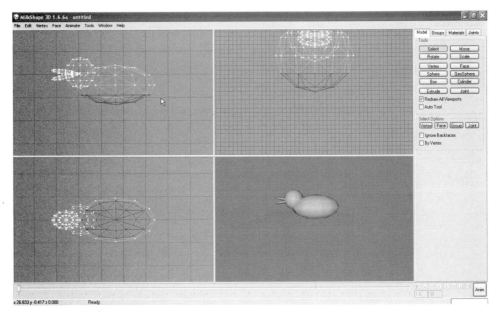

FIGURE 18.11 Select the faces at the bottom of the duck.

12. Choose Vertex, Edit, Y (see Figure 18.12).
13. Save the model as duck.ms3d.

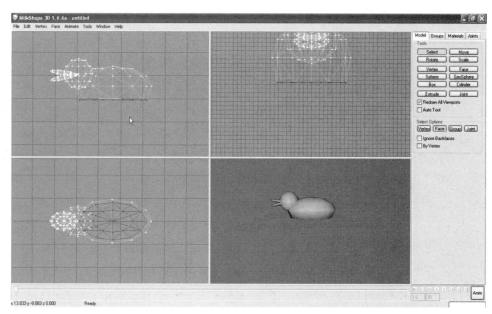

FIGURE 18.12 Edit the vertex.

STEP-BY-STEP SKINNING

1. Open Lithunwrap (see Figure 18.13).
2. Select File, Model, Open, locate the duck.ms3d file, and open it (see Figure 18.14). In the Select menu, make sure Groups is checked.
3. In the Select menu, choose Name (see Figure 18.15). If you were creating a more complex 3D model, it would be wise to spend the time to name various portions of the models with appropriate names. For example, we could change the names of the spheres to Head, Body, and so on. It's unnecessary for this example, but it is something you should keep in mind for future work.

FIGURE 18.13 Lithunwrap can be opened.

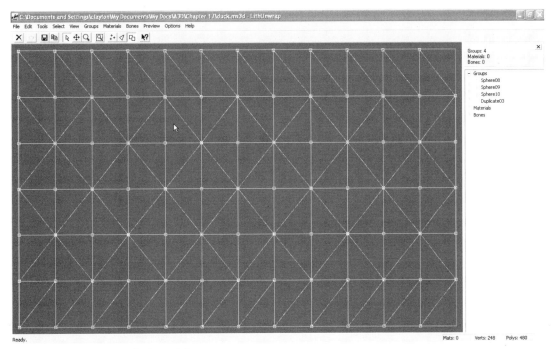

FIGURE 18.14 Locate the duck model.

FIGURE 18.15 Choose Name in the Select menu.

4. Choose Select All, Apply, Close.
5. Tools, UV Mapping, Planar (displays a window setup as in Figure 18.16) and click OK (see Figure 18.17).

FIGURE 18.16 The window is displayed.

6. Choose Materials, Modify (see Figure 18.18).
7. Click the Add button (see Figure 18.19). Type the name **skin** in the Description box and click OK.
8. The name now appears in the window (see Figure 18.20). Select skin and then click Assign. A window appears (see Figure 18.21) from which you can choose OK.
9. Click Close.

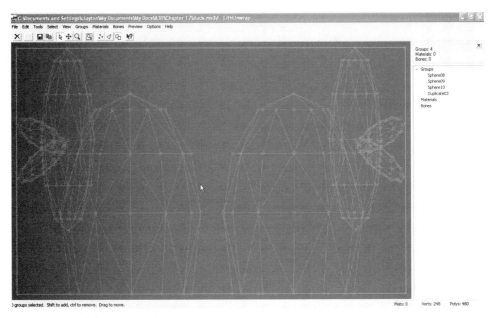

FIGURE 18.17 Click OK to continue.

FIGURE 18.18 We need to modify the materials.

FIGURE 18.19 Click the Add button.

FIGURE 18.20 The name appears in the window.

FIGURE 18.21 This window appears.

10. Choose File, UVMap, Save (see Figure 18.22). Type the name **skin.bmp** (see Figure 18.23). Click OK, as the defaults will work.

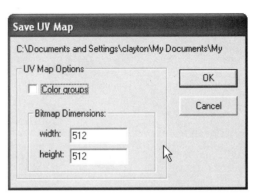

FIGURE 18.22 The first step in saving the UVMap.

FIGURE 18.23 Type the name for the skin.

11. Choose Materials, Modify (see Figure 18.24).

FIGURE 18.24 Modify the material.

12. Click skin and then click the Properties button (see Figure 18.25).
13. From the Map Type drop-down list, choose Bitmap (see Figure 18.26).
14. Click the Properties button beneath Bitmap.
15. Click Change (see Figure 18.27) and then locate skin.bmp, which we exported earlier (see Figure 18.28) and click OK.
16. Click OK to close the Diffuse Map Properties window.

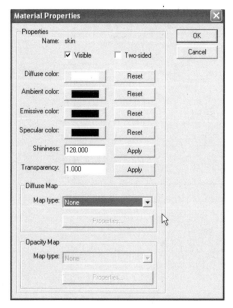

FIGURE 18.25 Choose the skin properties.

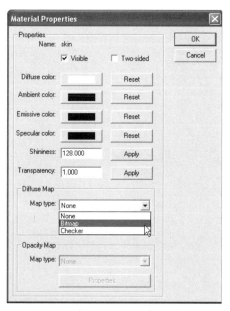

FIGURE 18.26 Choose Bitmap from the drop-down.

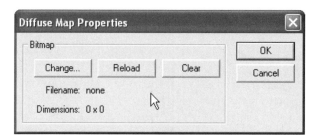

FIGURE 18.27 The Diffuse Map Properties window.

FIGURE 18.28 Locate the skin we exported.

17. Click OK to close Material Properties.
18. Click Close to close the Modify Material window. This takes you back to the main interface.
19. Choose Preview, Show Model (see Figure 18.29), and you can see the black and white exported image. We can now paint the image in PSP to create a skin that will appear on the model.

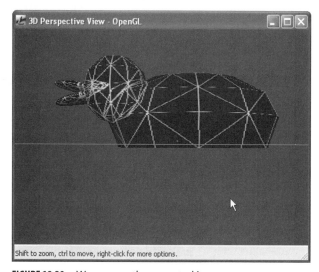

FIGURE 18.29 We can see the exported image.

STEP-BY-STEP PAINTING IN PAINT SHOP PRO

We painted a 2D representation of the duck model using Paint Shop Pro in the last chapter. In this chapter, we'll use this same process to create the skin for our 3D model. You might be wondering why doing a 3D model is the better of the two options if we have to paint the skin anyway. The main reason is because of the various animations that we will be required to do if we are creating a complicated sprite. For example, it is not uncommon to have 10 or 15 different animation sequences for sprites. If you have to draw each of these manually, it would take much longer than simply designing one 3D model and doing the animations within a modeling package. Additionally, if you ever need to use the model for another project, it will already be ready for 2D or 3D.

Painting the skin will involve many of the same tools you used in the last chapter. In fact, the entire process will be very similar. We'll use the following series of steps to create the new skin:

1. Open the exported UVMap we created in Lithunwrap into Paint Shop Pro (see Figure 18.30) and add a new raster layer.

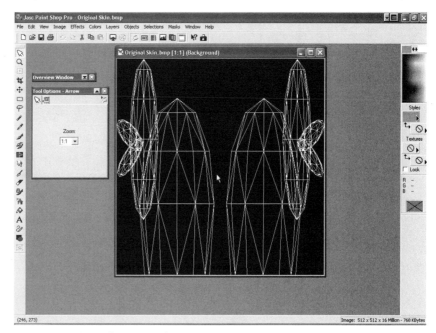

FIGURE 18.30 Open the exported image.

2. Paint the inside of the body a yellow color (see Figure 18.31).

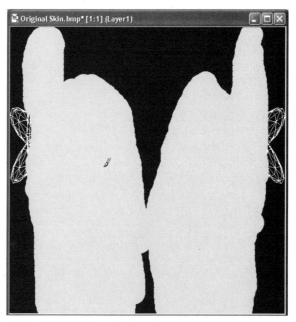

FIGURE 18.31 Paint the body yellow.

3. Paint the beak orange (see Figure 18.32).
4. Choose Layers, Properties (see Figure 18.33).

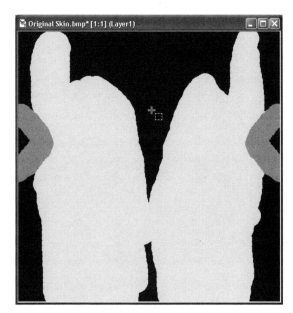

FIGURE 18.32 The beak needs to be orange.

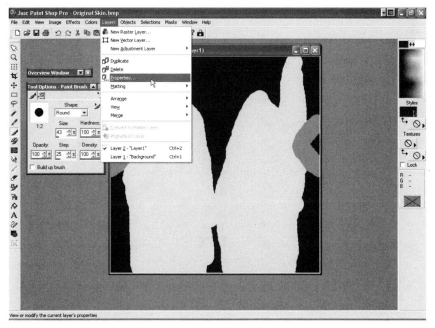

FIGURE 18.33 Properties needs to be selected from the Layers menu.

5. Layer Properties is open. Change Opacity to 25% (see Figure 18.34).

We can now see through the above layer to display the UVMap (see Figure 18.35).

FIGURE 18.34 The layer opacity needs to be set.

FIGURE 18.35 We can see through the layer.

6. Draw in the blue eye at the approximate location seen in Figure 18.36.
7. Open Layer Properties and change Opacity to 100% (see Figure 18.37).

FIGURE 18.36 Draw the blue eye.

FIGURE 18.37 Change Opacity to 100%.

The skin is now displayed with the eye in the approximate location (see Figure 18.38).

8. Save the image.

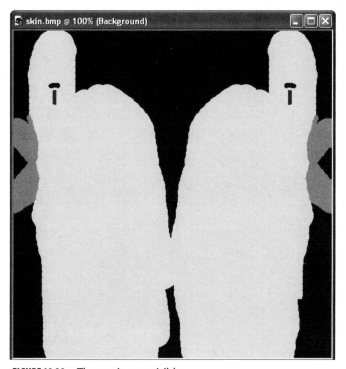

FIGURE 18.38 The eye is now visible.

BACK TO LITHUNWRAP

Once you have painted the UVMap, we need to go back to Lithunwrap and view the model to make sure that skin looks OK:

1. Open Lithunwrap.
2. Open the model (see Figure 18.39).
3. Preview the model (see Figure 18.40).

You should see the new skin we painted in Paint Shop Pro. It's now time to create the graphics we'll use in the game.

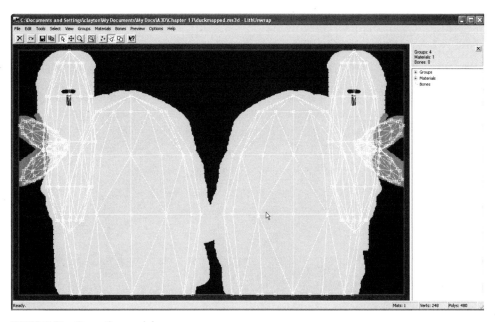

FIGURE 18.39 Open the model.

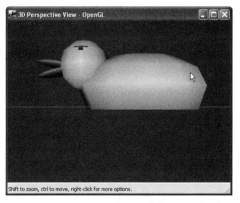

FIGURE 18.40 Preview the model to see the skin.

EXPORTING FILES FOR MMF

Open MilkShape and open the mapped 3D model. Once it is open, we can use the lower-right viewport to export a series of bitmaps to represent the duck in the game:

1. Right-click in the lower-right viewport and choose Textured from the pop-up menu (see Figure 18.41).
2. Right-click the same viewport and deselect the Draw Grid option.
3. Right-click again and choose Take Screenshot (see Figure 18.42).

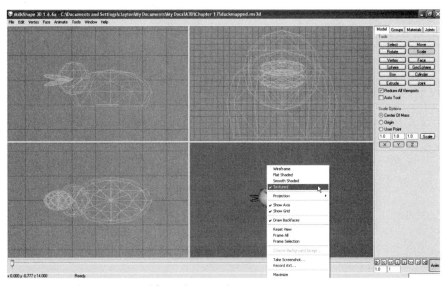

FIGURE 18.41 Choose Textured from the pop-up menu.

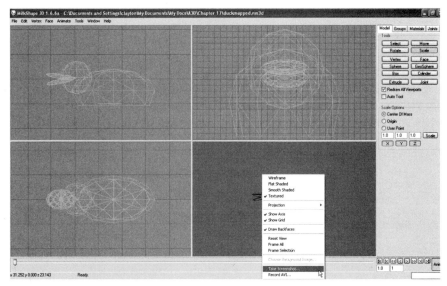

FIGURE 18.42 Take a screenshot.

4. Give it the name duck1.bmp and then save the file (see Figure 18.43). Make sure that you add the .bmp file extension because Milk-Shape seems to have problems unless you add it manually by typing it along with the filename.

FIGURE 18.43 Save the file.

5. In MilkShape, click the Select button and make sure the Select option is Group. Select all of the groups of the model.
6. Click the Rotate button.
7. Give a value of −45 in the X box in Rotate Options and click Rotate (see Figure 18.44).
8. Save the file as duck2.bmp.
9. Click Rotate again to rotate the duck 90 degrees (see Figure 18.45).
10. Save the file as duck3.bmp.

We have all three files we need, so you can choose Edit, Undo to move the model back to 45 degrees and Edit, Undo again to return it to the correct location. You could also have given a value of 90 where −45 had been to rotate it back.

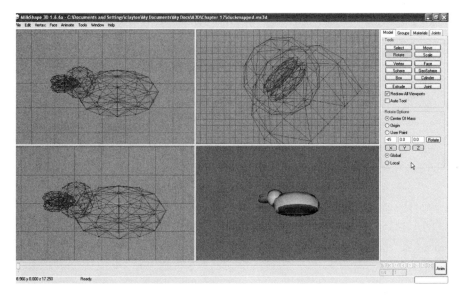

FIGURE 18.44 Use a value of –45.

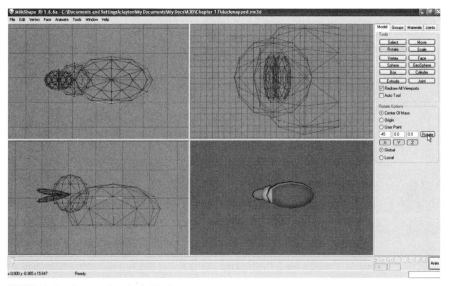

FIGURE 18.45 Rotate the duck 90 degrees.

CHAPTER REVIEW

In this chapter, we created a 3D model of a duck in MilkShape, the 3D modeling package we introduced earlier in the book. In the next chapter, we are going to begin creating the game in MMF.

FINISHING DUCK BLAST 3D

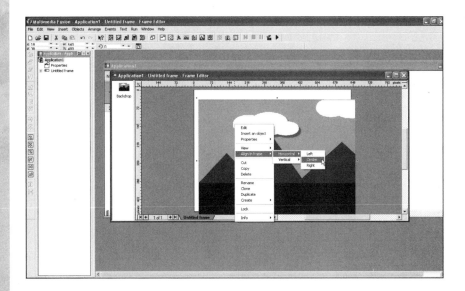

In the last chapter, we worked on 3D models for *Duck Blast*. This was the third chapter in a row in which we have worked on this project, with the previous two setting up the graphics and basics of the game. In this chapter, we are now going to finish the game in MMF.

LET'S START

To begin the project, we need to open MMF and create a new application. Open the Frame Editor for the first frame. The next step is to click Insert, New Object, Backdrop and position your mouse inside the frame. Click the left mouse button to place the object. A new icon will be visible on the form (see Figure 19.1).

FIGURE 19.1 A new icon is visible at the insertion point.

While the backdrop is still selected, choose File, Import, Bitmap. Browse to find the file we created back in Chapter 17, "Drawing Graphics for Duck Blast in Paint Shop Pro," and open the file as the new backdrop by clicking the Open button (see Figure 19.2).

FIGURE 19.2 The file is imported.

Click the OK button to close the window. You can see the results in Figure 19.3.

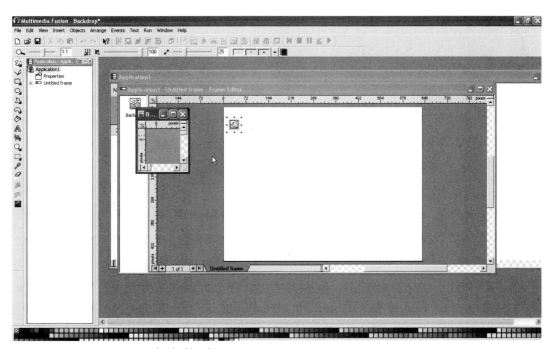

FIGURE 19.3 Your screen now looks like this.

Click the X in the upper-right corner of the small window in the middle of the screen. MMF will ask if you would like to save the changes to the backdrop (see Figure 19.4). Click Yes and you will see the final result of importing the file (see Figure 19.5).

FIGURE 19.4 You will be asked if you want to save the changes.

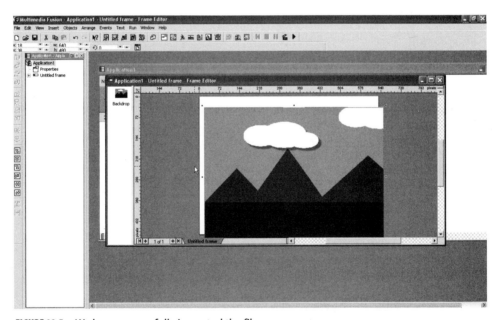

FIGURE 19.5 We have successfully imported the file.

Right-click the backdrop and from the pop-up menu choose Align in Frame, Horizontal, Center (see Figure 19.6). Next, right-click the backdrop again, and from the pop-up menu choose Align in Frame, Vertical, Center (see Figure 19.7). You can see the alignment in the frame in Figure 19.8.

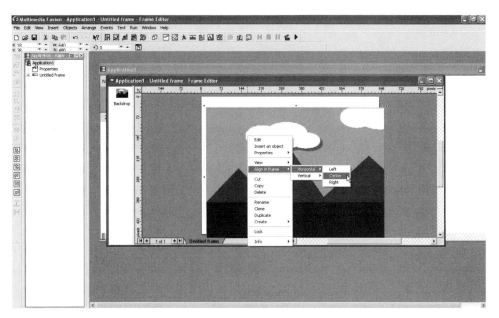

FIGURE 19.6 Choose horizontal center.

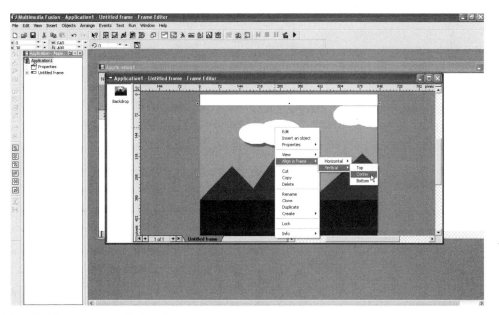

FIGURE 19.7 Choose vertical center.

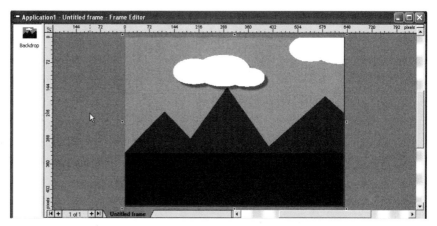

FIGURE 19.8 The backdrop is now aligned.

From the Insert menu choose Object, Active, position your mouse in the frame, and left-click the mouse button. The window seen in Figure 19.9 is displayed.

FIGURE 19.9 The Animation Editor is opened.

Double-click the Frame 1 image of a diamond and choose File, Import, Bitmap. Browse to find the duck1.bmp file we created in Chapter 18, "3D Models for Duck Smash," and click the Open button (see Figure 19.10).

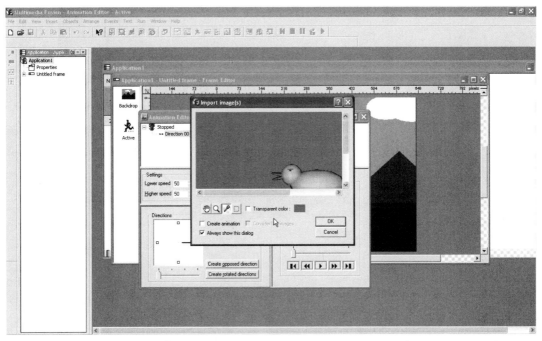

FIGURE 19.10 The image is opened.

You need to click the Transparent Color selection option (see Figure 19.11) and click OK. MMF usually does a great job of realizing the correct color button as it does this time. Next, choose Object, Crop. You should be left with only the duck like the one seen in Figure 19.12.

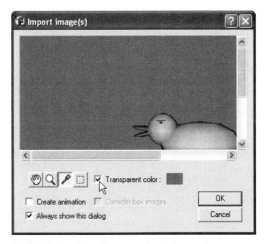

FIGURE 19.11 The Transparent Color option.

FIGURE 19.12 The duck is left by itself.

Click the X in the upper-right corner. A message box is displayed, asking if you would like to save changes. Choose Yes. The Animation Editor should now look like Figure 19.13.

FIGURE 19.13 Animation Editor with changes.

Right-click in the Animation Editor (see Figure 19.14) to display a pop-up menu. Choose the only option, which is called Insert a New Animation. The window seen in Figure 19.15 is displayed.

Choose Walking from the editor and click OK. Select the newly created walking animation in the Animation Editor. Right-click in the Animation

FIGURE 19.14 Insert a New Animation is displayed.

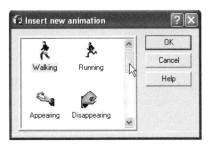

FIGURE 19.15 The Insert New Animation window.

Editor and choose Insert New Direction (see Figure 19.16). When you choose the menu item, the Insert New Direction window is displayed (see Figure 19.17).

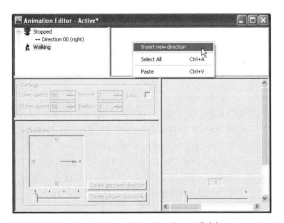

FIGURE 19.16 Insert New Direction is available as a pop-up menu.

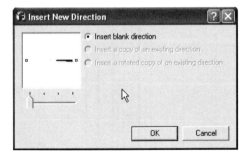

FIGURE 19.17 The Insert New Direction window.

You can select the left direction and click OK. In the Animation Editor, you can now see the newly created walking animation with a direction of left. If you click the left direction, you will also see that a standard frame has been created automatically (see Figure 19.18).

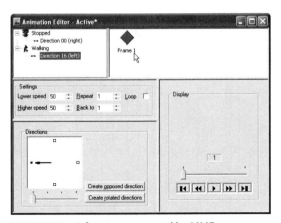

FIGURE 19.18 A frame was created by MMF.

Double-click the frame and import duck1.bmp into it, making sure to remember to crop the image after importing and make sure that Transparency has been selected. After the frame is created, let's copy the lone frame to the opposite direction as well so that, regardless of the movement, the same frame is displayed. In the Animation Editor, you can click the right direction (see Figure 19.19). A new window is displayed with several options (see Figure 19.20).

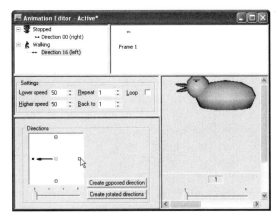

FIGURE 19.19 Click the right direction.

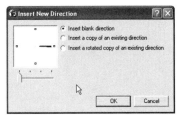

FIGURE 19.20 Insert New Direction options.

We will now insert a copy of an existing direction from the list (see Figure 19.21) and make sure that the left direction will be the source. Now, click OK. The walking animation is complete as the duck will move only left and right on the screen. Insert another new animation by right-clicking in the Animation Editor and choosing Disappearing from the list. Insert a new direction for Disappearing and choose the left direction. In the first frame created by default, import duck1.bmp. Make sure to crop and use transparency on the image so that we are left with only the duck.

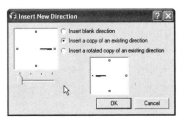

FIGURE 19.21 Make a copy of the existing direction.

Insert a new animation by right-clicking next to Frame 1 and choosing Insert New Animation from the pop-up menu. Double-click Frame 2 to display its default blue diamond image and import duck2.bmp into its location, again remembering to crop the image to leave only the duck. We now have a view of the duck sitting normally in Frame 1 and an image of the duck at a 45-degree angle in Frame 2. The next step is to single-click Frame 1. Along the upper left side of the screen, you will see several options, including Insert Animation, which is the second button from the top (see Figure 19.22). The Insert Animation window (see Figure 19.23) has an option for Create Morphed Animation. You can choose Frame 1 or Frame 2 and click OK. The screen seen in Figure 19.24 is displayed. Click on the button displayed in Figure 19.25. If you are given any warnings, you can ignore them. You should see a series of frames being inserted into the animation, and you can use this to preview the final result (see Figure 19.26). Click OK to close the window, and click OK to create the frames.

FIGURE 19.22 The Insert Animation button.

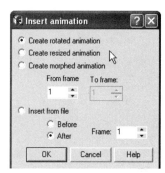

FIGURE 19.23 The Insert Animation window.

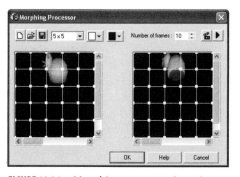

FIGURE 19.24 Morphing processor in action.

FIGURE 19.25 You'll need
to find and click this
button.

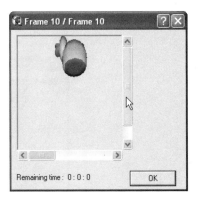

FIGURE 19.26 Final results are
displayed.

Now add another new frame (see Frame 11) and import duck3.bmp
into it. We can create another morphed animation between Frames 10 and
11 to give us a total of 19 frames for this animation. Click the X in the upper
right of the Animation Editor to close it. When you close it, a message box
will be displayed, giving you the option of saving the changes. Choose Yes.
You'll now have a duck visible in the Frame (see Figure 19.27).

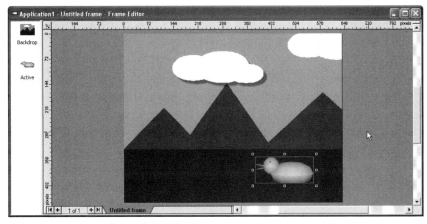

FIGURE 19.27 The duck is visible in the frame.

DUCK MOVEMENT

We are going to do a step-by-step on setting up the duck movement in
MMF.

1. Position the duck on the right side of the frame (see Figure 19.28).

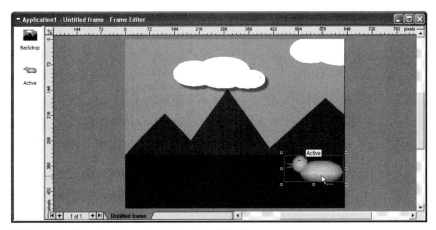

FIGURE 19.28 The duck is on the right side of the frame.

2. Right-click on the duck to display a pop-up menu (see Figure 19.29).

FIGURE 19.29 The pop-up menu has various properties.

3. Choose Properties, New Movement from the menu.
4. The Choose Move window is displayed (see Figure 19.30).

Bouncing Ball can be selected.

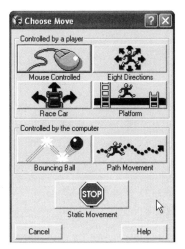

FIGURE 19.30 The Choose Move window is displayed.

The Ball movement setup window is opened (see Figure 19.31).

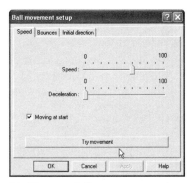

FIGURE 19.31 Ball movement options are visible.

5. Lower the speed to the second position (see Figure 19.32).
6. Click on the Initial Direction tab (see Figure 19.33).
7. Click on the open circle to deselect all directions.
8. Choose the left arrow only (see Figure 19.34).
9. Click OK to close movement.

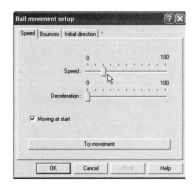

FIGURE 19.32 Change the speed for the object.

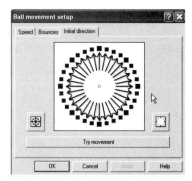

FIGURE 19.33 The initial direction of the object can be set to any of the available options.

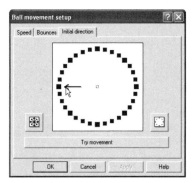

FIGURE 19.34 Left arrow should be the only direction that is selected.

MULTIPLE DUCKS

We're going to create several ducks based on the original, but first, we need to set the hot spot for the animations we've created. The hot spot is an invisible reference point for your object's X and Y coordinates. We need to set this on the original duck before cloning it.

Follow these steps to do so:

1. Select the duck with the mouse.
2. Right-click the duck and choose Edit to display the Animation Editor.
3. Double-click Frame 1 to open an animation.
4. Make sure the Hot Spot tool, which is available along the left side of the MMF screen (see Figure 19.35), is selected.

You may or may not see the hot spot currently, but if you click somewhere in the middle of the current frame, you will see it (see Figure 19.36).

FIGURE 19.35 Choose
the Hot Spot tool.

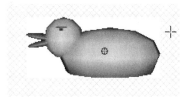

FIGURE 19.36 You can see the hot spot
in the frame.

5. Hold the Alt key on your keyboard and click in the upper left of the image to set the hot spot to X and Y values of 0. Holding the Alt key will allow you to apply the hot spot to all frames instead of opening each of them individually.

6. When you have positioned the hot spot, you can close the frame, and you will be given a prompt asking if you want to save the changes. You need to choose Yes to this.

7. Repeat the steps so that you set the hot spots for the remaining animations. After finishing the animations, you can close the Animation Editor. You may be prompted when closing, and again, you should choose Yes if you are asked about saving the animations.

You may need to reposition the duck in the lower right of the screen. Right-click on it and choose Clone.

The Clone Object window will appear (see Figure 19.37).

FIGURE 19.37 The Clone Object window.

8. Click OK to create the clone (see Figure 19.38).

9. Click the new duck and, using the upper left handle (see Figure 19.39), you can resize it so that it is approximately half the size of the original (see Figure 19.40).

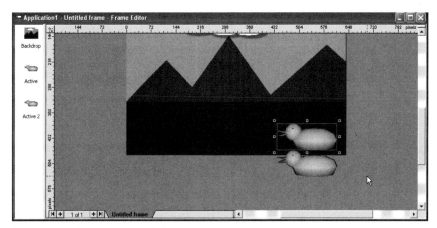

FIGURE 19.38 Create a clone of the object.

FIGURE 19.39 The upper-left handle will
allow us to resize the duck.

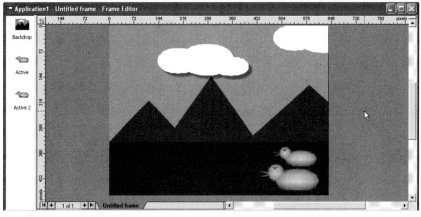

FIGURE 19.40 The duck should be half its original size.

10. Clone the original duck again and resize and position as in Figure
 19.41.

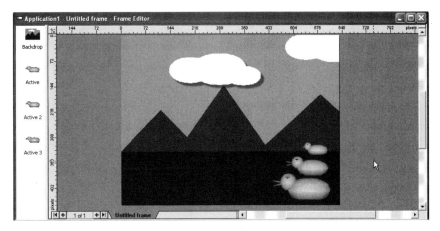

FIGURE 19.41 Clone the original duck.

MOVEMENT EVENTS

We now have three ducks that are positioned in the user interface, and it's time to enable them to interact in the frame. As MMF works in a step-by-step manner, we'll continue to do our work in the same way:

1. Open the Event Editor.
2. Double-click New Condition to open the New Condition window.
3. Right-click the first duck and choose Position, Test Position from the pop-up menu. This will display a new window (see Figure 19.42).

FIGURE 19.42 The Test Position window.

4. The arrow pointing left and inside the inner square (see Figure 19.43) is the one that needs to be clicked. Click OK to close the window.

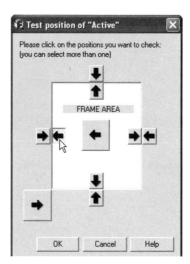

FIGURE 19.43 You can see the arrow that needs to be selected.

The new event is created (see Figure 19.44).

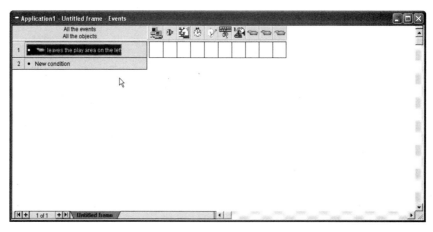

FIGURE 19.44 The new event has been created.

5. Right-click the column beneath the first duck in this row and select Movement, Wrap Around Play Area. This will force the duck to continue wrapping around as it reaches the right side of the screen.
6. Repeat the steps for each duck, and your events should now resemble Figure 19.45.

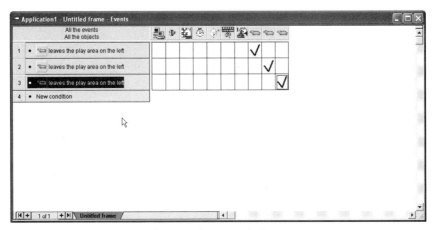

FIGURE 19.45 You can repeat the steps for every duck.

7. Close the Event Editor for now and open the Frame Editor.
8. Add a new active object to the frame by choosing Insert, Object, Active. The Animation Editor opens immediately.
9. Double-click Frame 1 to open the image, which is a diamond by default.
10. Choose the Eraser from the tools along the left side of the screen (see Figure 19.46) and erase the diamond.
11. Choose Continuous Brush Tool (see Figure 19.47).

FIGURE 19.46 The eraser can be selected.

FIGURE 19.47 The Continuous Brush tool.

Along the bottom of the screen, there is a palette of colors available for our tool (see Figure 19.48).

FIGURE 19.48 There are many colors available.

12. Choose a red color so that when we draw, it will be easily visible on the screen.

The Continuous Brush tool displays a toolbar along the top of the screen as well (see Figure 19.49). This toolbar, which is positioned beneath the standard toolbar when the Continuous Brush is selected, contains a variety of options. Among them is the size of the brush (see Figure 19.50).

FIGURE 19.49 A toolbar is available for the tool.

FIGURE 19.50 One of the options is the brush size.

13. Click the largest of the three visible options.
14. Position your mouse in approximately the middle of the Animation Editor, which is currently completely empty, and single-click the mouse to create a red dot in the middle of it.
15. Close the new image and save the changes.
16. Close the Animation Editor and save the changes.

The dot is now visible in the Frame Editor and is named Active4 by default.

17. Open the Event Editor.
18. Double-click New Condition.
19. Right-click the icon that looks like a chessboard and choose Start of Application.
20. Right-click the Mouse and Keyboard column next to the newly created event and choose Hide Windows Mouse Pointer.
21. Create a new condition.
22. Right-click the icon called Special, which looks like two networked PCs, and choose Always Never, Always.
23. Right-click the Active4 column positioned in the newly created event row and choose Position, Set X Coordinate. This displays the Set X Coordinate window (see Figure 19.51).
24. Type **XMouse** into the window (see Figure 19.52) and click OK.
25. Right-click the same square beneath Active4 and Position, Set Y Coordinate.

FIGURE 19.51 The Set X Coordinate window is displayed with the Expression Editor.

FIGURE 19.52 XMouse has been entered as the expression.

26. In the Set Y Coordinate window, type **YMouse** and click OK. The dot will now be positioned wherever you move the mouse and will act as a sort of scope for our next step.
27. Create a new condition. Choose Mouse and Keyboard from the New Condition window and choose The Mouse, User Clicks On an Object.
28. This will display the User Clicks On an Object window (see Figure 19.53). Click OK, leaving default objects. Click the first duck and click OK.
29. In the new event column we just created, right-click the square located beneath the first duck and choose Destroy. Although the mouse is not visible in our frame, MMF still checks for the events associated with the mouse. Now, when we click on the first duck, it will be destroyed.
30. Create a new condition. Right-click on the first duck in the New Condition window and choose Animation, Has an Animation Finished. Choose Disappearing from the Has an Animation Finished window.

FIGURE 19.53 The User Clicks On an Object window.

31. Right-click the square located under the Create New Objects column and choose Create Object. Choose the first duck from the available options. Position your cursor in the lower-right corner in the approximate location where the upper-left coordinate of the duck is currently located (see Figure 19.54) and click OK. We'll now have a duck re-created every time you destroy one.

FIGURE 19.54 Position the cursor near the duck.

32. Repeat steps 30–34 for the remaining two ducks, adjusting the positions when you create the new objects.

ADD MUSIC AND SOUND EFFECTS

Back in Chapter 13, "Creating Music and Sound Effects," we created the music and sound effects we'll now use for our game. MMF provides a

way to play MP3 files with the DirectShow object. You can add it to the
project by choosing it from the Insert an Object window, which can be
displayed by choosing Insert, Insert an Object. When it is displayed, you
can set the file that will be played and several other options. You can
browse to the file we created in Chapter 13 and remove the options se-
lected for displaying the DirectShow object. Although Figure 19.55 does
not indicate it, there is also an option for looping the music (this was not
available when the book was written), so make sure it is selected.

FIGURE 19.55 The DirectShow
options.

We can now add the sound effects that will play when we click on
the ducks. Open the Events Editor and locate the events related to the
mouse clicking on the ducks. Right-click in the box located in one of the
events and choose Play Sample (see Figure 19.56). The Play Sample win-
dow is displayed. You can choose the sound sample we created back in
Chapter 13 (on the CD-ROM it is called "Gun Shot") by clicking on the
Browse button and then clicking OK when finished. Your sound will be
played whenever this event occurs. Repeat the process for all of the duck
click events.

The final step in the project will be to display the mouse pointer we
had previously hidden. Double-click New Condition to create a new
event in the Event Editor. Right-click the chessboard icon from the list
and select End of Application from the available options. The event is
now available at the bottom of our events for the game. Our last step is to
right-click the row/column intersection between our newly created event
and the mouse and keyboard pointer and select Show Mouse Pointer
from the two available options. That's all there is to the application.

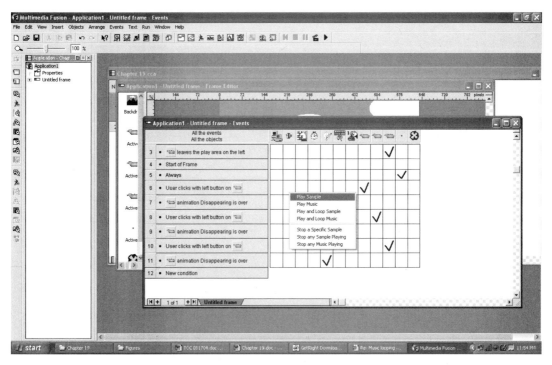

FIGURE 19.56 We need to choose Play Sample.

CHAPTER REVIEW

In the past three chapters, we have worked on this project by breaking down the process into the basics of the game, graphics, and so on. Now, in this chapter, we put the finishing touches on the game. In the next chapter, we are going to look at a new application called the 3D Gamemaker.

INTRODUCTION TO THE
3D GAMEMAKER

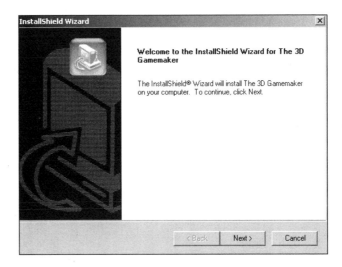

ON THE CD

O f all of tools we have looked at, perhaps none is quite as easy to use as the 3D Gamemaker. In this chapter, we'll take a quick look at the installation of the software. In the next chapter, we'll use the 3D Gamemaker to build a complete game in a matter of minutes.

There is a demo version of the 3D Gamemaker on the CD-ROM that comes with this book. This has all the functionality of the standard version but is lacking the capability to make an external game. If you would like to purchase the full version, please visit *www.darkbasic.com*.

INSTALLATION

ON THE CD

You can begin by placing the CD-ROM that accompanies this book into your drive. Next, double-click My Computer and then the letter of your CD-ROM drive. Locate the directory called Applications and inside it you will find another called 3DGamemaker. Inside the directory, you will find an installation file. Double-click it to begin the installation (see Figure 20.1).

FIGURE 20.1 The opening screen for installation.

From the opening screen, point your mouse over the Install the 3D Gamemaker area. It will light up similarly to Figure 20.2.

Once the area is highlighted, click the left mouse button to begin installing the 3D Gamemaker. This will display another window (see Figure 20.3).

Click the Next button on the window to display the license agreement, a portion of which can be seen in Figure 20.4.

FIGURE 20.2 The install area is highlighted.

FIGURE 20.3 The Install Wizard walks you through the steps.

FIGURE 20.4 3D Gamemaker's license agreement.

Read through the license agreement and then click Yes to continue the installation. You should choose Typical Installation from the window that is displayed next (see Figure 20.5).

FIGURE 20.5 You can choose the Typical Installation.

The next step in the Install Wizard, seen in Figure 20.6, asks you to choose the installation directory. You can leave it at the default setting unless you have some reason to choose another.

FIGURE 20.6 You need to choose an installation directory.

Next, you'll be presented with a window that resembles Figure 20.7. This allows you to choose a program group, but again, you can leave the default setting and click the Next button.

FIGURE 20.7 Choose a program group or leave the default setting.

The Install Wizard will display all the settings you have picked. You should review these settings (the defaults can be seen in Figure 20.8) and then choose Next if everything is okay. If not, you can go back and make changes.

FIGURE 20.8 Review your settings and then click Next.

The files will begin copying, and you should see a window like that in Figure 20.9 that displays the current information.

After the files have finished copying, you are given an option of creating an icon on your desktop (see Figure 20.10). If you create an icon, you will have easy access to the 3D Gamemaker. Otherwise, you can run it by choosing it from your Start menu. Choose the option you prefer.

The final install screen is displayed, and you can click the Finish button (see Figure 20.11).

FIGURE 20.9 The files are being copied to your computer.

FIGURE 20.10 You can decide if you would like an icon on your desktop.

FIGURE 20.11 The final step in the installation.

CHAPTER REVIEW

In this chapter, we walked through the simple installation of the 3D Gamemaker. In the next chapter, we'll look at the simple IDE that was designed to work in a series of steps. By completing these steps, you can quickly build one of the many styles of built-in Gamemaker games.

21

CREATING A GAME WITH THE 3D GAMEMAKER

In the previous chapter, we walked through the steps required to install 3D Gamemaker. Now that it's installed, we'll use it to develop a 3D shooter. The software comes with a variety of prebuilt environments and 3D models that can be used in your creations. We'll use tanks as the combatants and a space environment for the scenery.

GETTING STARTED

When you open 3D Gamemaker, a screen like that in Figure 21.1 is displayed. This screen allows you to choose between Standard and Beginner modes of operation. For the example in this chapter, you can choose Standard.

The graphics/models used in the 3D Gamemaker examples are included with the full release version of the software. The demo version on the CD-ROM does not include all of these graphics. You can follow the examples by substituting any model you would like because we are interested in the concepts of creating the game as much as the game itself. If you would like to follow along exactly, you can upgrade to the full version, which is a very cost-effective option for beginning developers.

FIGURE 21.1 3D Gamemaker allows you to choose Standard or Beginner operation.

After selecting Standard mode, a second window will appear (see Figure 21.2). From this window, you can choose Make Game, the top selection on the list.

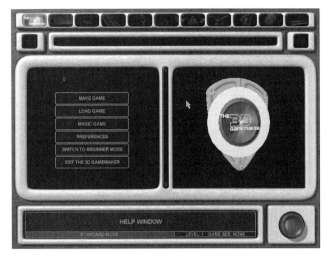

FIGURE 21.2 Choose Make Game from the menu.

The next window that is displayed is the standard IDE for the 3D Gamemaker. You'll see a series of icons across the top of the screen. Each of these icons represents a step in the creation of a game. Click the first icon. You'll see something like Figure 21.3.

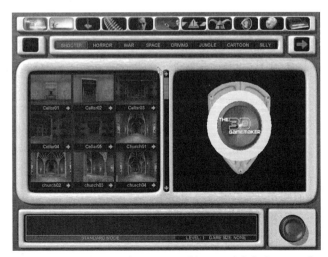

FIGURE 21.3 3D Gamemaker comes with several default types of games.

From the list of displayed genres, choose War. This will display a new screen with available environments. Choose Corridors2 or something similar. Figure 21.4 displays the selection.

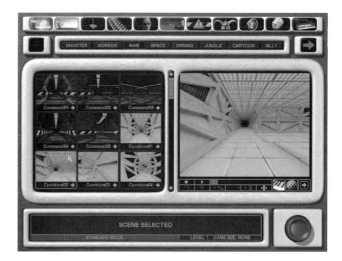

FIGURE 21.4 You can select from any of the prebuilt environments.

The next step is to click the next icon in the list. This time it looks like a joystick. This icon allows you to select from characters to control in the game. We'll use a tank. In Figure 21.5, you can see the selection being made.

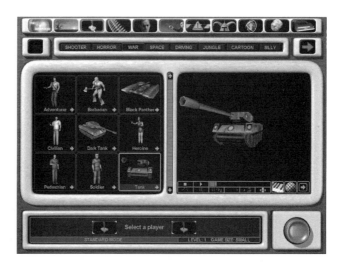

FIGURE 21.5 We'll control a tank in the game.

Like the previous steps, after selecting the character, you move on to the icon to its right. This icon allows you to select the bullets that will be fired from your character. You can choose the Frag Bomb from the list (see Figure 21.6).

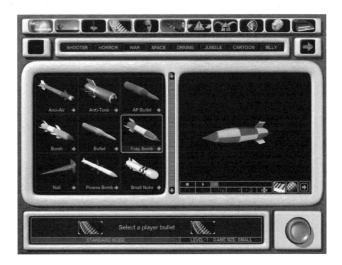

FIGURE 21.6 The Frag Bomb being selected.

After making the selection, you can move to the right again. This icon will allow you to pick your enemies in the level. Figure 21.7 displays the options, and you can choose Green Cobre from the list.

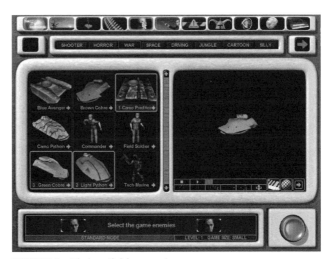

FIGURE 21.7 The available enemies.

Once again, select the icon to the right of the previous one. You can choose Gray Shell from the bullets (see Figure 21.8).

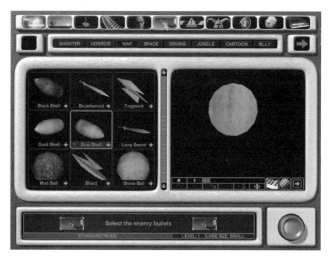

FIGURE 21.8 Available bullets in the 3D Gamemaker.

Choose the icon to the right, which allows you to select the obstacles that will be placed throughout the level. You can choose Debris from the list, as can be seen in Figure 21.9.

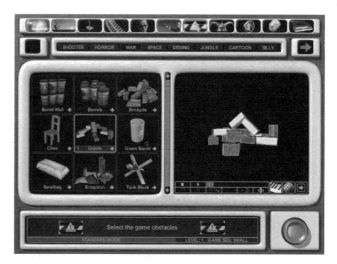

FIGURE 21.9 The Debris obstacle for the level.

The next icon will allow you to choose the end of level boss. From the enemies, you can select Dark Tank (see Figure 21.10).

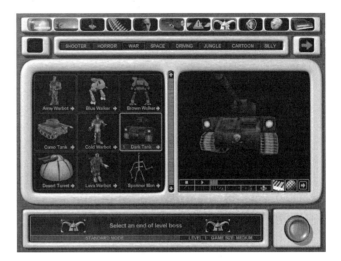

FIGURE 21.10 Dark Tank is the end of level boss.

Game items can be selected from the next level. We're going to add Energy boxes to the level that can be picked up by your tank. See Figure 21.11 for the selection.

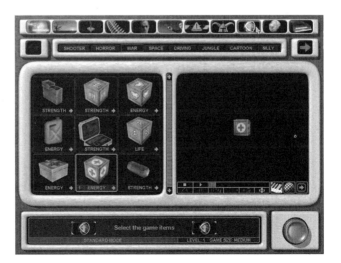

FIGURE 21.11 You can add energy pick-ups to the game.

GAME SETTINGS

The next icon allows us to make various settings to the game. In Figure 21.12, you can see the various options.

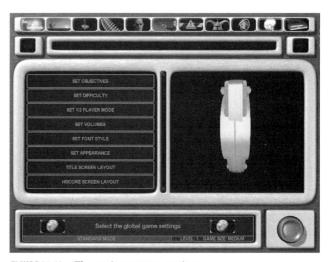

FIGURE 21.12 The various game settings.

Choose the Objectives option from the menu. This displays a screen like that in Figure 21.13. You can decide how you complete the game; in our example we'll use the default setting. Once you have finished, click the arrow in the upper left of the screen.

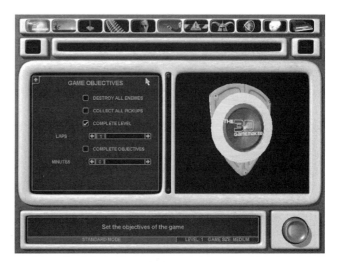

FIGURE 21.13 The game objectives.

When you are presented with the menu, choose Game Difficulty from the list. This will display an options screen like that in Figure 21.14. You can leave the settings at their default and try the level. If you decide it is too easy or too hard, you can come back to these options.

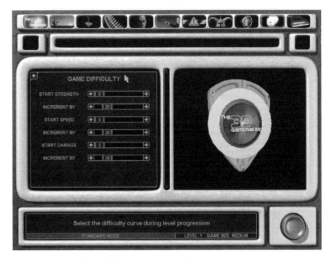

FIGURE 21.14 The difficulty settings for the game.

Again, click the arrow in the upper left to display the menu and choose Set 1/2 Player mode. From the menu that appears (see Figure 21.15), you can select Turn Based Play and then click the green arrow in the upper left.

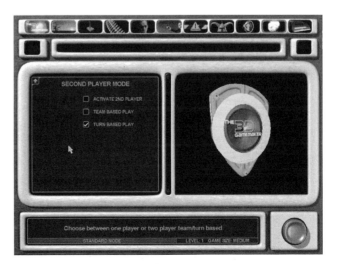

FIGURE 21.15 The options for 1/2 Player mode.

Now you are back in the main menu and can select Game Volumes from the list. This allows you to change the volume levels of in-game music and title score. You can change them as necessary and then return to the main menu.

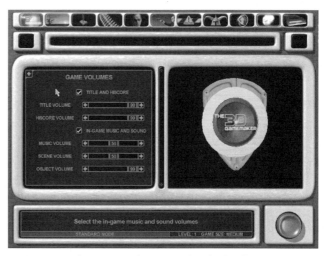

FIGURE 21.16 The Game Volumes can be changed.

The next step is to choose the fonts for the project. You can leave this as default or change to one of the available fonts that can be seen in Figure 21.17.

FIGURE 21.17 The various fonts that can be used by the 3D Gamemaker.

You can go through the other options in the list that can be seen in Figures 21.18 to 21.20. These options allow you to choose the Game Appearance, the Opening Screen, and the Hiscore screen.

FIGURE 21.18 The Game Appearance options.

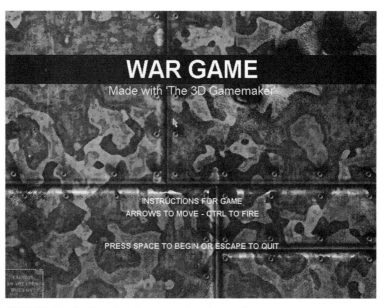

FIGURE 21.19 An Opening Screen can be changed.

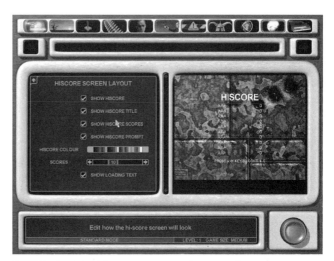

FIGURE 21.20 The Hiscore screen can be set up in many ways.

PLAYING THE GAME

After making all the selections, you can click the icon in the upper right of the screen that looks like a disc (see Figure 21.21). Choose Save Game from the menu that is displayed.

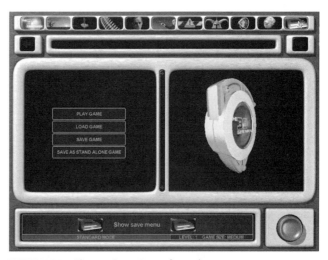

FIGURE 21.21 Choose Save Game from the menu.

The Save a Game menu is displayed. You can name your game any-thing you'd like. In the example seen in Figure 21.22, it is called Chapter 21.

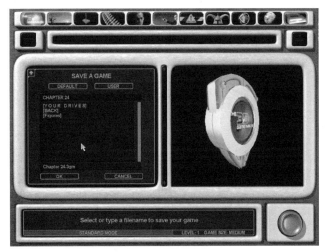

FIGURE 21.22 The Save a Game menu.

After you save the game, the original menu will again be presented (see Figure 21.23). You can now choose Play Game from the menu.

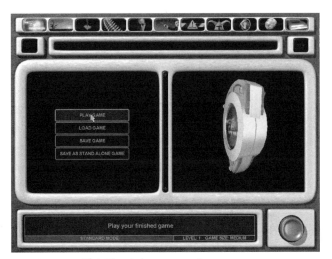

FIGURE 21.23 Click Play Game to start the game.

When you execute the game, you will see the opening screen. This screen, seen in Figure 21.24, is the screen we could have edited earlier.

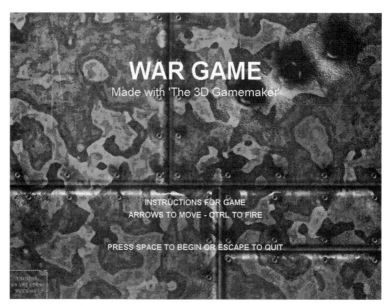

FIGURE 21.24 The opening screen of our game.

Press the spacebar to begin the game. You'll see the game beginning to load (see Figure 21.25). Once it has finished opening, the level will be open. You can see the level in Figure 21.26.

FIGURE 21.25 The game is being loaded.

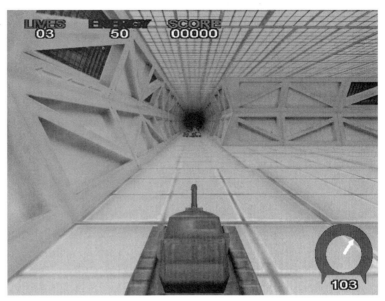

FIGURE 21.26 Our level is displayed.

You can test the game, and while playing, you'll see the enemies we placed into the level earlier. They are visible in Figures 21.27 and 21.28.

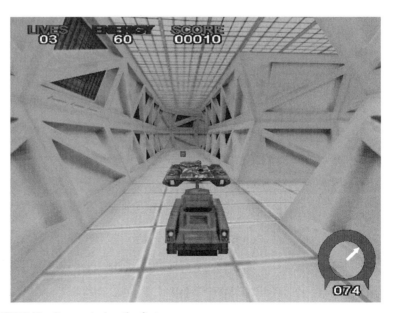

FIGURE 21.27 Encountering the first enemy.

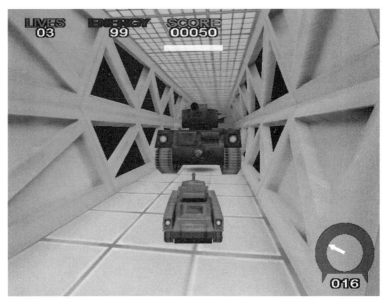

FIGURE 21.28 The end of level boss.

CHAPTER REVIEW

In this chapter, we built a game using the standard mode of 3D Game-maker. The built-in levels and models make it easy to build a complete project using 3D Gamemaker. In the next chapter, we'll look at a new type of development: creating modifications for existing commercial games using gmax.

SILLY ADVENTURE

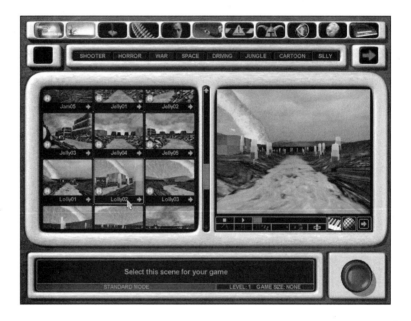

In the previous chapter, we built a 3D shooter in the 3D Gamemaker (T3DGM), the first of our projects. We're now going to build our second project, this time an adventure game we'll call *Silly Adventure*, which will sum up the game's content very well.

THE PROJECT

To begin this project, open T3DGM and choose Standard from the opening screen. Click the Make Game button and choose Silly from the buttons that are available along the top of screen. At this time, your screen should look something like Figure 22.1.

Choose Lolly02 for the level, which will update your project with this level. One of the nice features of T3DGM is the fact that you are instantly updated of any changes you make as you go along. As you can see in Figure 22.2, the level we have chosen is visible in the display immediately.

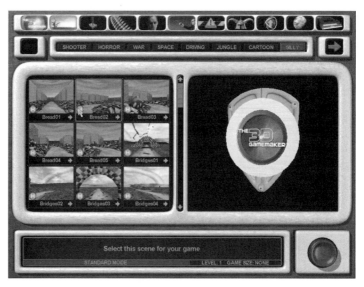

FIGURE 22.1 Your screen should appear similar to this.

The next step is to click the second icon along the top of the screen. This icon, which looks like a joystick, allows you to select the player for the game. When you click this icon, the interface is updated to reflect some of the available players in the currently selected category (see Figure 22.3). Click the Jungle category so that we can choose some of the characters

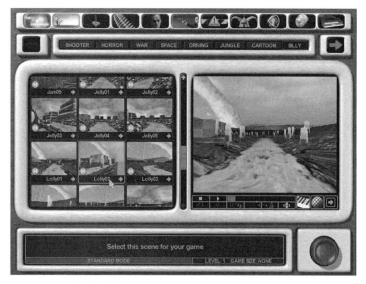

FIGURE 22.2 The level we have picked is displayed immediately.

from it (they can be seen in Figure 22.4). The one we are interested in is the tomato. Click it to preview the animation (see Figure 22.5) and then click the next icon in the list. This time it looks like some ammunition and is responsible for the player bullets.

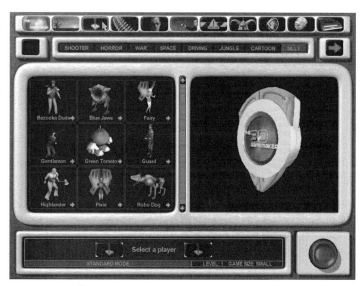

FIGURE 22.3 Players that are available in the category.

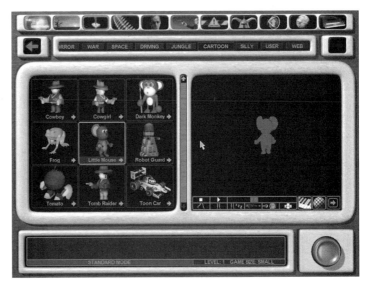

FIGURE 22.4 Characters specific to the Jungle category.

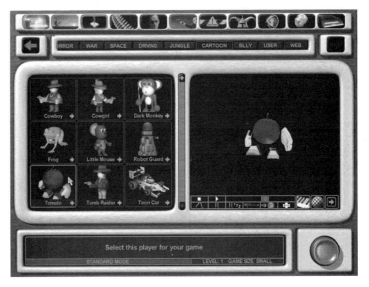

FIGURE 22.5 The tomato is selected.

At this time, because of the type of project we are creating, we are going to look for some "bullets" for our tomato character. We'll select the Cartoon category and choose Peas from the items. You can see the selection in Figure 22.6.

FIGURE 22.6 The selection we have made is visible.

The next step is to choose the icon located directly to the right of the bullets. This one looks like a mug shot and allows us to choose an enemy for our tomato. Click the Silly category and then choose Chick (see Figure 22.7). The next icon is for the enemy bullets. We are not going to allow the enemy to fire any bullets at us, so we'll move to the next icon, which

FIGURE 22.7 Chick has been selected.

is the Obstacle icon and looks like a caution sign. Once you have clicked the icon, you can choose Cartoon as a category and Boulder as an item (see Figure 22.8).

FIGURE 22.8 Boulders are added to the project.

It's now time to select the next icon; this one handles the end of level boss and looks like a Viking helmet. Choose the Cartoon category and the Blue Rabbit as the end of level boss (see Figure 22.9).

The next icon is the Game Items icon. It has a green arrow on it pointing upward. We don't need to set anything for our game, so we can click on the icon to its right that looks like a planet. These are the global game settings (see Figure 22.10).

There are many items in here, and as its category name suggests, they allow you to change the settings for your game. We are happy with the default settings, so we'll move to the last icon, which looks like a disc (see Figure 22.11). We can now choose Save Game from the list of available buttons, enter the name Silly Adventure (see Figure 22.12), and click the OK button.

FIGURE 22.9 The rabbit as displayed in T3DGM.

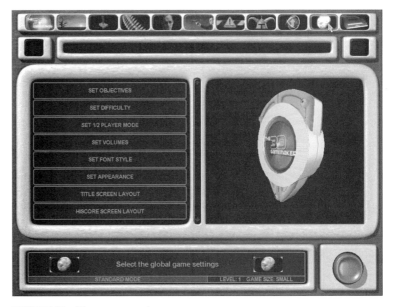

FIGURE 22.10 The game settings.

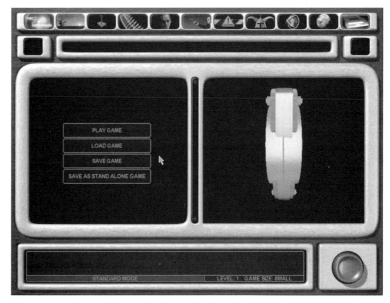

FIGURE 22.11 The last icon is selected.

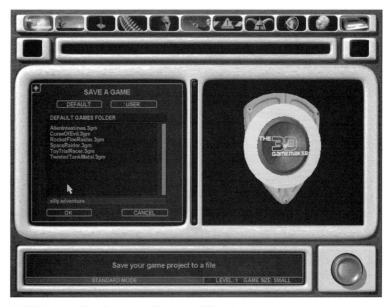

FIGURE 22.12 Give the game the name Silly Adventure.

Click the Play Game button to start the game. Figures 22.13 to 22.18 display various aspects of our game being played. You can save it to a standalone project if you would like so that it can be distributed to others.

FIGURE 22.13 The opening screen for our game.

FIGURE 22.14 The game is loading.

FIGURE 22.15 Actual game play is started.

FIGURE 22.16 The main character encounters the first enemy.

FIGURE 22.17 Nearing the end but running into the blue bunny.

FIGURE 22.18 Our game has ended.

CHAPTER REVIEW

In this chapter, we built our second game project with T3DGM. In a matter of a few steps, we were able to construct a completely playable game. In the next chapter, we are going to continue looking at the various features offered by T3DGM as we build another project.

SPACE WAR

In the last chapter, we built an adventure game in T3DGM using a silly theme that was represented in the name. We're now going to build our third project, this time an arcade style of game we'll call *Space War*. You'll again see the repetition of the steps required when creating a game in T3DGM, regardless of the style of game, making it the easiest of the available 3D game creators.

THE PROJECT

To begin this project, open T3DGM and choose Standard from the opening screen. Click the Make Game button and choose Space from the buttons that are available along the top of the screen. At this time, your screen should look something like Figure 23.1.

FIGURE 23.1 T3DGM at startup.

For our game, we'll choose Asteroids2, which will update the project with an image of the level. As you remember from the previous chapter, updates you make are instantly available with changes you make as you go along. As you can see in Figure 23.2, the level we have chosen is visible in the display.

The next step is to click the second icon along the top of the screen. This icon, which appears to be a joystick, allows you to select the player for the game. When you click this icon, the interface is updated to reflect some of the available players in the currently selected category, which should be

FIGURE 23.2 Our level is displayed automatically.

Space. The one we are interested in is Red Raider. Click it to preview the animation (see Figure 23.3) and then click the next icon in the list, which looks like some ammunition and is responsible for the player bullets.

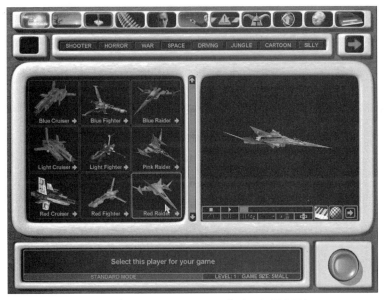

FIGURE 23.3 The main character's animation playing in T3DGM.

In this step, we are looking for some bullets for our spaceship. Again, we're in luck with our default category selection of Space because it contains a perfect bullet for the ship. It's called Orange Bolt and can be seen as it's selected in Figure 23.4.

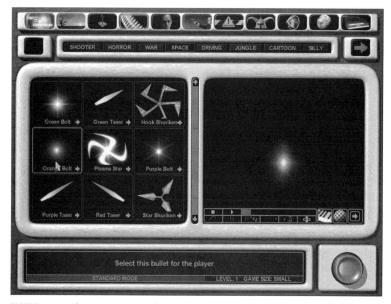

FIGURE 23.4 The ammunition for our player.

The next step is to choose the icon located directly to the right of the bullets. This one looks like a mug shot and allows us to choose enemies. In the last game we created, we created only a single enemy, but T3DGM allows us to create several types. With this in mind, click the enemy called Alien Saucer a single time. You'll see a number 1 appear within the box that holds the model (see Figure 23.5). Click the enemy called Gray Saucer, and a number 2 will appear next to it (see Figure 23.6). Finally, click the Green Recon, and a 3 will appear next to it (see Figure 23.7).

Click the next icon, which is for the enemy bullets. We'll stick with the Space category and choose Red Bolt from the options (see Figure 23.8).

We'll move to the next icon, which is the Obstacle icon and looks like a caution sign. We'll again leave Space as a category and choose Small Asteroid from the available options (see Figure 23.9).

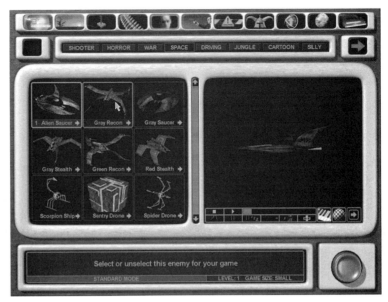

FIGURE 23.5 Our first enemy.

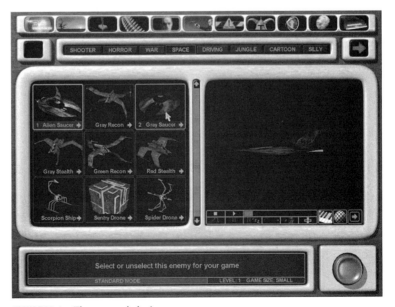

FIGURE 23.6 The second choice.

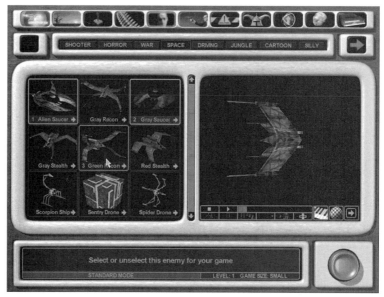

FIGURE 23.7 A final selection.

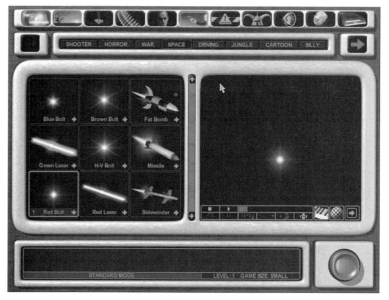

FIGURE 23.8 The enemies will all fire the same bullet.

It's now time to select the next icon; this one handles the end of level boss and looks like a Viking helmet. Leaving the Space category as our default selection, click Shuttle as the end of level boss (see Figure 23.10).

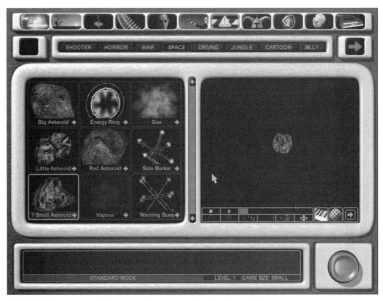

FIGURE 23.9 Asteroid obstacles appear in the level.

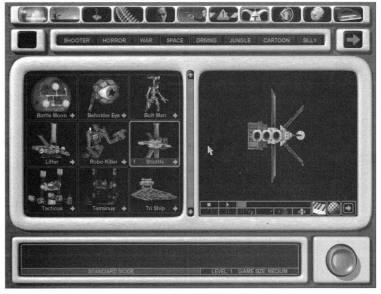

FIGURE 23.10 Our end of level boss.

The next icon is the Game Items icon. It has a green arrow on it pointing upward. We don't need anything for this and can click on the icon that looks like a planet and is the global game settings (see Figure 23.11).

FIGURE 23.11 Game settings are available.

There are many items in here that allow you to change the settings for your game. We are happy with the default settings, so we'll move to the last icon, which looks like a removable disc (see Figure 23.12). We can choose Save Game from the list of available buttons, enter the name space war (see Figure 23.13), and click the OK button.

FIGURE 23.12 The final icon.

FIGURE 23.13 Give the project the name space war.

Click the Play Game button to play the game. Figures 23.14 to 23.16 display various aspects of our game being played. You can save it to a standalone project if you would like so that it can be distributed to others.

FIGURE 23.14 The game at opening.

FIGURE 23.15 Avoiding asteroids in the level.

FIGURE 23.16 An enemy appears at the horizon.

CHAPTER REVIEW

In this chapter, we built our third game project with T3DGM. In a matter of a few steps, we were able to construct a completely playable game. In the next chapter, we are going to move slightly away from the point-and-click method of game creation and create custom levels and models in T3DGM.

CUSTOM 3D MODELS
IN T3DGM

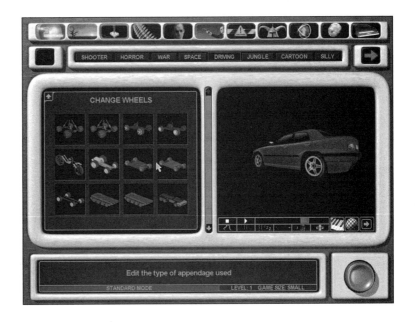

As you have seen, T3DGM is probably the easiest development tool ever created for the creation of 3D games. Within minutes, you can have a fully functional game by following a series of steps. In this chapter, we're going to look at some advanced features offered by T3DGM, including the capability to create new models out of the existing collection, along with the Level Editor, which as its name implies, allows us to create custom levels for our games.

You can use a 3D modeling tool such as MilkShape to create entirely new objects for T3DGM. While this is one method, there are certainly others that will take far less time. As we have already created a model in MilkShape earlier in the book, we're going to concentrate on the other methods in this chapter.

CUSTOM 3D MODELS

T3DGM ships with a large collection of 3D models that are ready for you to use, including a variety of automobiles, characters, and alien ships, to name a few. These objects are fine for a variety of projects, but if you get the desire, you can also alter their properties to create new ones to complement the existing varieties.

Open T3DGM and create a new game project. You can pick any scene you would like, as we're really interested in changing the way the player model looks. For reference, the figures in this chapter will reflect the Driving category with City3 as the scene.

The first step is to choose the Car model from the driving category for the player. The model will look like Figure 24.1 when loaded. Click the small

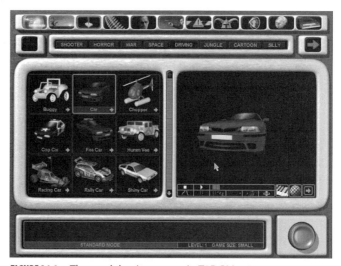

FIGURE 24.1 The model as it appears in T3DGM.

green arrow located in the lower-right corner of the box in which the Car model is located. You will see our first set of options (see Figure 24.2).

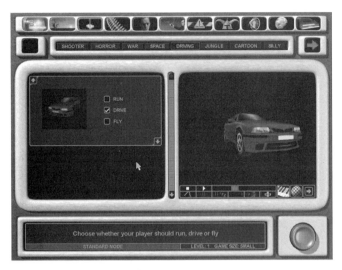

FIGURE 24.2 The first set of options.

These options allow us to choose how the model will be handled in the games we create. For a car, we will simply leave the model selected to Drive. The down arrow located next to the new options can be clicked to display a new set of options (see Figure 24.3). Click the down arrow again to display a third set of options (see Figure 24.4). Clicking again displays

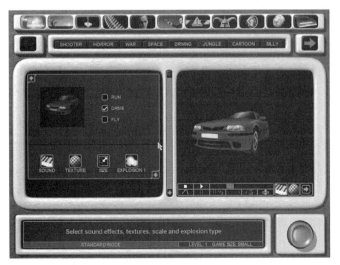

FIGURE 24.3 A new set of options.

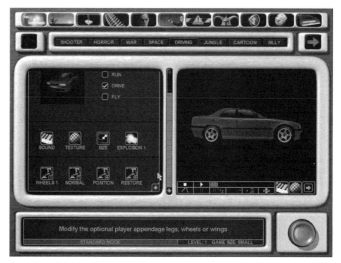

FIGURE 24.4 Our third set of options.

another set of options (see Figure 24.5), and with one last click, we can see the final set of options (see Figure 24.6). All of the options that are available to customize this model are now within our reach. We can scroll through these with the scrollbar located directly to the right of the model. Let's move up to the first set of options, beginning with the size.

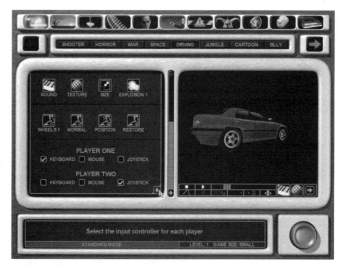

FIGURE 24.5 The fourth level of options.

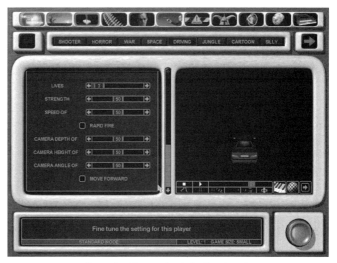

FIGURE 24.6 We have finally reached the last level.

As its name suggests, clicking this button will display a set of options for changing the size of the model. Dragging in any direction will immediately update the model, which is reflected in the interface (Figure 24.7 shows the model with the X direction much smaller). You can make your model much larger or smaller in an individual direction or all of them simultaneously.

Click the Restore button to bring the object back to its normal size and then click the up arrow in the upper-left corner of the Options window to

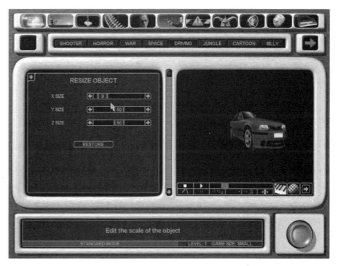

FIGURE 24.7 X is now smaller.

move back to the original set of options. The next step is to move the scroll-bar down slightly to the next set of options, which includes a Wheels button among others. Click the Normal button located next to the Wheels button. The caption beneath the button changes to Add Wheels. Now, click the Wheels button to display the various wheels we have at our disposal (see Figure 24.8). Click the various wheels to see what they look like on the Car model. Figure 24.9 displays the wheels in the lower-right corner of the available selections.

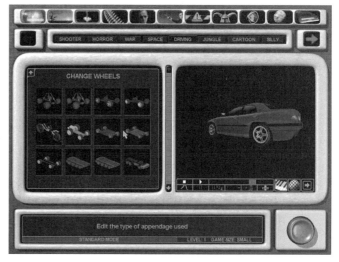

FIGURE 24.8 Several types of wheels are available for our car.

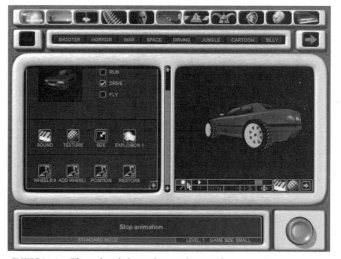

FIGURE 24.9 The wheels have been changed.

You can also position the wheels relative to the bottom of the model. Back at the Options screen, click the Position button next to the Wheels and Add Wheels buttons. This provides three ways we can position the wheels. Move the wheels farther beneath the vehicle so that it appears the car is raised (see Figure 24.10).

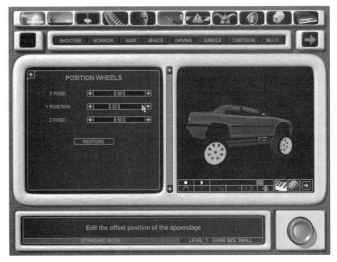

FIGURE 24.10 The vehicle appears to be raised.

Click the up arrow in the upper right of the Options window to return to the standard set of options. Use the scrollbar on the right to move down to the next set of options, which provides settings for how the model will be controlled. You can change this to keyboard, mouse, or joystick, depending on your needs. Using the scrollbar to move down to the next set of options gives us the ability to change the number of lives, speed, and strength properties of the model. Moving to the final set of options gives us the ability to change the way the model appears related to the camera.

By changing these properties, we can create entirely unique models, but we have only touched upon a few of the available options. As you already know, going back to the first set of options, we can change the model's properties to running, flying, or driving. Click the Run checkbox to change the object. When you choose Run, the third set of options, which normally sets up the wheels, it now provides options for setting up the legs for the model. You can now add any one of the legs to the bottom of the object in place of the wheels. While this particular option does not make a great deal of sense for a car, it might come into play when you wish to alter

an object that typically walks. You can also change the object to flying, which allows you to choose wings or propellers like an airplane or helicopter, another interesting way you can alter the models.

While all of these options definitely add variety, there is one final option we have yet to look at. This one alters the texture of the model, which will allow us to create models that look entirely different from the originals. We'll use Paint Shop Pro for this, but first we need to download and install a plug-in that will allow us to open the textures, which are in the DDS format. Close T3DGM, saving first if you would like to go back later. You need to browse to the following Web site and download the DDS texture file plug-in for Photoshop: *http://developer.nvidia.com/object/nv_texture_tools.html*

This file works perfectly with Paint Shop Pro and can be installed by downloading and copying the file to C:\ program files/jasc software/paint shop pro/plugins (assuming you installed Paint Shop Pro to the default location). There are additional notes on the Web site that suggest you may have to add a couple of additional files to the Windows\System directory, and if needed, you can download and copy the appropriate files. Lastly, you will need to have DirectX installed. The DirectX 9 SDK is available from Microsoft freely and is a great download if you have the time. After the installation, start up Paint Shop Pro. Using the traditional File, Open menu, open the DDS file from the following directory: C:\Program Files\Dark Basic Software\The 3D Gamemaker\Objects\05Driving\2Player\Car.

There is only a single DDS file in this directory, called carm.dds. When you open the file, you will be given a message similar to that in Figure 24.11. Choose Yes from this window. The file is now open and looks something like Figure 24.12.

FIGURE 24.11 This will be displayed when you open the file.

You have several options for changing these textures, using all the tools available in Paint Shop Pro. For example, you could quickly add numbers, repaint sections of the map, or paint an entirely new one. For our example, we'll be creating an entirely new texture for the model so that we can offer a different color of the same vehicle. Choose the Freehand

FIGURE 24.12 The file is displayed.

Selection tool from the toolbar. Next, draw a selection around the model, leaving the wheels unselected (see Figure 24.13).

FIGURE 24.13 Everything is selected with the exception of the wheels.

Choose Adjust, Colors Balance, Color Balance from the Paint Shop Pro menu. A window will appear that looks like Figure 24.14. We can now move the sliders to quickly adjust the colors. For our first texture, we'll turn the blue area into a shade of green. Adjust the sliders so that they look like Figure 24.15. Click the OK button to close the window and then choose Save As from the File menu. Make sure to choose Save As so that you do not accidentally overwrite the original version. The Save As dialog box appears, and you can choose a name of carm_green.dds. A new window will now appear that gives various options for saving the file. You can leave the defaults and click the Save button.

FIGURE 24.14 The PSP Color Adjustment window.

FIGURE 24.15 The sliders are adjusted appropriately.

You can now close Paint Shop Pro and reopen T3DGM. Create a game and load up the Car model. Open the options (see Figure 24.16) and click on the carm.dds filename. This opens up the Texture Select screen that looks like Figure 24.17. Click Your Own Bitmap to display a new screen (see Figure 24.18). Click the Get Texture button and browse to the appropriate

location on your drive where you saved the texture (see Figure 24.19). Select the file and click the OK button. The texture is now loaded (see Figure 24.20). A small selection box is visible in the upper-left portion of the texture. Resize the selection box so that it covers the entire texture we have imported (see Figure 24.21). Click the Get Texture button, and the texture is resized to fill the entire texture area (see Figure 24.22). Click the Paste button and then click the Finish button, which is displayed immediately after you have clicked the Paste button (see Figure 24.23). Click the Update button to see the changes (see Figure 24.24).

FIGURE 24.16 The options for loading a texture.

FIGURE 24.17 The Texture Select screen.

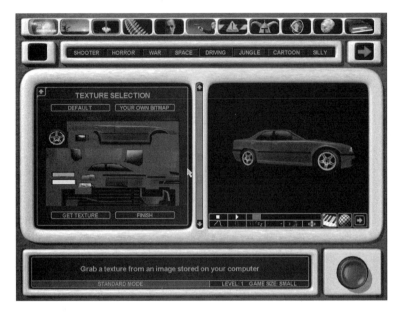

FIGURE 24.18　Click Your Own Bitmap.

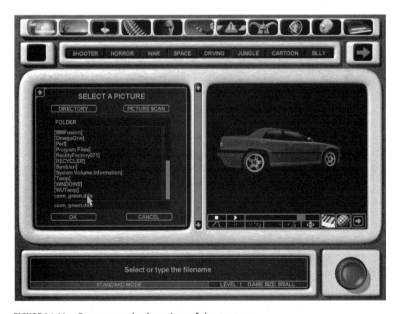

FIGURE 24.19　Browse to the location of the texture.

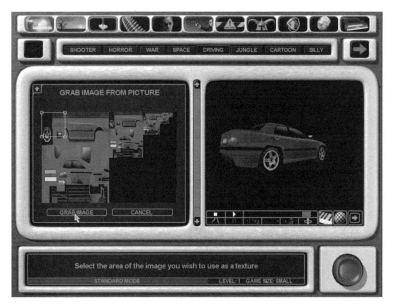

FIGURE 24.20 Our texture is loaded.

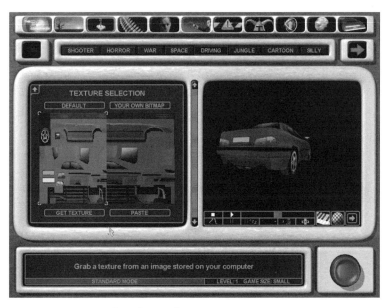

FIGURE 24.21 Resize the selection box.

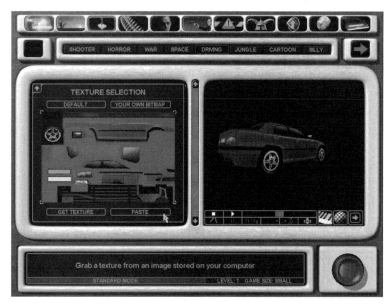

FIGURE 24.22 Click the Get Texture button.

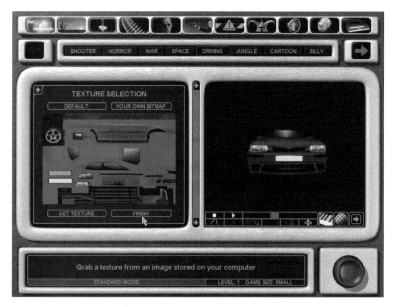

FIGURE 24.23 Click the Finish button.

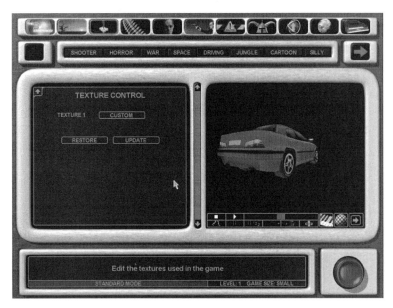

FIGURE 24.24 Click the Update button to see the change.

CHAPTER REVIEW

As you have seen, customizing the built-in objects is a quick and easy way to make our games look unique. We were able to create a custom color of vehicle, resize the vehicle, and place a variety of tires beneath it to give it a custom look with a few clicks of the mouse. In the next chapter, we are going to look at how T3DGM similarly allows us to create custom 3D levels.

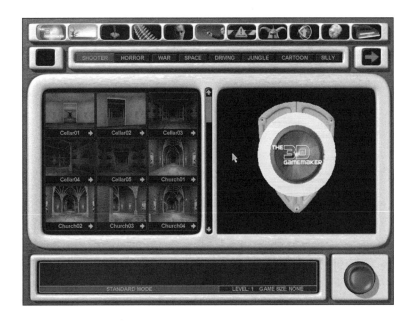

BUILDING CUSTOM
3D LEVELS

In the previous chapter, we looked at how we can combine models in T3DGM into new models. We'll move on in a similar direction as we'll now learn how to build custom 3D levels that can be used instead of the built-in variety we have seen up to this point.

STARTING OUT

We will start work on a custom 3D level by opening T3DGM. Once you have it opened, create a new game. At this time, your screen will look like Figure 25.1.

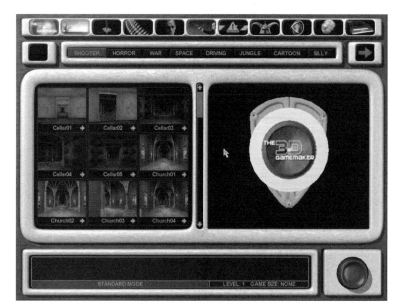

FIGURE 25.1 T3DGM at startup.

Using the scrollbar along the top of the screen, scroll to the button called User and click on it. This will open a new option, as seen in Figure 25.2.

Click the Make New Scene button, which will open the editor seen in Figure 25.3.

Along the left of the screen, you will see several types of tiles that we can use to create our custom level. By placing these tiles in different directions and arrangements, we control how the level looks. Along the top

FIGURE 25.2 A new set of options.

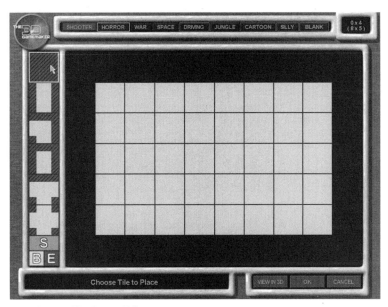

FIGURE 25.3 The Scene Editor.

of the screen, you will see the same categories we have had at our disposal throughout our development with T3DGM. These categories affect the type of texture that is displayed in each tile during gameplay.

To create a new tile, we choose one of the items along the left of the interface and choose one of the categories from the top. Next, we position the tile in the interface and then left-click the mouse button to place it (see Figure 25.4). To rotate the individual tiles, you can single-click them. This will allow us to rotate them in 90-degree intervals as seen in Figure 25.5.

FIGURE 25.4 Placing the tile.

FIGURE 25.5 Rotating the tiles 90 degrees.

Along the lower left on the screen, we can see three different buttons with the letters S, B, and E on them (see Figure 25.6). Each of these has very specific and important requirements in our custom-built levels. The letter S stands for the player start position, which is set by clicking on the S button and then clicking within one of the tiles. Likewise, the B indicates the end of the level and can be set by choosing and placing it. Lastly, the E stands for the end bosses you'll see in the levels. You're already familiar with these categories from our previous projects that used the built-in levels.

FIGURE 25.6 The letters S, B, and E are extremely important for our levels.

Construct a very simple level with all of these components using Figure 25.7 as a guide. Next, click the View in 3D button to see our creation (see Figure 25.8).

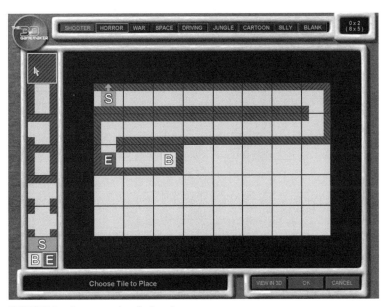

FIGURE 25.7 An example of a level.

FIGURE 25.8 View the level in 3D.

That's all there is to creating a custom 3D level. Like everything in T3DGM, this is a very simple process, although we are somewhat limited to the types of levels we can build. This isn't as much a limit in the software as it is a design that was required to keep everything easy for us.

Once you have reviewed the level, you can hit the Esc key to end the test and to return to the level building interface. To save the design, you can click the OK button, at which time you are given the ability to enter a filename (see Figure 25.9). As this was an extremely simple level, you do not need to save at this time.

There are a couple of additional details that will probably be important to you. At first glance, you may think you are limited to the standard level size displayed on startup. Although you should always do your best to keep your level sizes to a minimum (this helps your games run more smoothly on less-powerful systems), you can increase the number of tiles needed to lay out your scenes by holding down the Shift key and pressing a directional arrow in the direction you would like to increase the playing size. As an example, you can see in Figure 25.10 that the playing surface was adjusted to the right as we used the Shift key and the right directional arrow. To navigate the larger sizes, you use the directional arrow keys (make sure to release the Shift key and that you are pressing only the arrow keys) to move in the desired directions.

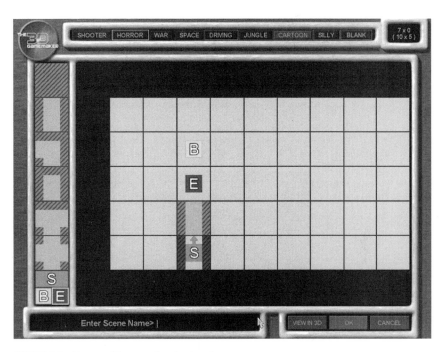

FIGURE 25.9 Enter a filename for the level.

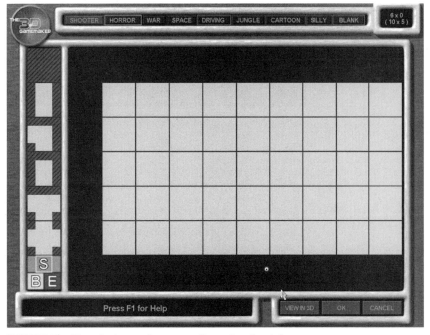

FIGURE 25.10 The playing surface was adjusted to the right.

Along with changing the playfield size, we can also alter between categories of tiles. The tiles can be changed individually to a different category as you place them in the scene. This again allows you to further customize a level, although you'll again need to use some discretion. For example, there are not many times you'll want to switch between categories such as Horror and Comedy because the contrasting styles may not look good together (see Figure 25.11).

FIGURE 25.11 Contrasting styles may appear out of place.

The last thing to keep in mind is the limitations that are inherent with the custom levels. For example, you can see how the details in Figures 25.12 and 25.13 are much different. Figure 25.12 is one of the built-in levels, and Figure 25.13 is a custom-designed level. Along with a lack of detail, you are also limited in the fact that you cannot create areas to jump over, such as the one see in Figure 25.14, because a custom-built level does not allow for variations in height to a tile.

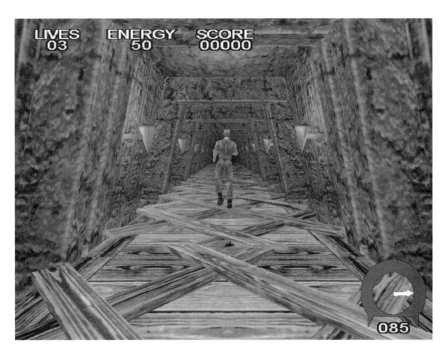

FIGURE 25.12 Built-in level from T3DGM.

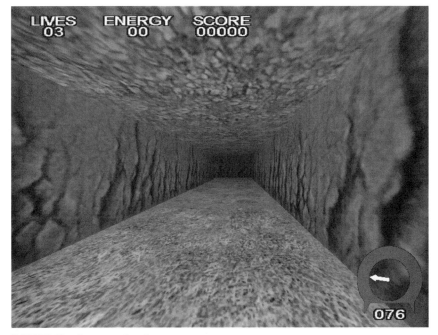

FIGURE 25.13 A custom level.

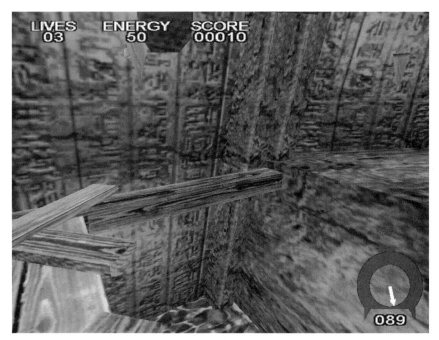

FIGURE 25.14 Variations in height, such as this, are not available in a custom level.

CHAPTER REVIEW

In this chapter, we built a simple level using the design tools built into
T3DGM. We used all of the level design tools in doing so. In the next
chapter, we're going to build a first person shooter with a custom level
and then substitute an existing built-in level so that we can see how this
affects the final gameplay.

TOMB RAIDING X 2

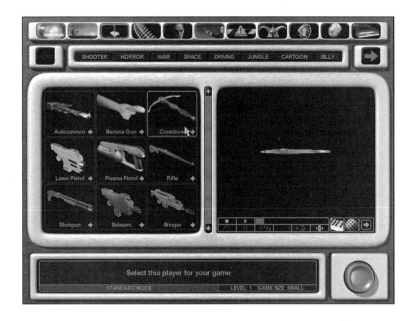

In the last two chapters, we created custom-built models and scenes. In this chapter, we're going to return to the design process and create a new game using a custom-created scene, and then we'll change the game to use a prebuilt scene.

CUSTOM SCENE

First, open T3DGM and create a new game. Choose User Scene from the scrollbar and then click Custom Scene. Choose Jungle as a category, and using Figure 26.1 as a reference, create a scene. It does not have to be exactly the same as the scene in the figure, but do something similar. Make sure to set the beginning point, the end point, and the boss.

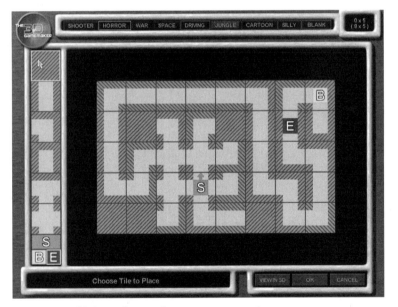

FIGURE 26.1 This is a reference for you to use to make your own scene.

When you finish the scene, click the OK button and give it the name Jungle. You will now see your custom design visible as a user-created scene (see Figure 26.2). Choose the scene and then click the Player icon so that we can pick the character we'll control. For this example, we'll create a First Person Shooter, so choose the Shooter category and then pick the Crossbow from the available options (see Figure 26.3).

FIGURE 26.2 The custom design is visible.

FIGURE 26.3 The crossbow is our selection.

Next, click on the Player Bullet button and then select Quarrel from the list (see Figure 26.4). After the player bullet, we can click on the

Enemy button and then choose Jungle from the list of available categories. We'll now pick Goblin Scout (see Figure 26.5) from the list.

We don't need to choose a weapon for the enemy or obstacles, so we can move on to the end of scene boss. You can pick Forest Troll from the

FIGURE 26.4 Choose Quarrel for a weapon.

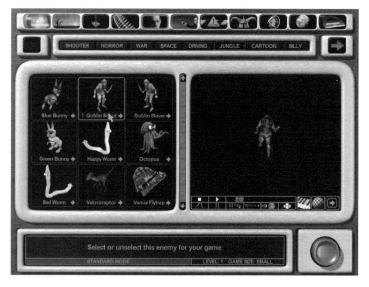

FIGURE 26.5 Our enemy is the Goblin Scout.

list (see Figure 26.6). We are now finished, so you can run the final product (see Figure 26.7).

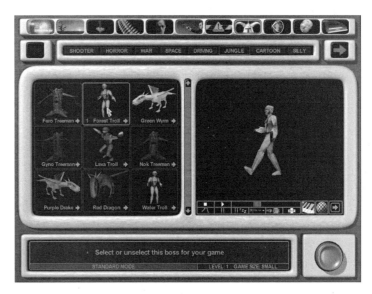

FIGURE 26.6 Choose the Forest Troll.

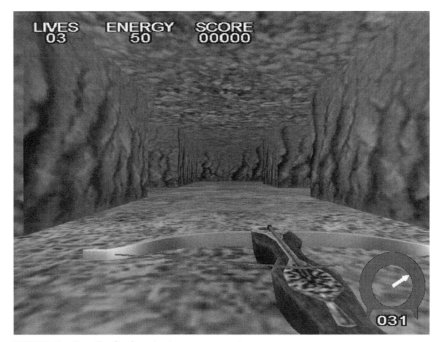

FIGURE 26.7 Run the final project.

BUILT-IN SCENE

After playing the scene and testing it, you can quickly switch from our custom scene to a built-in scene. Press Esc to end the test and return to the user interface. Click the Select a Scene button and choose Jungle as the category. From the list of scenes, you can choose Caverns01 (see Figure 26.8). That's the only required step to change this game because the weapons, enemies, and other options will retain their original settings.

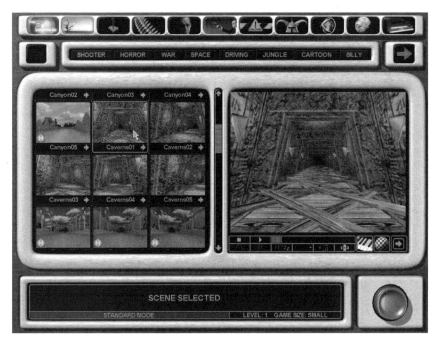

FIGURE 26.8 Choose Caverns01 from the list.

Test the game again and notice the differences in the scenes (see Figure 26.9).

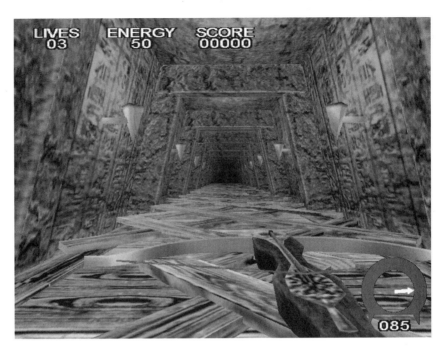

FIGURE 26.9 Testing the game.

CHAPTER REVIEW

In this chapter, we created a new game and scene. After testing the scene, we proceeded to replace the custom-built scene with a built-in one. The game was then tested again to verify that everything will continue to work correctly, and as you have seen, it does function as expected. With the capability to change levels, players, and other objects so easily, T3DGM enables you to quickly build up a complete library of custom games.

INTRODUCTION TO REALITY FACTORY

In the previous seven chapters, we used a tool called T3DGM for our projects. In this chapter, we are going to look at our final tool, which is called Reality Factory. These final two chapters are going to take a quick look at the tools involved with Reality Factory. We'll spend just enough time to get it up and running because our interest in Reality Factory will center on getting you ready to take the next step for many aspiring game developers: programming.

INSTALLATION

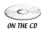
ON THE CD

Reality Factory (RF) is available on the CD-ROM that comes with this book, or you can download a more recent copy from the Reality Factory home site at *www.realityfactory.ca*. Either way, you can follow these steps for installation:

1. Double-click the Reality Factory install program to start the installation (see Figure 27.1). On the CD-ROM, this is the rf071.exe file in the Applications directory.

FIGURE 27.1 Start the installation.

2. Click Next to continue the installation (see Figure 27.2).
3. Click Next and choose Next to continue the installation (see Figure 27.3).

FIGURE 27.2 Choose Next.

FIGURE 27.3 Continuing the installation.

4. Click Yes from the next screen, which looks like Figure 27.4, to create the installation directory.

FIGURE 27.4 Click Yes on the next screen.

5. Click the Start button from the window that looks like Figure 27.5. File lists are displayed as they are being copied (see Figure 27.6).

FIGURE 27.5 Click the Start button.

6. From the next screen, make sure to launch the configurator (see Figure 27.7) and then click Next.

FIGURE 27.6 Files are being copied.

FIGURE 27.7 The configurator needs to be selected.

7. The next step in installation is displayed in Figure 27.8. Click the Exit button to close the window.

FIGURE 27.8 The next step.

The screen in Figure 27.9 will be displayed. Click the OK button.

FIGURE 27.9 Click the OK button.

8. Once processing is complete, a new window can be seen (see Figure 27.10). Click OK to continue the installation.

FIGURE 27.10 The new window can be seen.

Now is the time to download any available patches (at the time of writing, they were at 0.7D) and extract them to the directory you used for installation. If you are unfamiliar with extracting files or need to download a tool for the extractions, you can do a search at any of the major search engines to find such a tutorial. The updates are in ZIP format, and Figure 27.11 displays the extraction options that are available if you are using WinRar and right-clicking on the file. You can use any extraction tool, but you need to extract the files to the installation directory to overwrite any of the existing files.

FIGURE 27.11 WinRar options for extraction.

RUNNING VIDEO SETUP

Before running Reality Factory, it is imperative that you run the Video Setup program that comes with it. This will set the video driver and the resolution to something your system can handle. The 32-bit D3D driver may not work on all computer systems, so if you have problems, the 16-bit driver might be a better option. The Video Setup program will determine if it can run, before it is set. By default, the resolution is set to a full screen 800 × 600. Run Video Setup at this time and set it appropriately. You can see how it should appear in Figure 27.12. If you wish your screens to look comparable to the ones in the next chapter, choose Standard (800 × 600) and click Accept to close.

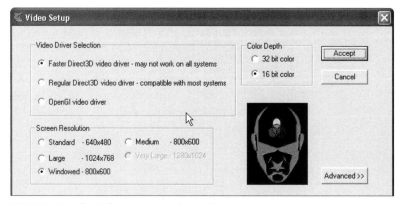

FIGURE 27.12 The Video Setup window with settings.

RF TOOLS

There are a number of applications that come with RF. Most noticeable is the World Editor, which will be looked at in the next chapter. There are several additional tools that we will briefly look at:

RF INI Editor: This INI editor allows you to change and set options defined in the RealityFactory.INI file. You can use this to define the game level, the player actor, and the menu.

Actor Studio: Reality Factory models are referred to as actors and are in a custom format with an .act extension. This tool can create the ACT files from other formats.

Actor Viewer: This allows the user to view ACT files and animations.

Font Maker: The Font Maker can generate fonts that can then be used in RF. It uses the standard windows TrueType fonts that are installed.

TXL File Editor: Reality Factory levels use a format for the textures with the TXL extension. If you are familiar with Doom, these are similar to the WAD file. You can use this editor for the creation of these files.

CHAPTER REVIEW

In this chapter, we installed the Reality Factory suite of applications and briefly looked at the tools that come with it. Our next chapter will give us a much more in-depth view of RF and will be the last in this book.

28

GETTING STARTED WITH REALITY FACTORY

In the final chapter of this book, we are going to look at the basics of an application that is more difficult to use, but that is also much more powerful. The name of the software is Reality Factory, and like the others in the book, it is a complete game creation system for non-programmers. We are covering this last in the book because it will give you some additional avenues to pursue once you have mastered some of the easier applications. You can also use Reality Factory to learn how to program using a basic scripting language.

Reality Factory development began shortly after the original Genesis 3D open source release (*www.genesis3d.com*) in 1999 as a rapid game prototyping tool that allowed game developers and designers to create demonstrations of game designs quickly.

Reality Factory has since evolved into a complete toolkit for independent game developers. With its open source roots and growing independent community, Reality Factory is one of the fastest developing, most complete game development toolkits available in the world. Providing a complete game creation system for non-programmers, RF Pro is an independent game developer's dream.

WHERE TO START?

When learning any new software program, particularly one as complicated as a complete game engine and tool suite like Reality Factory, it is easy to feel overwhelmed. This chapter is designed to help get you familiar with the primary Level Editor that you will be using to create your RF levels, RF Edit Pro.

Before we jump into the editor, however, let's take a brief tour through the Reality Factory tool suite and see what the engine has to offer. At this point, we assume that you have managed to install the Reality Factory engine (either the one provided on this book's CD-ROM or potentially a newer release from *www.realityfactory.ca*). New releases come out approximately every two months or so, so it's a good idea to check the Web site often for updated releases and bug fixes, not to mention resources, sample scripts demonstrating certain types of gameplay, and more.

Reality Factory installs by default to `C:\realityfactory`. Inside the main root directory you will see a number of applications (EXE files), dynamic link libraries (DLLs), and some other resources. The RealityFactory.exe application is the main game engine itself. If you create a game with Reality Factory, you are in essence customizing the behavior of the engine by adding a custom menu, heads-up display, weapons, characters, and of course, levels.RealityFactory.exe becomes YOUR game (you can rename it once you are done making your game, add your own icon, and so on) and is freely distributable for commercial and noncommercial use.

 Check the *www.realityfactory.ca* site for more details on the Reality Factory license, and check out *www.opensource.org* for more information on open source software in general if you are not familiar with it. Open source software (OSS) has recently caught on as a phenomenon in the operating system and business market and is slowly catching on in the game industry. OSS projects rely on community input and feedback, not to mention contributions (code, resources, financial, and such) to further the projects' development. Instead of keeping the software's code (the blueprint of the software) locked away in a vault where no one can see it, like proprietary software, OSS projects provide the world with the means for examining, testing, and using the code based on any of hundreds of different open source licenses, some more restrictive than others. The Reality Factory license is known as an MIT-style license, which is one of the most liberal licenses (meaning you can do just about anything you want with the software) that software is released under. Please check *http://www.opensource. org/licenses/mit-license.php* for more information on the MIT-style license definition and other background on open source software in general.

The rest of the Reality Factory directory structure is broken into a number of subdirectories, described below:

Icons: This directory stores icons for the entities that you place into your levels (lights, doors, and so on). These are used only by the editors.

Install: This is the directory of configuration files for your RF game. You can define custom effects, heads-up display, menu, attributes, camera settings, and much more just by modifying these INI files. Check the Reality Factory documentation for more information on the INI files.

Media: This is where the content of your game is stored. There are a number of subdirectories underneath that contain the different elements of your game, including actors, audio, bitmaps, levels, and video that make up your game.

Scripts: Reality Factory has an integrated scripting language (called Simkin) that is used to customize the behaviors of your game's characters (friendly and not-so-friendly). Scripting in RF is beyond the scope of this tutorial, but you can check the Reality Factory site for more details on the syntax and functions available to you. There are a number of sample scripts provided in the Scripts directory of your install, and they can be opened with any text editor (like Notepad) for viewing and customization. Simkin is similar to more advanced languages like C or Perl, but is much easier to learn and use.

Source: This directory contains the entity definitions for the Reality Factory engine. This is the glue between the editors and the game

engine itself. The editors read the `gameentitydatatypes.h` file (a C++ header file defining the entities, such as lights and doors) when you load a level. This tells the editor what properties or options are available with each entity so when you compile your level for testing in the game engine, the game engine can read the information and execute the game level.

Tools: All the Reality Factory tools are in this directory. There are a number of applications, each designed to help you with a specific component of Reality Factory game creation. They include `ActorView.exe` (an actor viewer so that you can view your RF actors), `Astudio.exe` (the Actor studio (which is used to compile your 3D models into game-ready actors), `rfpack.exe` (drag-and-drop textures onto rfpack to build your own custom texture libraries that can be used in your game levels), `rfvfs` (loads and displays RF pack files, which can be used to simplify distribution of your finished game and supports encryption of your game's content to protect it from theft/hacking), and many others.

BASIC NAVIGATION

To start, let's check out one of the Reality Factory editors—RF Edit Pro. Navigate to the Tools directory of your RF install and double-click on `RFEditPro.exe` to launch the editor. Once it is opened, you will see something similar to Figure 28.1.

FIGURE 28.1 The Level Editor in Reality Factory.

 If you get an error about not being able to find the texture library when opening the editor, please refer to the "Setting Grid Scale and Grid Snap" section later in this chapter for instructions on how to tell the editor where your texture library is, as well as where the other various paths are in your current RF install.

This section will cover creating a basic room in the RF Edit Pro editor. We will create the geometry, texture and light the room, and then test and preview the level in-game to see how it looks.

We have the editor open; where do we start? Let's start with basic navigation in the editor. Depending on your own preferences, you may wish to hide the Properties sidebar when working because it gives more screen area when editing. If you use dual monitors, you can also turn the Entity and Properties panels into floating panels and move them onto the other screen for better visibility of your workspace. You can show and hide the various elements of the editor using the View menu.

USING THE CAMERAS

The editor has four different viewports, each of which gives you a different view of the level you are building. Three of these views are wireframe fixed viewpoints; the fourth is a dynamic flyaround camera that you can use to see what you're building on the fly. It's not a full in-game look like editors such as the Unrealeditor (you can't see lighting or actors), but it lets you see the level geometry and textures pretty much as they will appear in the game. It has wireframe and textured views that can help quite a bit in seeing what you are building.

The controls for the Textured viewport are:

Hold Left Mouse Button (LMB) and Move: The mouse moves forward, backward, and turns left and right.

Hold Right Mouse Button (RMB) and Move: The mouse rotates the viewpoint 360 degrees to let you look around.

Hold Spacebar Along the LMB: You will strafe the camera up, down, left, and right without actually changing the view angle.

Left-Click: Select brushes or faces, depending on which mode you are in. Right-click in one of the other viewports to switch between modes or go to the Mode menu and switch between them from there.

Controls for the other three viewports are the same:

LMB: Selects brushes in the View window.

RMB: Opens a context menu that lets you switch between modes (Face and Brush) and lets you choose which tool you are going to

use (Move, Rotate, Rotate 45, Resize, or Shear) and lets you choose a few other settings.

Some other useful control shortcuts are:

Ctrl+Left-Click: To select multiple brushes or entities, both in the textured preview window and the three wireframe windows.

Shift+Left-Click: In the Textured view to choose a texture from your texture library. Useful for finding a texture you've used before—just point and click.

Shift+Hold LMB: Move the mouse to clone brushes and entities. This works in the three wireframe views.

To add a brush to your level, simply click Add to World on the sidebar, hit Enter on your keyboard, or hit the Insert key on your keyboard.

EDITING MODES

Game levels in Reality Factory are created using one of two types of geometry: BSPs or Actors. Well look at each in more detail now.

Actors

Newer game engines have begun to phase out use of specialized geometry pipelines like BSPs in favor of using standard 3D objects created in a traditional 3D modeling program like Maya, 3D Max, or MilkShape 3D. Reality Factory is no different in this regard.

The upcoming release (as of this writing) of Reality Factory provides a new StaticMesh entity, which for the first time provides level designers with the capability to use standard 3D models as level geometry, with full per-poly collision detection, and more precise texture support (paint your textures in the 3D modeling program, apply whatever complex U/V mapping you wish, and so on). As the saying goes, this changes everything.

Up until this point, RF Actors were used only for the main game characters (player and NPC) as well as props that the designer can place around his levels. The new StaticMesh system brings RF up to date with other game engines such as Unreal by providing a way for designers to add detail to their levels with built-in Level of Detail (LOD), accurate shadowing, and more complex geometry than was previously possible with BSP-based level designs. It is now possible to create your entire level geometry in an advanced 3D modeling program like Maya or 3D Max. At this point the RF level editors become more of a placement tool, where the designer imports his individual 3D models (as ACT files), places them appropriately in the editor, and then adds lights, scripted events, and other entities.

This tutorial does not cover creating an Actor-based level and focuses primarily on using the Level Editor for creating basic geometry. Even though BSPs are losing favor with game developers, they are still very useful for certain types of geometry, in particular interiors and other geometry types with limited view distances.

BSP Worlds

Much like the Half-Life/Unreal development process, BSPs are used for the core shell of your game level. BSP geometry is created in one of the three Reality Factory editors. BSP worlds are built from combinations of basic building blocks, or brushes, very much like Half-Life, Unreal, or Quake levels. Each brush is created from a core set of six shapes, covering many common geometric shapes. Combining different shapes and combinations of brushes creates your world.

Setting Grid Scale and Grid Snap

To start off, however, let's do one simple thing. We need to set our Grid Scale and our Grid Snap. These are important steps because they will help align your brushes together and make sure that you are creating a world that doesn't have any leaks or overlaps or wasted faces in it.

Go to Project, Level Options to open a window that looks like Figure 28.2.

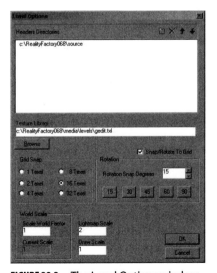

FIGURE 28.2 The Level Options window.

Set Grid Snap to 16 Texel to start with and click OK. The other settings let you customize the default rotation snap and the location of your texture library and entity header files. You can leave the rotation snap at 15 degrees for now.

Next, go to Project, Grid Snap and make sure that there is a checkbox enabling the grid snap. This will save you a lot of headaches in the future. If you need to align something custom, you can always disable it, set up the geometry, and then reenable it for the major geometry in your levels.

THE SIX PREFABS

When creating your geometry in the RF level editors, you are given the choice of several predefined geometric shapes to use as building blocks. These building blocks are called brushes.

The six prefabs available are:

- Cube
- Sphere
- Cylinder
- Stairs (or ramp)
- Cone
- Arch

Adding Prefabs to Your Map

Each prefab can be customized, or tailored to your specific needs. To do so, enter Template Select mode by either right-clicking on one of the wireframe viewports and choosing Template Select mode, by using the menus Mode, Template Select, or by hitting the T keyboard shortcut. The editor is pretty slick this way, providing nice common sense keyboard shortcuts for common actions.

 If you can't switch to the Template Select mode, make sure you don't have any of the action tools enabled, such as Move, Rotate, or Resize.

Once you are in Template mode, click on the desired template (one of the six in the previous list). We'll start with a nice simple cube. When added, the default cube looks like Figure 28.3.

Many first room tutorials use a simple hollow box and go from there, but we're going to try to get you started in a different manner by getting you to create the walls from separate brushes. Hollow brushes don't render as fast as solid brushes, and there are potential rendering issues that you may run into with hollow and cut brushes; avoid at all costs, unless absolutely necessary. This brings us to the next step—customizing our prefabs.

FIGURE 28.3 The default cube added to the editor.

CUSTOMIZING THE PREFABS

As you can see in Figure 28.4, you have a Customize Template button on the right side of the user interface. Simply click this and it will enable the grayed-out options above, letting us tweak and create different sizes and shaped objects. You now have access to many more than the six defaults.

FIGURE 28.4 The Customize Template button is available on the right.

What we want to do is create a solid cube that we can resize and play with from there. Enter the Customize mode and then click on the Solid radio button. The wireframe views should change to a solid cube shape

instead. Let's resize the cube and start building our world. Right-click on the wireframe view and enter Resize mode. Alternately, you can use the menu Change, Scale or hit the L key.

If you hold your mouse over one of the sides or corners of the cube, you should see the resize arrows, indicating which direction you will be scaling the brush if you select it there. Let's resize the cube down so that it will become the floor of our new world. In the Side view, left-click (LMB) on the top of the cube and drag it down toward the bottom of the cube. This will resize the cube so that it is fairly thin in two of the views. Our cube should now look like Figure 28.5.

FIGURE 28.5 Resize the cube similarly.

You can see the grid markings on this screen, which are represented as yellow dots. These are the snap settings. If you zoom in on the view, you can see that there is a smaller 1-texel grid marking as well. The larger grid provides guides to help align your brushes.

Now that we have our floor ready to go, hit Enter on the keyboard or go to Tools, Apply Entity, Template. This will add the template cube into the world. The texture that is applied when you add the brush to your world is the first in your texture library, or whatever the last texture you applied on the world.

Let's use the Front view this time and resize the Cube template to create walls for our new kingdom. You can tell we are still in Template mode by the purple outline in the four views.

If you attempt to click in the 3D view while in Texture mode, the editor may switch automatically to Brush Select mode, and the template (blue brush) will disappear. If this is the case, simply press T to reenter

Template mode and continue your work. The editor will remember the previous state of your template, so you don't need to re-create the positioning and size.

Resize the brush so that we have a wall lined up as seen in Figure 28.6.

FIGURE 28.6 Resize the brush.

You can see the first brush we created in Figure 28.6. If you are looking at your screen, the unselected brushes are white, and selected brushes are green. You should note that we are not overlapping the new brush with the old one. Grid Snap will make sure that they are perfectly aligned together. This is essential for successful level compilation (and running of your new game). You can zoom in on the brush corner to make sure that you are connecting and aligning the brushes together. It's worthwhile to check and make sure because sometimes you don't get an actual view when you are zoomed out. The detailed smaller grid will show you brushes that you thought were aligned that aren't. This is where the Grid Snap becomes crucial to the level-design process.

You can see the larger grid (the yellow dots) matched against the smaller grid (green dots) in Figure 28.7. Our two brushes are ready to go and nicely aligned, so we'll apply it to the world (again, hit Enter or go to Tools, Apply Entity/Template).

Each of the dots in the smaller grid represents one texel. A texel is the basic unit of measurement in our virtual world.

Now we have two brushes set up: one for our floor and one for the ceiling. Our next step is to look at cloning.

FIGURE 28.7 The grids are both visible.

CLONING BRUSHES

Our level currently has two brushes. Not too spectacular, but we're making progress at least. To clone brushes, you need to enter Brush Select mode, by right-clicking and selecting it from the context menu, or using the Mode menu (Mode, Brush), or by hitting the B keyboard shortcut.

We need to left-click on one of the two brushes. It doesn't matter if you choose Floor or Wall. If you have done everything correctly, the brush you selected should turn a mauve-green color. This indicates that this brush is ready to be modified. Right-click on one of the wireframe views to open the context menu and make sure that you don't have any of the action modifiers applied (Move, Rotate, Resize, and so on). The second section of the context menu should have no check marks in it.

This indicates that our brush is ready to clone. Hold the Shift key (either one), left-click, and drag the brush toward the opposite wall (or ceiling). You should see a selected brush (the green color) moving around with your mouse. While still holding Shift and left-clicking, move the brush into position.

If you let go of the brush after you've cloned it, you will have to go into Move mode to adjust it into position. Otherwise, you might continue to clone the brush again and again, which is not the desired outcome.

Selecting Multiple Brushes

Selecting multiple brushes and entities is easy. You simply hold Ctrl and left-click to your heart's content. To deselect a brush in a group, simply hold Ctrl and reclick on the brush. It will toggle it from Select to Deselect. If you followed the previous steps for the floor, ceiling, and two walls of our room, you should have a level that looks like Figure 28.8.

FIGURE 28.8 Our level is nearly finished.

We have our four brushes, walls, and ceiling, but the ceiling isn't showing up in the 3D view.

REBUILDING THE TEXTURED VIEW

The 3D view in the editor runs a limited version of the G3D renderer, which means that it requires a BSP tree to render its own internal view. Of course, you can tell with one look at the editor that the full version of the level isn't what we are looking at. Unlike some editors such as Jet3D and Unrealedit, the Genesis 3D editors don't provide a fully lit 3D view.

If this is a problem for you, you can use 3D Studio Max to create your Genesis levels and convert them into either 3DT level files or ACT Actor files.

What the above ramble was meant to describe was the process of rebuilding the BSP view in the editor. After each change you make to the brushes, the editor must do a rebuild on the fly, calculating the textured 3D view that you see. This is not noticeable when you first start out (like with our four brushes), but when you get upward of 500 brushes and dozens of textures, the editing process can become extremely slowed by the constant rebuilding of the BSP view. In the RF Edit Pro editor, you will see a message in the lower-left corner saying Rebuilding Trees. This can take anywhere from near-instantaneous to almost a minute on some larger levels.

To enable or disable the auto-rebuild, go to Mode, AutoRebuild BSP and uncheck it. This means that the Textured view won't be updated until you click the Rebuild button or go to Build, Rebuild BSP Tree.

Multiple Brush Cloning

Our new room has two walls, and we need to finish off the others. Let's be a bit fancy to show some other features of the editor. Select the two walls in the room (Ctrl+left-click) and then clone them. Move them aside so that you can tell they are different from our first two walls, something like Figure 28.9.

FIGURE 28.9 The brushes are cloned.

We've cloned the brushes in the lower-left window. Notice that the other windows haven't updated themselves. This is because the screen shot was taken during the clone process. Once you let go of the mouse button, the other wireframe windows will update, and the Textured view will update if you have auto-rebuild enabled.

Rotating Brushes

Now that we have cloned our brushes, we need to rotate them 90 degrees from their current position, after which we will move them into place, perpendicular to our original two. To rotate the brushes, we need to right-click (with the brushes selected) in the top view (upper right) and choose Rotate 45. This will spin the two brushes around 45 degrees. Do this again, and the brushes will be in their proper rotation.

It is important with the various action modifiers (Move, Resize, Rotate) that you are clicking in the correct view. Luckily, the new editor has a pretty good undo/redo capability (Ctrl+Z to undo your last action), so you aren't as affected as with the old editor. Previously, one wrong move and you had to rebuild entire sections of your map, which was not much fun.

Make backups of your level periodically (do a save as a different filename), just in case you break the level, something goes drastically wrong, and so forth.

LEAKS

If you have any Quake or Half-Life mapping experience, you will be familiar with the concept of leaks in your level. Leaks are caused when your level geometry (brushes only) does not entirely seal your level. By definition, a BSP must be a completely sealed interior environment; even if you are planning to show a massive outdoor terrain through a skybox, the underlying geometry (the BSP) will need to be sealed.

This is why using Snap to Grid is a crucial time-saver: It ensures that your brushes are properly placed so that your level doesn't have leaks.

RESIZING MULTIPLE BRUSHES

One of the nicest features of the new RF Edit Pro editor is multiple brush scaling. This means that you can have any number of brushes selected and scale the whole lot of them at once. No need to resize dozens of brushes to the same height.

In Figure 28.10, you can see the almost-finished first room. Note the one thing that we need to correct before the room is finished.

FIGURE 28.10 Almost finished level.

Look in the top (upper-right) and front (lower-left) views for a clue. We have overlapping brushes. The two walls that were just cloned and moved into place are too long, and they are overlapping the original two brushes.

This is a big problem in Reality Factory level editing. You will have more lighting, rendering, and other glitches because of overlapping brushes than any other reason. Always check your editing to make sure you are aligning your brushes perfectly and making sure that there is no overlap.

Because we already have the brushes selected, we can scale them into place using Multiple Brush Scaling.

Right-click and choose Resize from the menu or go to the Change, Scale menu option. You can click and drag the brushes so that they are not overlapping; both will resize accordingly.

Our first room is now complete, but before we can compile and test the room, we need to do two things:

1. Add the default entities.
2. Change that default texture to something more eye appealing.

Let's get to it, so we can see our level in the editor.

ADDING ENTITIES

There are three entities that you must always add to your Reality Factory levels before you first test them:

- PlayerStart
- PlayerSetup
- EnvironmentSetup

 The Reality Factory documentation is available in HTML, PDF, and CHM (compiled help) format and can be viewed online or downloaded for offline viewing. They can be obtained from the Reality Factory Web site at www.realityfactory.ca. Additional tools and information are also available.

To add entities, first go into Template Select mode and open the Templates panel. Choose the entity you want to add from the drop-down list. If you have the entity selected, the main template view (the purple one) should change from a brush shape (the cube we are using above, for example) to a small square with an x in the middle.

Make sure that your entity is inside the cube like ours currently is, and then hit Enter to add the entity to the world.

When you add your PlayerStart, make sure that you are placing the entity near the ground because the PlayerStart actually appears where the player's feet are. If you place them up in the air, the player will do a noticeable drop when he starts the level (and potentially cause damage to the player, depending on your gravity and damage settings).

Now that we have the three entities placed in our world, let's get it ready for testing in the engine.

TEXTURING YOUR LEVELS

Our level is ready to go and has the default entities, but from the Editor view, we can already tell it looks bad because of the texture that it defaulted to. Go into Brush Select mode (press B) and select the wall brushes in the map (holding Ctrl to multiple select) and then click on the Textures tab on the left panel.

Scroll through the Texture browser on the left panel and choose a nice wall texture. You can add your own textures to a library and create new texture packs using the RF Pack Utility (found in your RF\tools directory).

If we had created our level out of a single hollow box, texturing would have been a bit more complicated. If you use individual solid brushes, you have more control over the texturing and don't need to worry about changing unwanted faces when texturing. This is something that becomes an issue with larger, more complicated levels.

Our sample uses a green brick texture. Click Select to apply the texture to our selected brushes. Next, select the floor and choose a floor texture and select the roof and apply a roof texture. You can come up with something that looks like Figure 28.11.

We can now compile this level and see what it looks like in the engine.

FIGURE 28.11 The final level.

COMPILING YOUR LEVELS

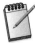

Compiling a Reality Factory level consists of several phases, each necessary to create a ready-to-go level file that you can share with friends and others.

Before you compile your level, you need to make sure that all entities are within the level itself, in particular the camera. Even though the camera isn't used in the game, it is used by the editor to determine how the editor should compile your level. Just remember to fly the camera inside your level prior to compile and you should be fine.

Go to Build, Compile to open the Compile window (there is a Toolbar button for this as well, mouse over them for ToolTips). The path at the top of the window is where the editor is saving the compiling BSP file. Make sure that this makes sense for your RF installation. If you copy RF files from one place to another, you will need to edit this. You can use .map or .preBSP for the extension of the map file listed. These are temporary files that are used for the different stages of the compilation process.

You should save all your RF levels in the \media\Levels directory, so for the default RF installation this would work out to be C:\Reality-Factory\media\Levels. The settings above are the default, and for most situations they will be fine, with one exception: the default light level.

If you have the default light level checked, you will end up with a very bland look for your levels; everything seems washed out, the depth and perspective aren't as defined as they might be, and so on. Each Reality Factory level must be sealed for the BSP compiler to be successful. You can refer back to the section on leaks if you need to refresh your memory about this.

So, with the default settings left enabled, let's compile the level. Check the Preview in Reality Factory box, which will prompt the editor to automatically run the level in the game engine to test.

Here is the output from the test map:

```
** BSP Compile Version: 15
** Build Date/Time: Dec 9 2001,09:28:05
--- Load Brush File ---
Num Solid Brushes : 6
Num Cut Brushes : 0
Num Hollow Cut Brushes : 0
Num Detail Brushes : 0
Num Total Brushes : 6
--- Remove Hidden Leafs ---
--- Remove Hidden Leafs ---
--- Weld Model Verts ---
--- Fix Model TJunctions ---
```

```
--- CreateLeafClusters ---
--- Save Portal File ---
--- Create Area Leafs ---
--- Save GBSP File ---
Num Models : 1, 80
Num Nodes : 6, 264
Num Solid Leafs : 6, 360
Num Total Leafs : 7, 420
Num Clusters : 1, 4
Num Areas : 1, 8
Num Area Portals : 0, 0
Num Leafs Sides : 36, 288
Num Planes : 24, 480
Num Faces : 16, 576
Num Leaf Faces : 16, 64
Num Vert Index : 65, 260
Num Verts : 19, 228
Num FaceInfo : 9, 576
Num Textures : 3, 156
Motion Data Size : 40
Tex Data Size : 391680
--- Vis GBSP File ---
NumPortals : 0
Total visible areas : 1
Average visible from each area: 1
FileName C:\RealityFactory068\media\levels\basic_tutorial.BSP
--- Radiosity GBSP File ---
Num Faces : 16
Num Normal Lights : 0
Num RGB only Lights : 0
Num RGB Always Visible Lights : 0
Num Suns with fallofftype 0 : 0
Skipping RWM Gouraud coloring 65 RGB faces (Full Vis only)
Light Data Size : 4690
Num Light Maps : 16
Compile successfully completed
```

When you preview your level, you can test the game engine in a number of different viewpoints, each available for your games. Also, you can choose to have only one of the views, or you can let the player select what view he wants to use. It's completely up to you.

Figures 28.12 through 28.14 provide a preview in three different views.

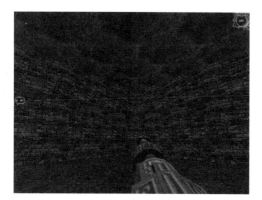

FIGURE 28.12 First-person view.

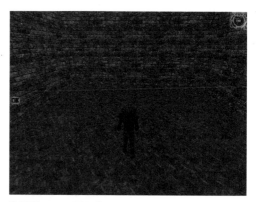

FIGURE 28.13 Third-person view.

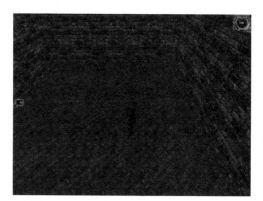

FIGURE 28.14 Diablo-style view.

First-Person: Press F1 to Activate

The first view is the venerable first-person shooter game. Since the development of games such as Wolfenstein 3D, Doom, Quake, and Onwards, the world has been addicted to first-person shooters.

Note the default HUD setup that we get: health and mana meters in the upper right, a radar in the upper left, and a working compass in the middle left. These are basic examples of the types of custom HUD elements you can create with the engine by modifying the HUD.ini file (in the Installs directory of your RF directory).

Third-Person Floating Camera View: Press F2 to Activate

Games like *Alice in Wonderland* and *Heavy Metal :: Fakk 2* used this viewpoint very well. The controls are essentially the same as a first-person

shooter. However, you get a floating view of the player you are controlling. This is an excellent view because you get to watch the player run and jump around, do flips, and so on.

Third-Person Diablo-Style Camera: Press F3 to Activate

Diablo-style hack-n-slash games are extremely popular, and you can use the Reality Factory engine to create your own Diablo-style role playing games. With this view, the camera stays at a certain angle from the player instead of floating behind.

LINKS

Here are some additional links to help you with your Reality Factory development:

Main Reality Factory Web site: *www.realityfactory.ca.* You can grab updated downloads of the engine, check out demos created with RF, and more here. If you are interested in a printed manual, CD updates of the engine, and more, they are all available from the main RF site as well.

Support Forums: *http://support.realityfactory.ca.* Join the friendly community of game developers. The forums are like an extended team that is extremely useful when you get stuck or need help with your game development process.

The support forums are excellent at the RF site, and e-mail is checked regularly. If you have questions or comments, please feel free to check out the site.

CHAPTER REVIEW

In the final chapter of the book, we have briefly covered Reality Factory. This is a very powerful engine, and it takes a while to understand all the features. This engine will allow you a great deal of future learning opportunities because it is greatly expanding and offers the ability to learn some basic programming as well as point-and-click construction. Good luck with your future projects!

ABOUT THE CD-ROM

The companion CD-ROM is packed with everything you need to make all of the games in this book including development tools, graphics tools and 3D modeling tools. Each of these applications performs certain functions that will be needed if you want to build the games included in this book.

GENERAL MINIMUM SYSTEM REQUIREMENTS

You will need a computer that can run Windows 98 or better with a CD-ROM drive, sound card, and mouse to complete the tutorials and play all of the games in this book.

Included applications are contained in the Applications directory. The following descriptions detail which folder they are in and give some basic information about each application:

THE 3D GAMEMAKER (WWW.THE3DGAMEMAKER.COM) DEMO

The filename for this application is T3DGM_Demo_CD.zip and it is contained in the Applications Folder on the CD-ROM. Everything is included in the installation file including the built-in 3D models, environments, weapons, etc

Minimum System Requirements

400 MHz Pentium II Processor
Windows 95 / 98 / 2000 / ME / XP (Home/Pro)
600 MB of hard disk space
64 MB of RAM

DirectX Version 7.0a
Fully DirectX compatible Graphics Card with 3D Acceleration and
8 MB Memory
Direct X compatible Sound Card
4x Speed CD-ROM Drive

Recommended System Requirements

600 MHz Pentium III Processor
Windows 95 / 98 / 2000 / ME / XP (Home/Pro)
600 MB of hard disk space
128 MB of RAM
DirectX Version 8.0a
Fully DirectX compatible Graphics Card with 3D Acceleration and 16
MB Memory
Direct X compatible Sound Card
16x Speed CD-ROM Drive

Multimedia Fusion (www.clickteam.com) Trial

MMFDemo.exe is contained in the Applications folder and is the file-name for Multimedia Fusion. It is a tool used to create a variety of applications and is very appealing to beginning game developers.

System Requirements

The software has been shown to work on computers as slow as a 200 MHz Pentium with Windows 95. The general requirements listed at the top of this document can be used as a basic guideline.

MilkShape 3D 1.70 (http://www.swissquake.ch/chumbalum-soft/) Trial

The Milkshape 3D modeler is named ms3d170.zip and is included in the Applications Folder. It is an excellent and easy to use 3D modeler.

System Requirements

There are no specific requirements needed to run the software (again, use the general guidelines mentioned above) but you will want a 3D video card such as a Geforce or Radeon to do 3D modeling.

PAINT SHOP PRO 8.1 (WWW.JASC.COM) TRIAL

One of the best 3D graphics programs for game developers and is great for creating 2D artwork for your games. The name of the file is psp810entr.exe and is included in the Applications Folder.

Minimum System Requirements

Pentium processor or equivalent
Microsoft Windows 98/98SE, NT4 SP6, 2000 SP4, ME, XP
128 MB of RAM
400 MB of free hard disk space
16-bit color display adapter at 800x600 resolution
Microsoft Internet Explorer 5.0 or later (Windows 98 requires Internet
 Explorer 6.0 or later)
Macromedia Flash Player
Paint Shop Pro 8 Recommended Configuration
Pentium 1.0 GHz or better processor
Microsoft Windows XP
256 MB of RAM or more
400 MB of free hard disk space or more
32-bit color display adapter at 1024x768 resolution or higher
Microsoft Internet Explorer 6.0 SP1 or later
Macromedia FlashPlayer

REALITY FACTORY .071 (HTTP://WWW.REALITYFACTORY.CA/) FREE

One of the easiest to use and most powerful 3D game development environments for non-programmers, the freeware version of Reality Factory is included in the Applications Folder and is named rf071.exe.

System Requirements

Pentium III 600 MHz
64 MB RAM
32 MB Video Card

FOLDERS

There are several additional folders on the CD-ROM that contain useful information:

- **Color Figures** In the "Figures" folder of the CD-ROM, you will find color versions of every figure seen in the book.
- **Graphics Files** You can find all of the graphics we create in the book in the "Graphics" folder of the CD-ROM.
- **Sample Game Files** In the "Projects" folder of the CD-ROM are all the files and assets used in the book.
- **Sound Files** The "Music and SFX" folder of the CD-ROM contain all the music files and sound effects that we composed in the book.

INDEX